Catching
the Moment

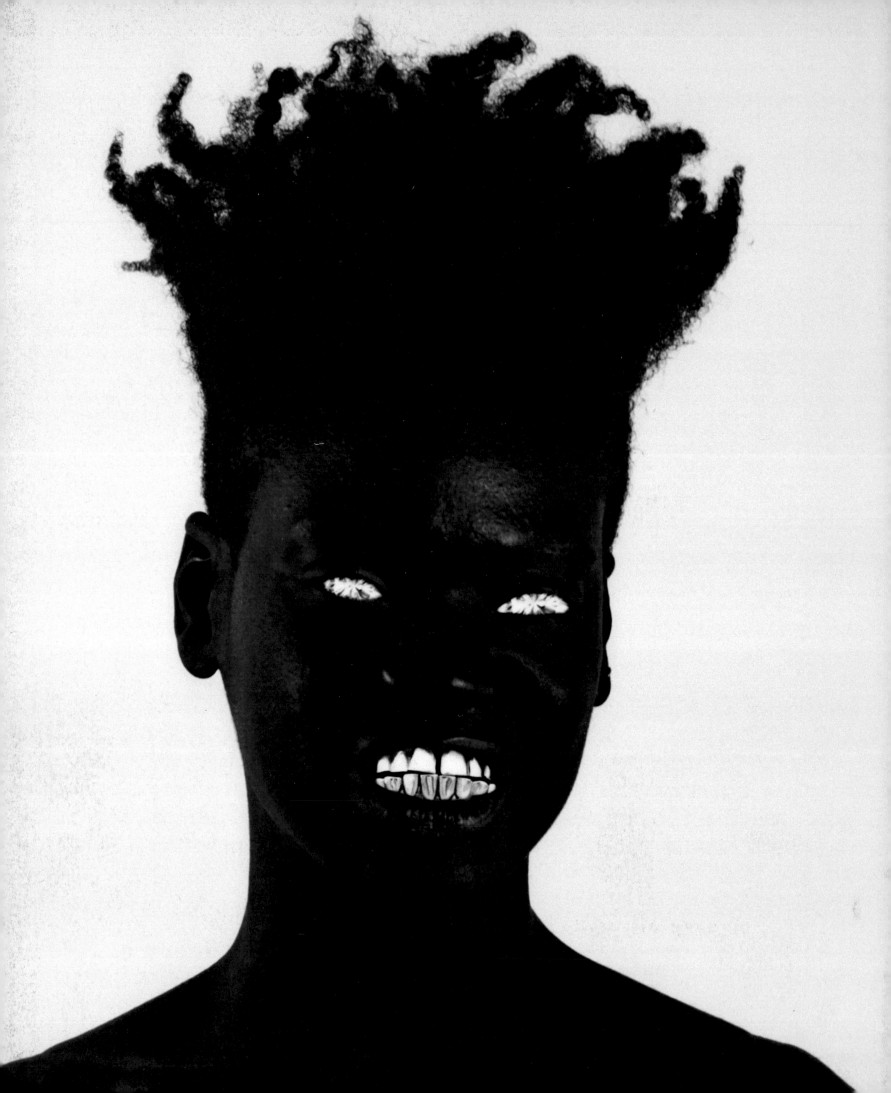

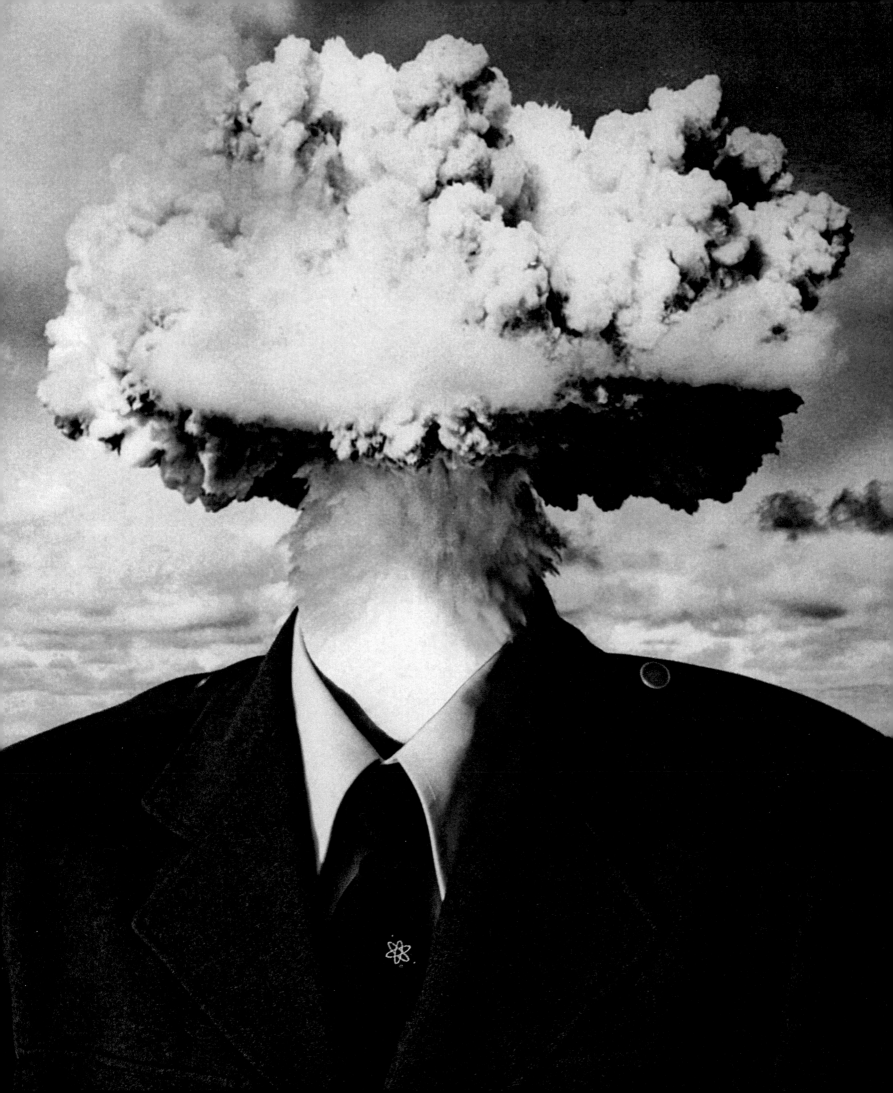

Catching the Moment

Contemporary Art from the Ted L. and Maryanne Ellison Simmons Collection

Edited by
Elizabeth Wyckoff

Essays by
Sophie Barbisan
Andrea L. Ferber
Clare Kobasa
Elizabeth Wyckoff

SAINT LOUIS ART MUSEUM

HIRMER

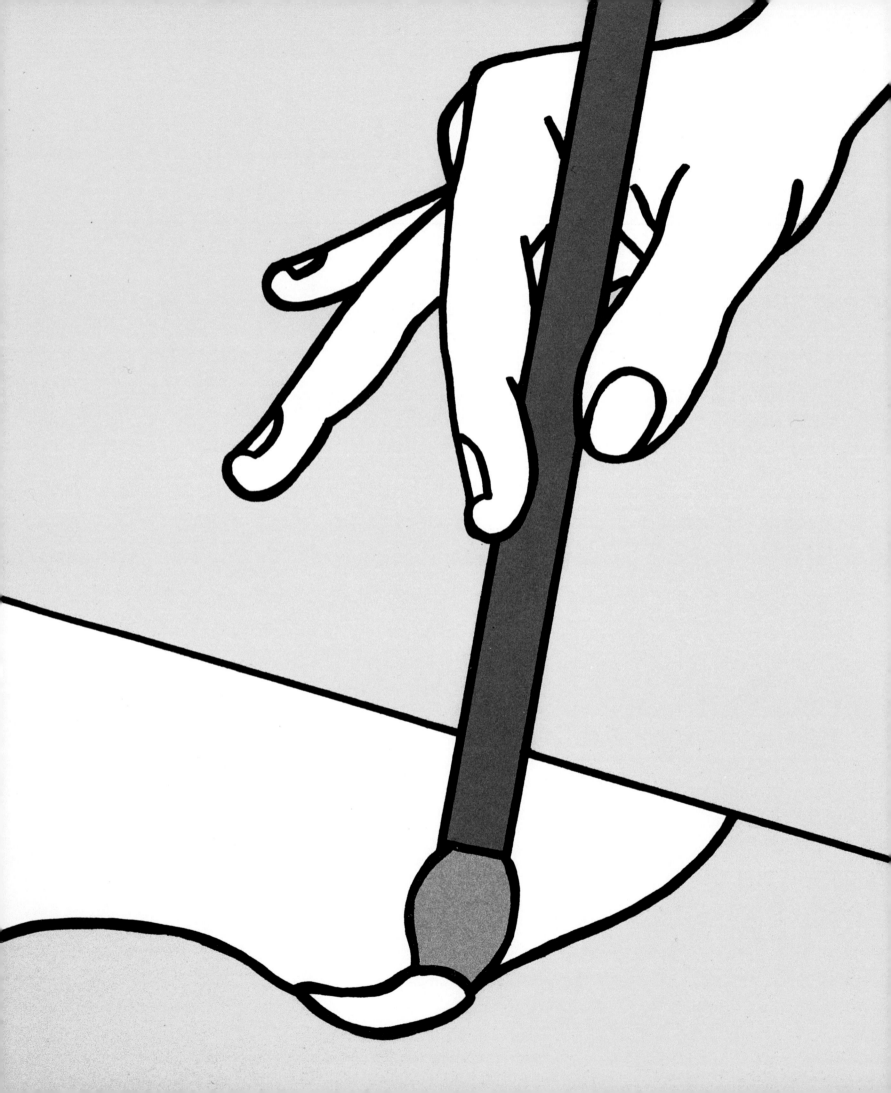

Contents

Director's Foreword

The Saint Louis Art Museum has long acquired art in the present moment, collecting new objects alongside works from across history, of many shapes and sizes, and from nearly all corners of the globe. The conversations that unfold among these artworks are central to the presentation of a wide-ranging museum collection like this one. Continuous growth is key to the institution's success, as is the support of successive generations of donors, and the addition of more than 800 contemporary artworks from the collection of Ted L. and Maryanne Ellison Simmons to the Museum is a case in point. The acquisition, a combined gift and purchase, was made possible through the collectors' generosity and foresight. It builds on a strength of the Museum—works on paper produced in the United States since 1960—but also crucially expands it in many new directions. *Catching the Moment: Contemporary Art from the Ted L. and Maryanne Ellison Simmons Collection* presents a stunning, representative selection of works from this vast acquisition and aims to capture its distinctive character.

Incredibly, the Simmons collection dovetails with the Museum's existing holdings and augments areas where greater representation had been lacking. Of the 43 artists in the collection, 25 are new to the Museum. Several of them were collected by the Simmonses in depth, including 20 works by H. C. Westermann, 27 by Roger Shimomura, 60 by Kiki Smith, 123 by Enrique Chagoya, and more than 400 by Tom Huck. Others, including Bruce Conner, Helen Frankenthaler, Robert Gober, Jane Hammond, Peter Hujar, Donald Judd, Bruce Nauman, Jaune Quick-to-See Smith, Paul Thek, Kara Walker, and David Wojnarowicz, are represented by fewer but no less outstanding works.

The Simmonses were not novices when they began assembling these prints, drawings, photographs, and multiples some 20 years ago. They had already assembled a superb collection of early American furniture, with which they appointed the New England–style saltbox house they built on the outskirts of St. Louis. When they began to pursue contemporary graphic art, Maryanne contributed her considerable expertise as an artist and as a professional printer and publisher. Ted continued to harness the focus and drive of a Hall of Fame–bound Major League Baseball player to dive deeply into the research, taking advantage of the travel that went along with his profession to explore collecting opportunities.

Advised by David Kiehl, the Whitney Museum of American Art's curator of prints, to buy work by artists of their own generation,

they began their odyssey with Kiki Smith. From there they circled out, exploring Smith's network of peers and friends—landing on Hujar, Thek, and Wojnarowicz—and, not coincidentally, on work that spoke to one of the defining issues of their generation: the AIDS crisis that took so many lives in the 1980s and 1990s. They continued radiating out as they discovered new artists they could become passionate about, artists with a message, direct or indirect, that spoke to them. It is that prevailing mood for topical, impassioned statements in the art the Simmonses collected that most urgently contributes to the Saint Louis Art Museum's collection.

When the Museum presented *Graphic Revolution: American Prints 1960 to Now*, a 2018 survey of contemporary prints and multiples, the exhibition's curators, Gretchen L. Wagner and Elizabeth Wyckoff, reached out to collectors across St. Louis. The Museum's collection is strong, but numerous individuals had also acquired significant works that expanded the stories the exhibition could tell. It was very clear from the start that the loans from the Simmons collection would add a distinctive point of view that simply was not represented elsewhere. That less than two years after the close of that exhibition the entire Simmons collection would come to the Museum,

however, was hardly a foreseeable event. I would like to convey a deep debt of gratitude to Ted L. and Maryanne Ellison Simmons for their commitment to the Saint Louis Art Museum, to the city of St. Louis, and most especially, to the art and artists of their time.

Catching the Moment: Contemporary Art from the Ted L. and Maryanne Ellison Simmons Collection provides a broad introduction to the work of Kiki Smith, Enrique Chagoya, and Tom Huck, whose work is represented in significant depth, but also presents themes that bring the work of multiple generations of artists together. Two essays in this catalogue by the co-curators of the exhibition, one by Elizabeth Wyckoff and Andrea L. Ferber and another by Clare Kobasa, investigate salient characteristics of the art, while a third by Sophie Barbisan, the Museum's paper conservator, illuminates some of the technical aspects—both complex and straightforward—in contemporary printmaking. An interview with the Simmonses explores their motivations, the origins of their collecting practice, and hints at more to come. The professional teams at the Museum and at Hirmer Publishers have collaborated to produce this impressive exhibition and its accompanying volume, which in turn serves to bring the Simmons collection into public view.

Min Jung Kim
The Barbara B. Taylor Director

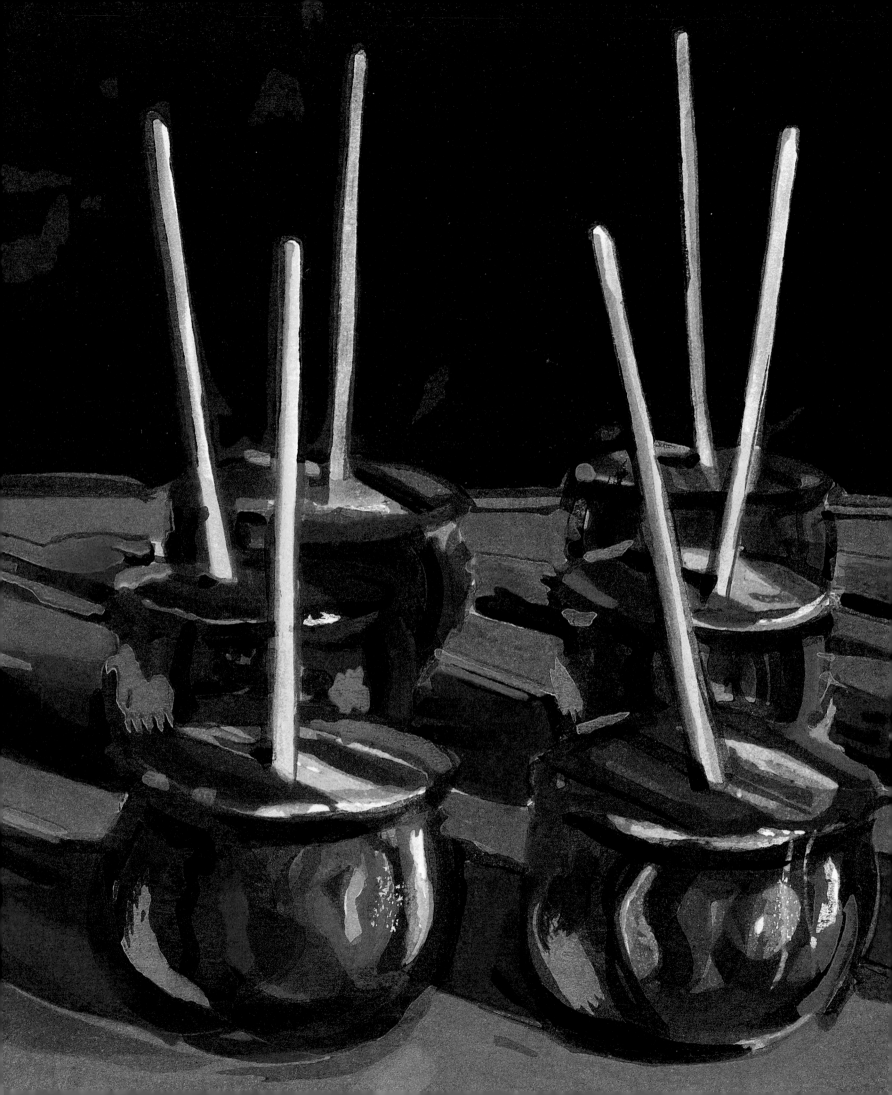

Acknowledgments

Our first thanks go to Ted L. and Maryanne Ellison Simmons; their generosity extends beyond the works of art celebrated in this catalogue and exhibition to their willingness to engage in conversation and provide all manner of other assistance. The catalogue owes its success to the efforts and talents of a great many of our colleagues at the Saint Louis Art Museum. We would like to extend our gratitude to the curatorial department, with callouts to Bobbi Austin, Nichole Bridges, David Conradsen, Katherine Feldkamp, Hannah Klemm, Eric Lutz, Alexander B. Marr, Molly Moog, Hannah Wier, and Abigail Yoder. Renée Brummell Franklin, chief diversity officer, provided welcome guidance, and our colleagues in the library ably hunted down all variety of necessary resources. Many individuals external to the Museum also contributed their valuable expertise to this effort.

We are grateful to Jeanette Fausz, assistant director for exhibitions and collections, and to many members of her department. Our gratitude goes especially to Jeanette and registrar Ella Rothgangel for a truly Herculean effort in shepherding the acquisition. The conservation department has been invaluable; many thanks especially to our co-author Sophie Barbisan and past and present colleagues Raina Chao, Brian Koelz, Miriam Murphy, L. Hugh Shockey, and Amaris Sturm. The exhibition and catalogue benefited greatly from design efforts by Jon Cournoyer and David Burnett. This catalogue would not have been possible without the efforts of Christopher Moreland, Joshua Meyer, Alejandro Franco, and all the other art preparators who made works available for study and photography.

An acquisition of this scale reflects the tremendous dedication of the Development and External Affairs team, including Bobby Sanderson, Jennifer Thomas, and Amber Withycombe. The Digital Experience and Media department provided crucial support; our thanks go to Cathryn Gowan, Ann Aurbach, Jason Gray, Janeshae Henderson, and photographers Jenna Carlie and Lisa Mitchell. Rachel Swiston, publications manager, guided the catalogue with grace and intelligence from its rapid-fire beginnings through to its final form. We are grateful to Rainer Arnold and Elisabeth Rochau-Shalem at Hirmer, as well as editor Susan Higman Larsen, who cast a keen eye on the texts, and designer Sophie Friederich, whose efforts can be seen throughout this volume. Finally, we are indebted to former Museum director Brent R. Benjamin and to Min Jung Kim, the Barbara B. Taylor Director, whose leadership and encouragement has been crucial to recognizing and celebrating this remarkable acquisition.

Elizabeth Wyckoff
Curator of Prints, Drawings,
and Photographs

Andrea L. Ferber
The Andrew W. Mellon Foundation Fellow
for Prints, Drawings, and Photographs

Clare Kobasa
Assistant Curator of Prints,
Drawings, and Photographs

Explanatory Notes

Abbreviations:
A.P.: artist's proof
B.A.T.: bon à tirer ("good to pull," same as "ready to print")
P.P.: printer's proof
R.T.P.: ready to print

Measurements:
All dimensions for two-dimensional works given as full sheet, except where noted.

Credit line, unless otherwise noted:
Saint Louis Art Museum, Gift of Ted L. and Maryanne Ellison Simmons; and funds given by the Marian Cronheim Trust for Prints and Drawings, Museum Purchase, Friends Fund, The Sidney S. and Sadie Cohen Print Purchase Fund, and the Eliza McMillan Purchase Fund

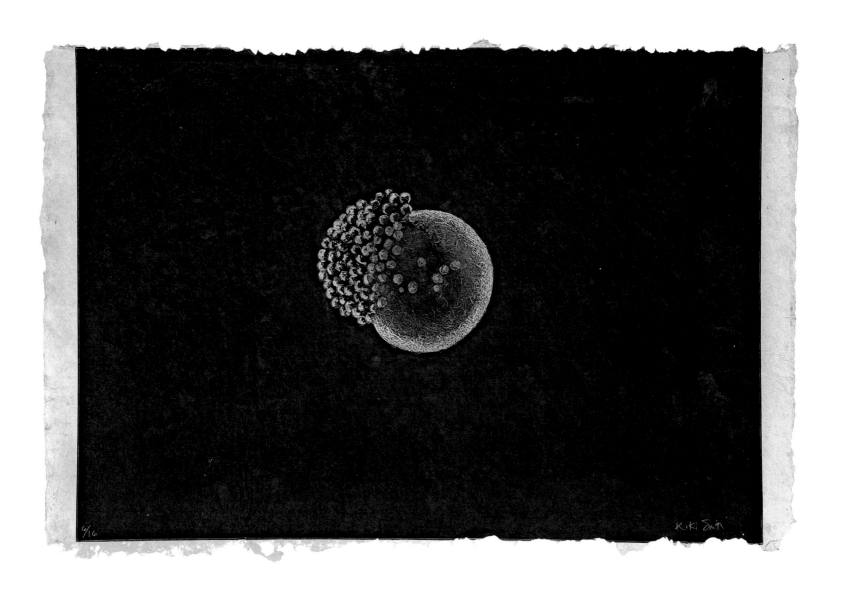

1
Kiki Smith, American
(born Germany), born 1954
Black Flag, 1989
etching and aquatint
edition: 6/16
printed and published by San Antonio
Art Institute, San Antonio, TX
20 ³/₄ × 32 ⁵/₈ in. (52.7 × 82.9 cm)
801:2020

2
Kiki Smith, American
(born Germany), born 1954
Kiki Smith 1993, 1993
etching and aquatint
edition: P.P. 3/3
printed and published by Universal
Limited Art Editions, West Islip, NY
73 $^7/_{16}$ × 36 $^5/_8$ in. (186.5 × 93 cm)
818:2020

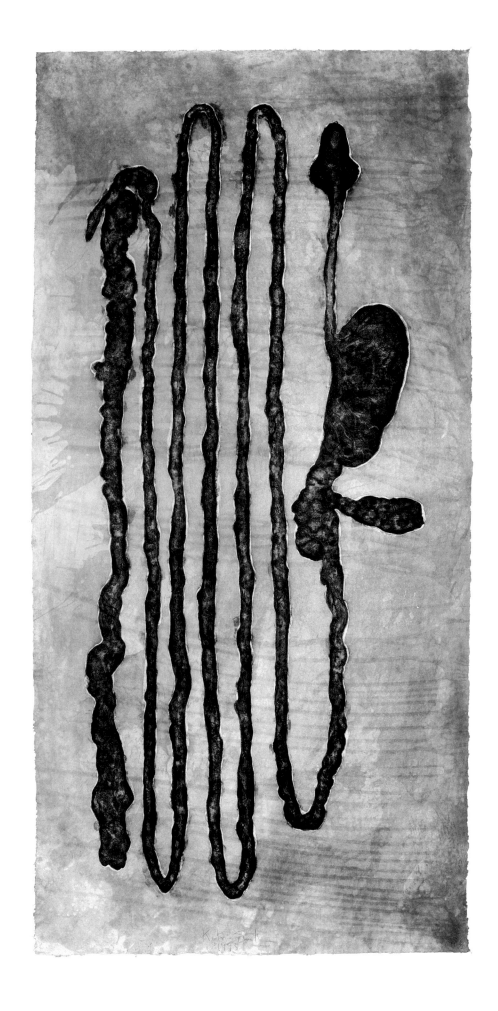

3
Kiki Smith, American
(born Germany), born 1954
Finger Bowl, 1995
silver
edition: 25/25
fabricated by Ranieri Sculpture
Casting, New York
published by Artes Magnus,
New York
6 1/2 × 16 × 16 in. (16.5 × 40.6 × 40.6 cm)
813:2020

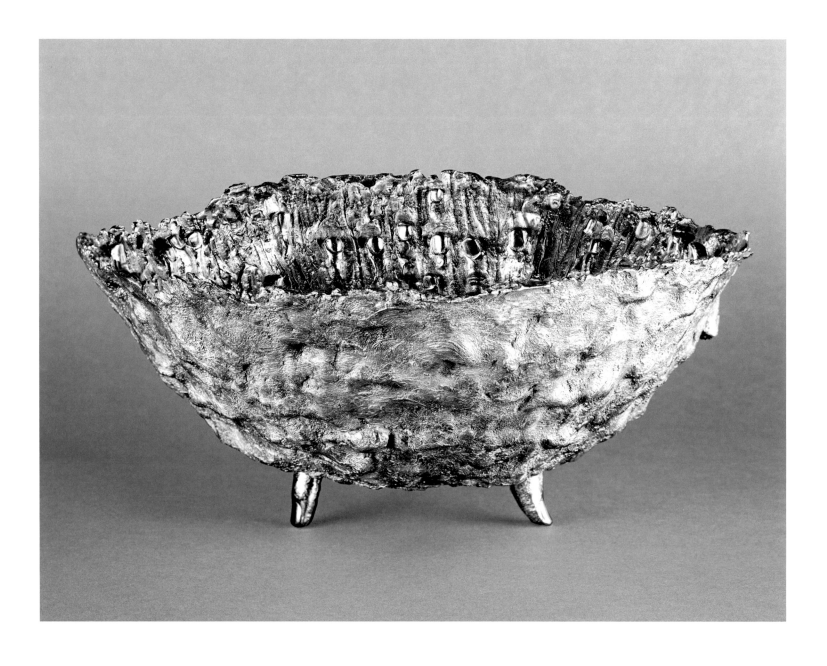

4
Kiki Smith, American
(born Germany), born 1954
Home, 2006
aquatint, etching, and drypoint with
chine collé
edition: 3/20
printed and published by Crown
Point Press, San Francisco
26 1/2 × 31 in. (67.3 × 78.7 cm)
815:2020

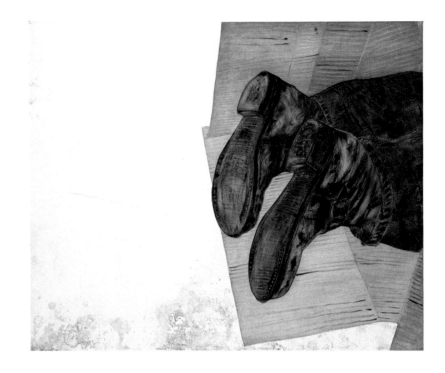

5
Kiki Smith, American
(born Germany), born 1954
Still, 2006
aquatint and etching with chine collé
edition: 5/20
printed and published by Crown
Point Press, San Francisco
26 1/2 × 31 in. (67.3 × 78.7 cm)
828:2020

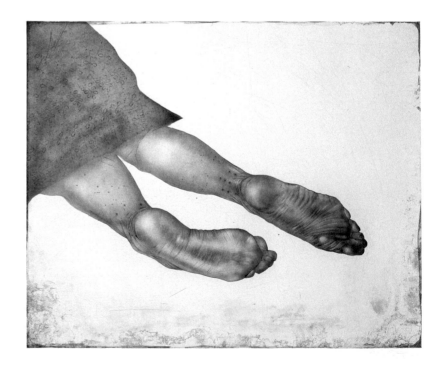

6
Kiki Smith, American (born Germany),
born 1954
Untitled (Earth Print), 1997
lithograph
edition: B.A.T.
printed and published by Derriere
L'Etoile Studios, New York
25 $^9/_{16}$ × 56 $^7/_{16}$ in. (65 × 143.4 cm)
833:2020

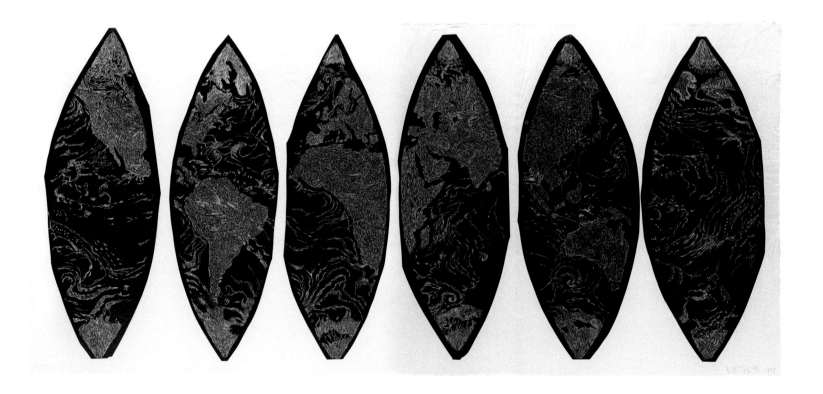

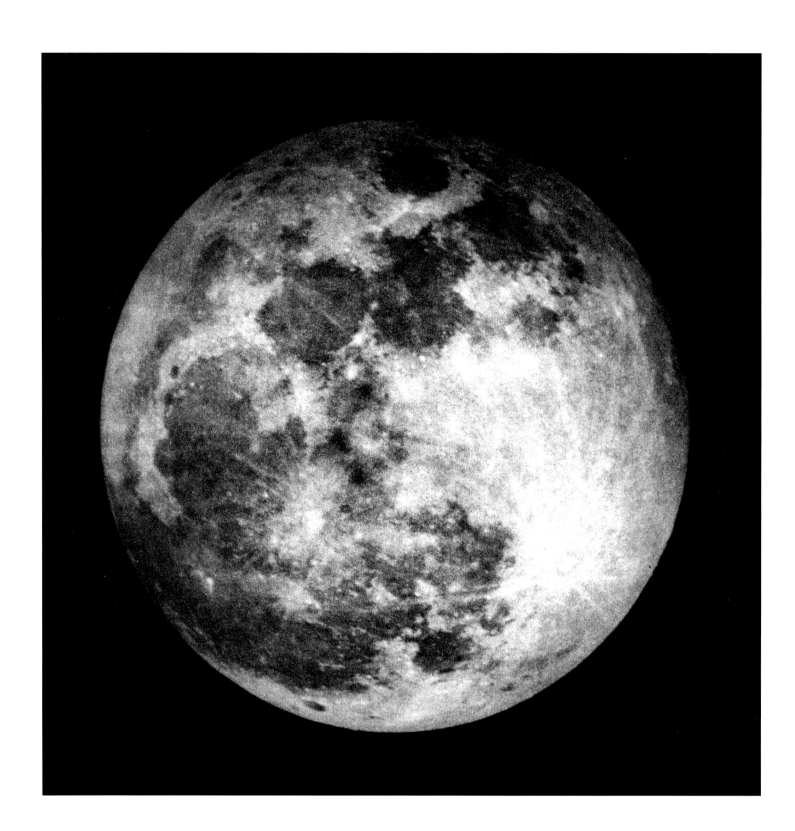

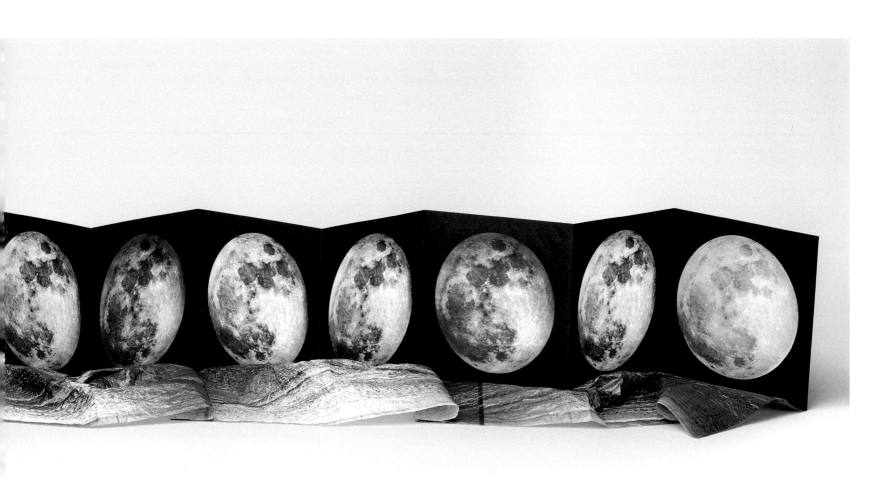

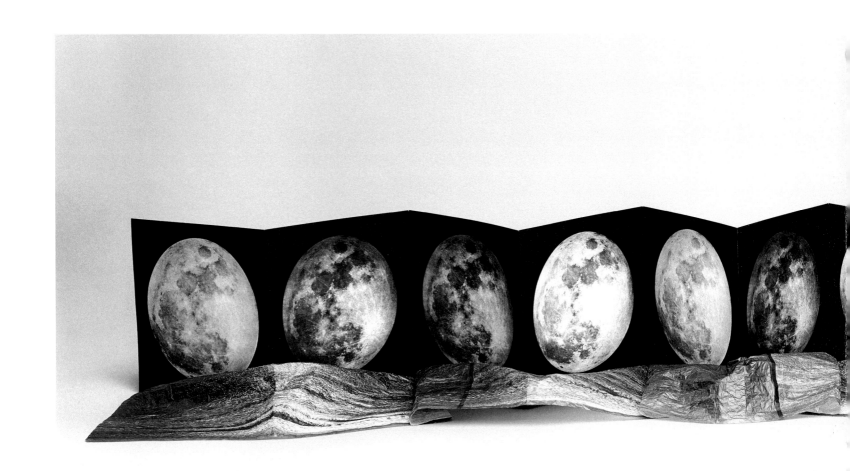

7
Kiki Smith, American
(born Germany), born 1954
**Tidal (I See the Moon and
the Moon Sees Me)**, 1998
photogravure, photolithograph,
and screenprint
edition: 3/39
printed and published by LeRoy
Neiman Center for Print Studies,
Columbia University, New York
19 1/8 × 125 1/2 in. (48.6 × 318.8 cm)
830:2020

8
Kiki Smith, American (born Germany),
born 1954
**Come Away from Her (after Lewis
Carroll)**, 2003
etching, aquatint, drypoint, and
sanding with watercolor additions
edition: 24/28
printed and published by Universal
Limited Art Editions, West Islip, NY
50 3/8 × 73 11/16 in. (128 × 187.1 cm)
799:2020

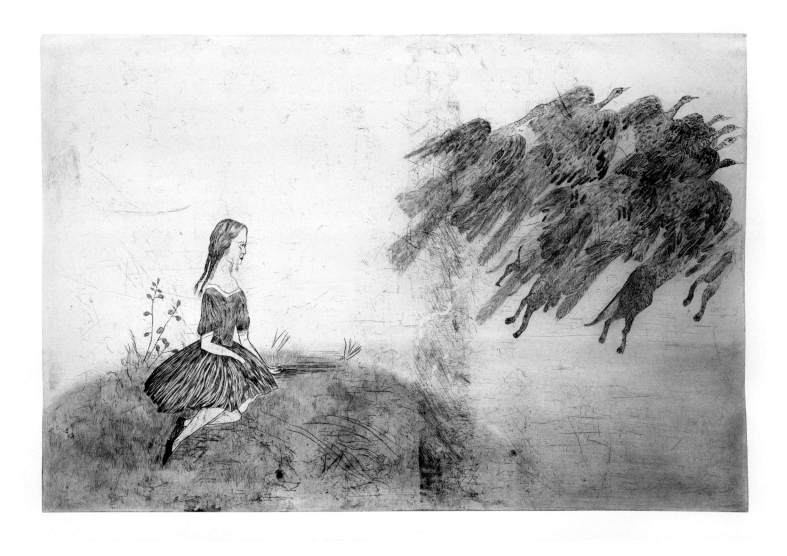

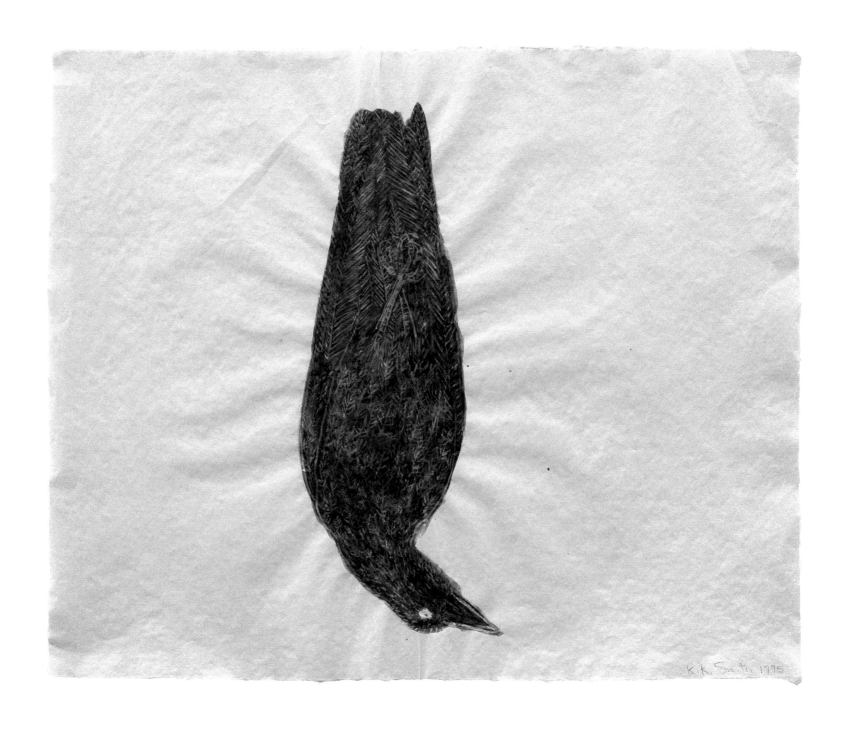

9
Kiki Smith, American
(born Germany), born 1954
Untitled (Bird), 1995
ink and gouache
19 $\frac{1}{2}$ × 21 $\frac{1}{8}$ in. (49.5 × 53.7 cm)
831:2020

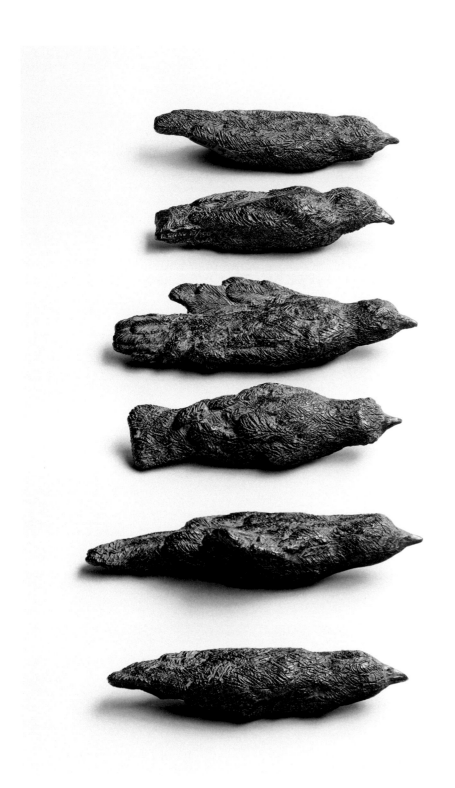

10
Kiki Smith, American
(born Germany), born 1954
Bird Group, 1999
bronze with emerald inlay
edition: 54–59/150
fabricated by Raineri Sculpture
Casting, New York
published by A/D Editions, New York
each, approximately: 1 × 5 × 1 in.
(2.5 × 12.7 × 2.5 cm)
796:2020.1-.6

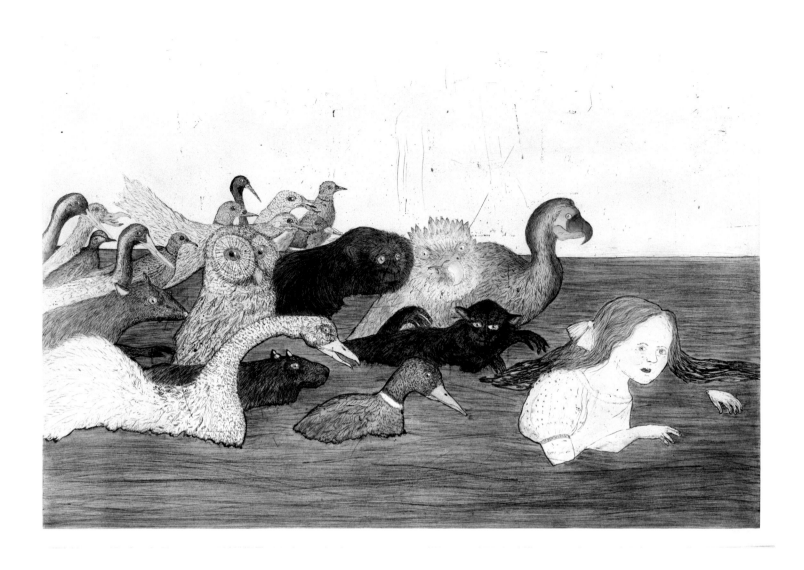

11
Kiki Smith, American
(born Germany), born 1954
**Pool of Tears II (after Lewis
Carroll)**, 2000
etching, aquatint, drypoint, and
sanding with watercolor additions
edition: 21/29
printed and published by Universal
Limited Art Editions, West Islip, NY
51 × 74 3/4 in. (129.5 × 189.9 cm)
825:2020

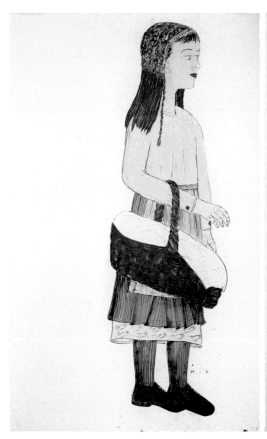

12
Kiki Smith, American
(born Germany), born 1954
Companions, 2001
lithograph on two sheets
edition: 22/26
printed and published by Universal
Limited Art Editions, West Islip, NY
overall: 54 × 99 in. (137.2 × 251.5 cm)
806:2020a,b

13
Kiki Smith, American
(born Germany), born 1954
Me in a Corner, 2005
porcelain
edition: 8/13
fabricated by Gheorghe Adam
published by Thirteen Moons,
New York
10 × 8 × 10 in. (25.4 × 20.3 × 25.4 cm)
819:2020

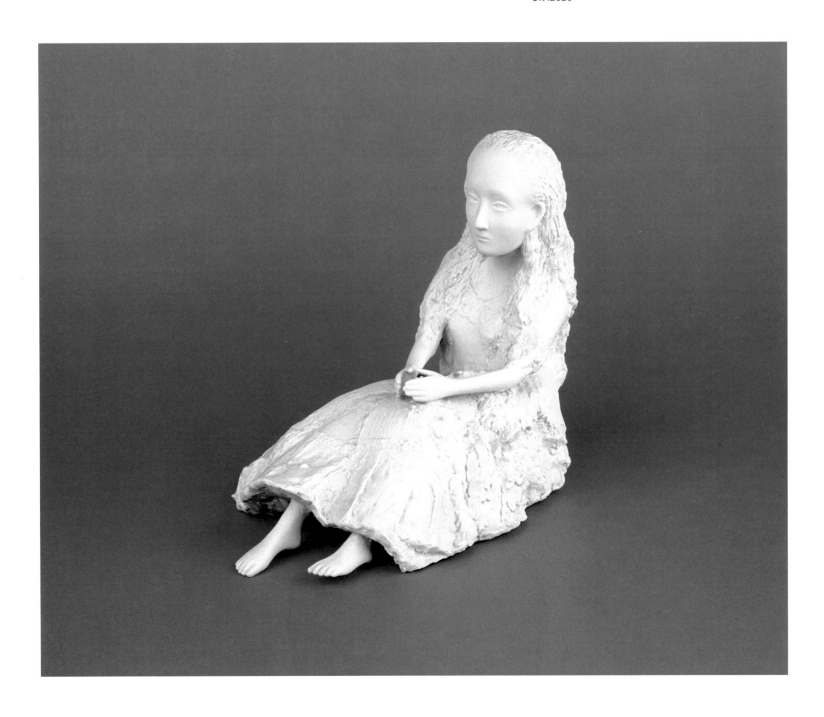

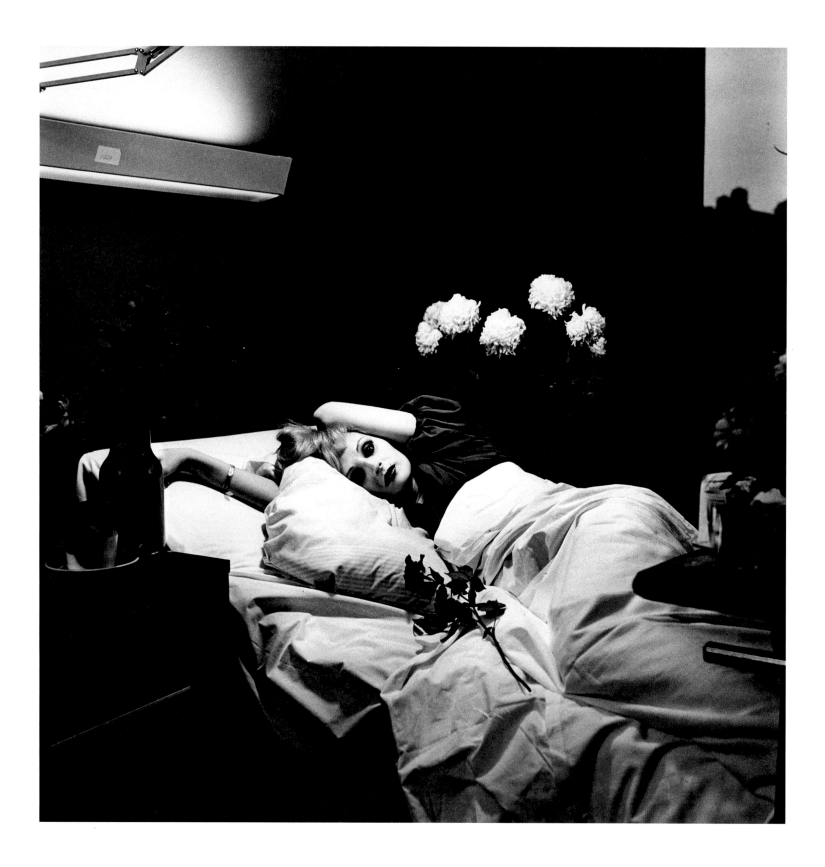

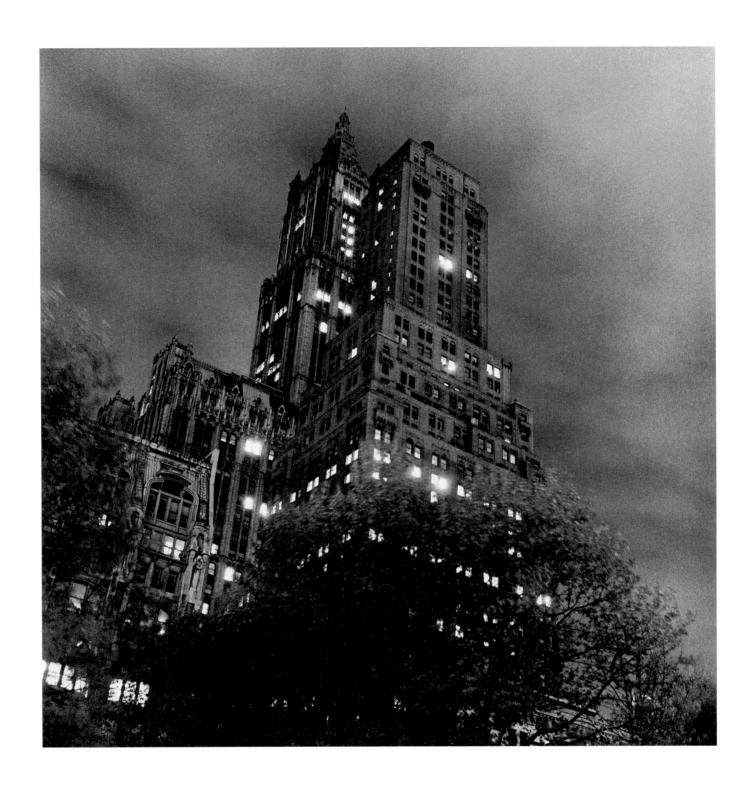

14
Peter Hujar, American, 1934–1987
Candy Darling on Her Deathbed, 1973
gelatin silver print
image: 14 ⁵/₈ × 14 ⁵/₈ in. (37.1 × 37.1 cm)
731:2020

15
Peter Hujar, American, 1934–1987
Woolworth Building, 1976
gelatin silver print
image: 14 ⁵/₈ × 14 ⁵/₈ in. (37.1 × 37.1 cm)
Gift of Ted L. and Maryanne
Ellison Simmons; and funds
given by Jeffrey T. Fort
736:2020

16
Paul Thek, American, 1933–1988
Potlatch, 1975
ink and gesso on newspaper
23 × 29 in. (58.4 × 73.7 cm)
837:2020

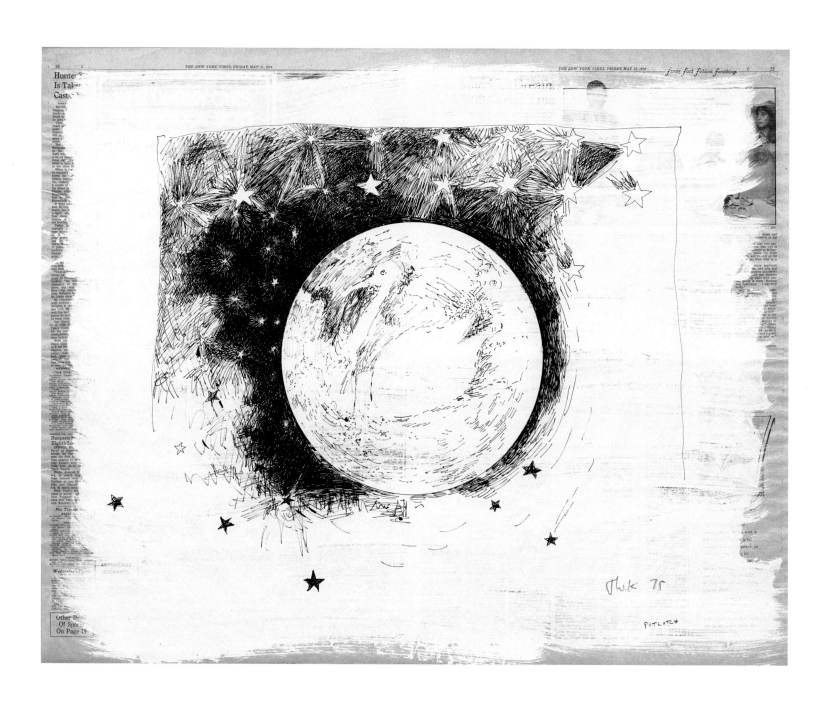

17
Peter Hujar, American, 1934–1987
Paul Thek, 1975
gelatin silver print
image: 13 1/2 × 13 1/2 in. (34.3 × 34.3 cm)
Gift of Ted L. and Maryanne
Ellison Simmons; and funds
given by Jeffrey T. Fort
733:2020

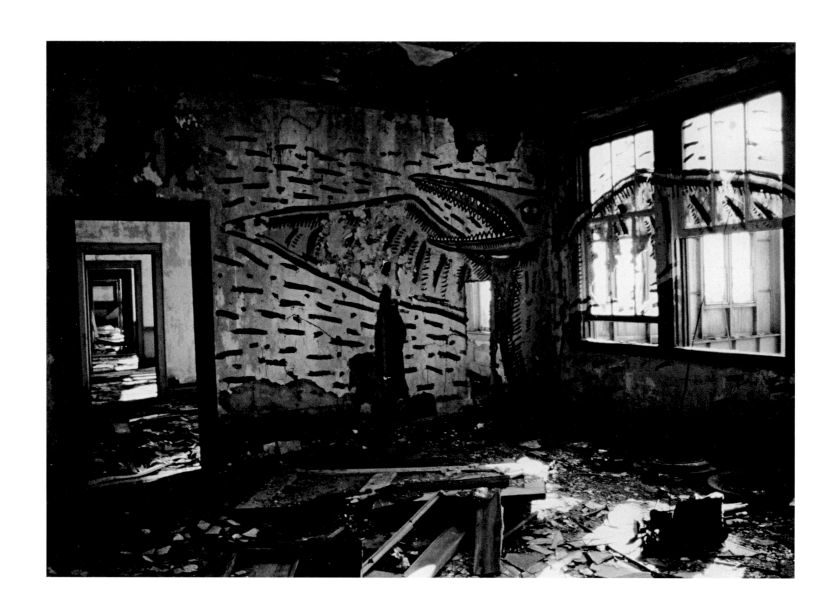

18
David Wojnarowicz,
American, 1954–1992
photographed by Marion
Scemama, French, born 1950
**Pterodactyl–Pier 28, Mural
David Wojnarowicz**, 1984
chromogenic print
edition: 3/12
image: 10 $^7/_{16}$ × 5 $^1/_8$ in. (26.5 × 13 cm)
857:2020

19
David Wojnarowicz,
American, 1954–1992
Untitled (Face in Dirt), 1991
gelatin silver print
edition: 10/10
image: 19 × 19 $^3/_4$ in. (48.3 × 50.2 cm)
858:2020

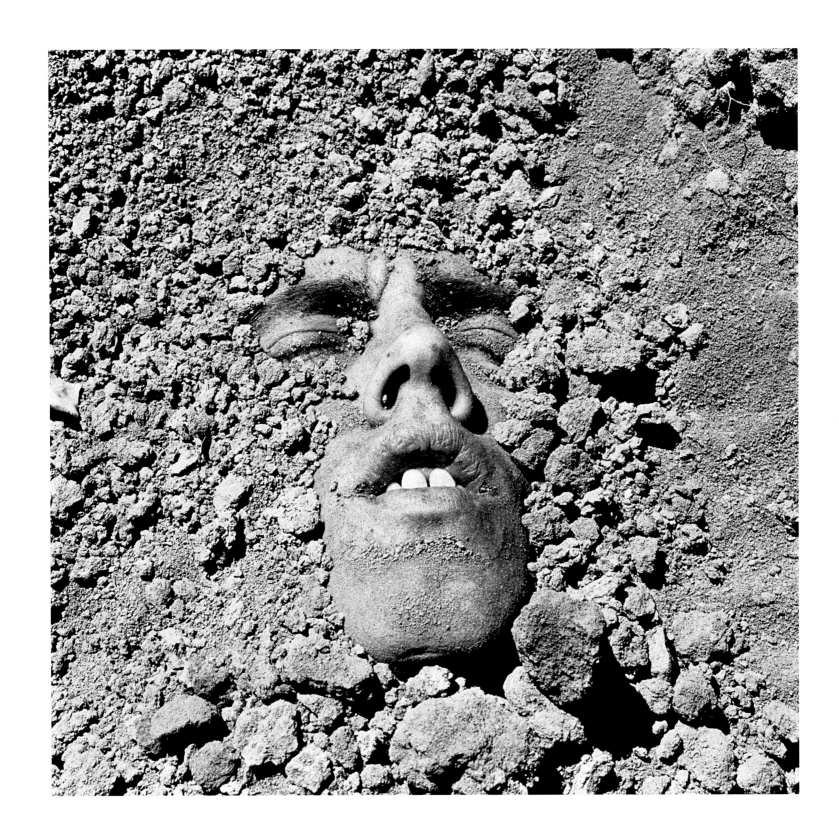

One day this kid will get larger. One day this kid will come to know something that causes a sensation equivalent to the separation of the earth from its axis. One day this kid will reach a point where he senses a division that isn't mathematical. One day this kid will feel something stir in his heart and throat and mouth. One day this kid will find something in his mind and body and soul that makes him hungry. One day this kid will do something that causes men who wear the uniforms of priests and rabbis, men who inhabit certain stone buildings, to call for his death. One day politicians will enact legislation against this kid. One day families will give false information to their children and each child will pass that information down generationally to their families and that information will be designed to make existence intolerable for this kid. One day this kid will begin to experience all this activity in his environment and that activity and information will compel him to commit suicide or submit to danger in hopes of being murdered or submit to silence and invisibility. Or one day this kid will talk. When he begins to talk, men who develop a fear of this kid will attempt to silence him with strangling, fists, prison, suffocation, rape, intimidation, drugging, ropes, guns, laws, menace, roving gangs, bottles, knives, religion, decapitation, and immolation by fire. Doctors will pronounce this kid curable as if his brain were a virus. This kid will lose his constitutional rights against the government's invasion of his privacy. This kid will be faced with electro-shock, drugs, and conditioning therapies in laboratories tended by psychologists and research scientists. He will be subject to loss of home, civil rights, jobs, and all conceivable freedoms. All this will begin to happen in one or two years when he discovers he desires to place his naked body on the naked body of another boy.

20
David Wojnarowicz, American, 1954–1992
Untitled (One Day This Kid . . .),
1990–91, 2012 edition
letterpress
edition: 87/100
published by Printed Matter, New York
8 1/2 × 11 in. (21.6 × 27.9 cm)
859:2020

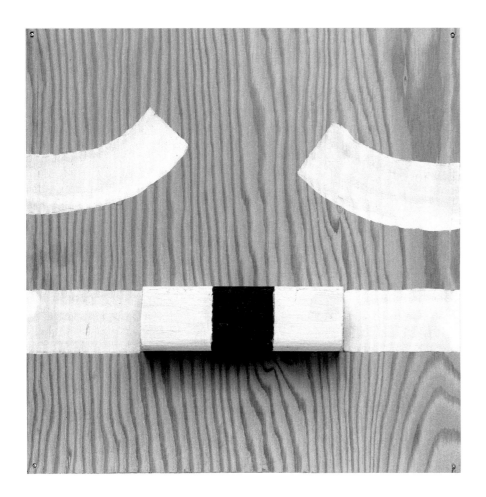

21
Richard Tuttle, American, born 1941
Two With Any To, #9, 1999
acrylic on fir plywood
11 × 11 × 1 ³/₄ in. (27.9 × 27.9 × 4.5 cm)
846:2020

22
Richard Tuttle, American, born 1941
authored by Thomas McEvilley,
American, 1939–2013
Color as Language, 2004
artist's book
edition: 88/100
printed by Russell Maret, New York
published by The Drawing Center,
New York
9 ¹/₄ × 6 ¹/₈ in. (23.5 × 15.6 cm)
844:2020

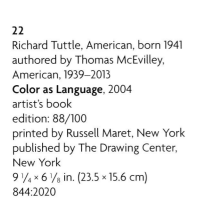

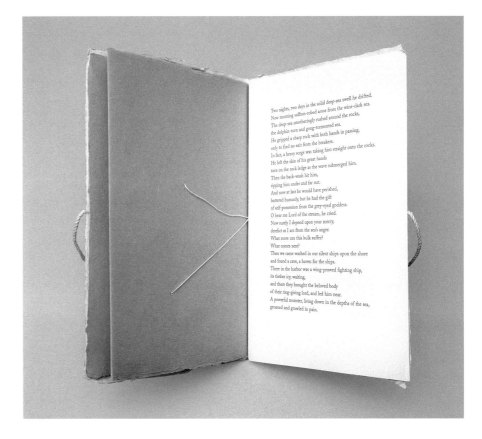

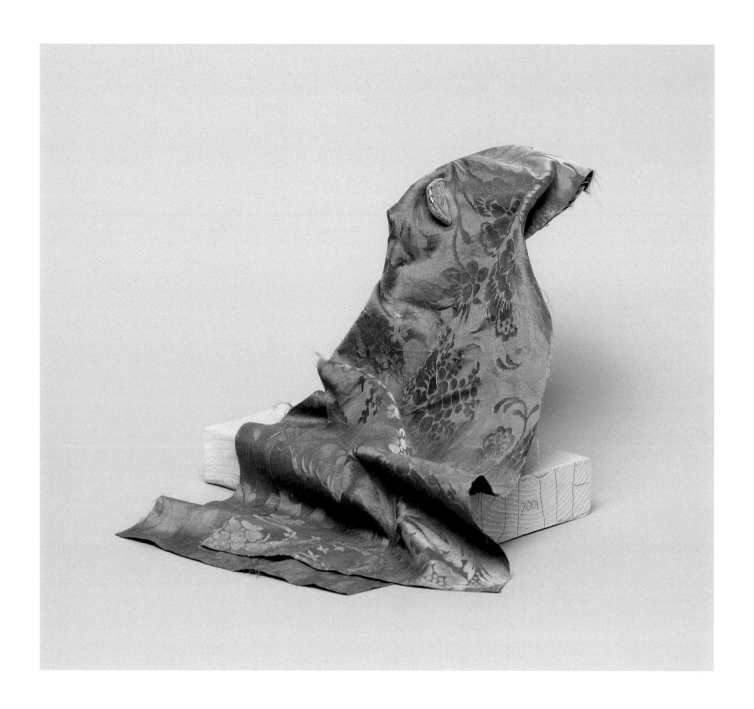

23
Kiki Smith, American
(born Germany), born 1954
Richard Tuttle, American, born 1941
Bouquet, 2001
silk, pinewood, gold, and wire
edition: 10/18
published by Editions Fawbush,
New York
9 ¹/₂ × 10 × 9 in. (24.1 × 25.4 × 22.9 cm)
base: 1 ¹/₂ × 9 × 5 ¹/₄ in.
(3.8 × 22.9 × 13.3 cm)
803:2020

24
Damon Davis, American, born 1985
**Eyes of Diamonds, Teeth of
Gold**, 2018
inkjet print
12 × 7 ⁷/₈ × 1 ¹/₄ in. (30.5 × 20 × 3.2 cm)
550:2020

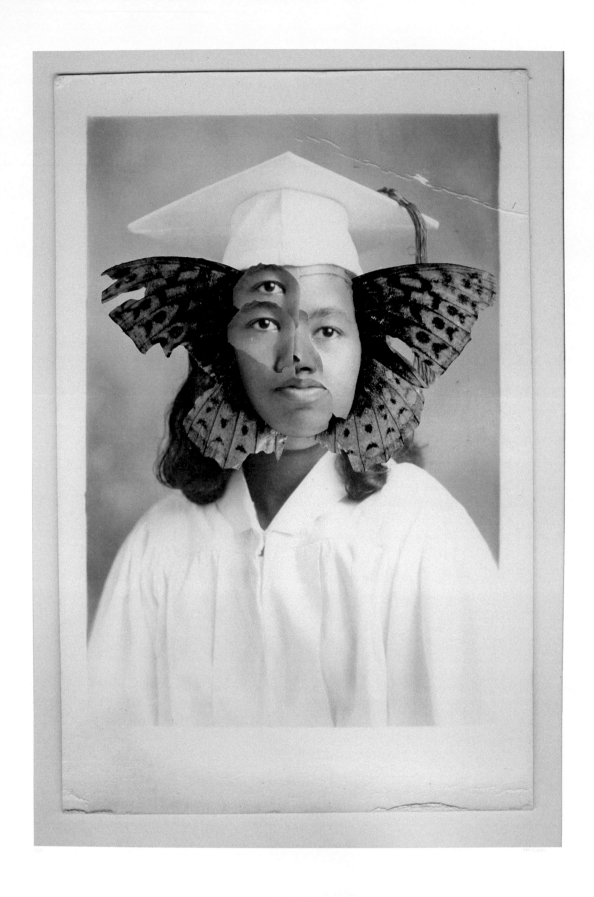

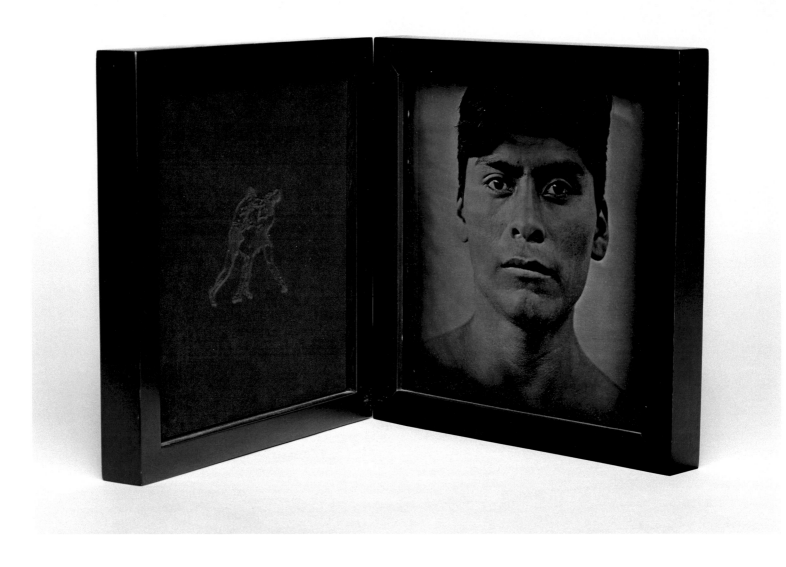

25
Damon Davis, American, born 1985
Graduation 1, 2019
inkjet print
edition: 2/5
51 1/2 × 38 in. (130.8 × 96.5 cm)
551:2020

26
Luis González Palma,
Guatemalan, born 1957
Destinos, 2000
ambrotype in wood and velvet case
edition: 8/10
published by Segura Publishing
Company, Tempe, AZ
closed: 9 1/4 × 9 1/4 × 2 1/4 in.
(23.5 × 23.5 × 5.7 cm)
open: 9 1/4 × 18 1/2 × 1 1/8 in.
(23.5 × 47 × 2.9 cm)
769:2020

Bomb Suspect's Brother Mutilates Himself

CHARLESTON, S.C., March 10 (Reuters) — The brother of a man charged in the fatal bombing of an Alabama abortion clinic intentionally cut off his left hand with a circular saw to send a message to government agents searching for his brother, the authorities said today.

The Federal Bureau of Investigation said it had received a videotape that the brother, Daniel Rudolph, had made while he was amputating his hand at his home in North Charleston, S.C. The videotape includes an undisclosed message to Federal agents who have mounted a nationwide manhunt for the man charged, Eric Robert Rudolph, 31, the officials said.

Daniel Rudolph amputated the hand on Sunday and drove himself to the nearby Summerville Medical Center. An ambulance crew was sent to retrieve the hand, and Mr. Rudolph was transferred to Roper Hospital, where the hand was surgically reattached, officials said.

Daniel Rudolph has been interviewed by the F.B.I. as part of a manhunt for his brother, but a bureau spokesman said he was not under investigation in the fatal Jan. 29 attack on the New Woman All Women Health Care Clinic in Birmingham, Ala. An off-duty policeman was killed in the explosion and a nurse

The Times Book Review, every Sunday

(partial text at top: 56 million cell phone users would ... her Vermont town of Charlotte. "We)

(partial text at right column: install ir / stuck on / ples and / like Verr / ed. / The cell / sures of tl / out. To ke / they must / serving a s. / ulation. The / paying off / which they / auction. / To Verm / seem as i' / invaded b / only a bott / Some to / nances lir / and possi / a tower-f / ure out w / the risk / impatie / and it i / that cc)

CAT Sitter
Quality care
for your pets
5.00 per VISIT
5320869

THE POLITICAL SCENE

the different variations nature plays on the theme of human existence will delight, not frighten, us."

The casual manner is authentic Bradley—"authentic" is a word his supporters tend to toss around, worshipfully the wa_ _have used "charisma _ _ guile.

27–29
Robert Gober, American, born 1954

Untitled, 2000–2001
intaglio print, custom handmade paper, 100% cotton rag paper with pigments, folded, torn, and burnished
4 1/8 × 5 1/16 in. (10.5 × 12.9 cm)

Untitled, 2000–2001
intaglio print, custom handmade paper, 50% cotton linter, 50% cotton rag paper with pigment, torn and burnished
2 5/8 × 3 1/4 in. (6.7 × 8.3 cm)

Untitled, 2000–2001
intaglio print, custom handmade paper, 50% abaca, 50% cotton rag paper with pigment, folded, torn, and burnished
1 7/8 × 3 in. (4.8 × 7.6 cm)

edition: 3/15
printed by Todd Norsten, American, born 1967
published by the artist
616:2020.1-.3

30
Robert Gober, American, born 1954
Monument Valley, 2007
wood engraving on Legion
interleaving paper
edition: P.P. 2/3
printed by The Grenfell Press,
New York
published by the artist
3 ⅝ × 1 ¾ in. (9.2 × 4.5 cm)
615:2020

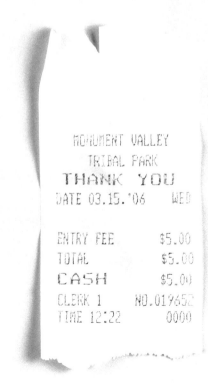

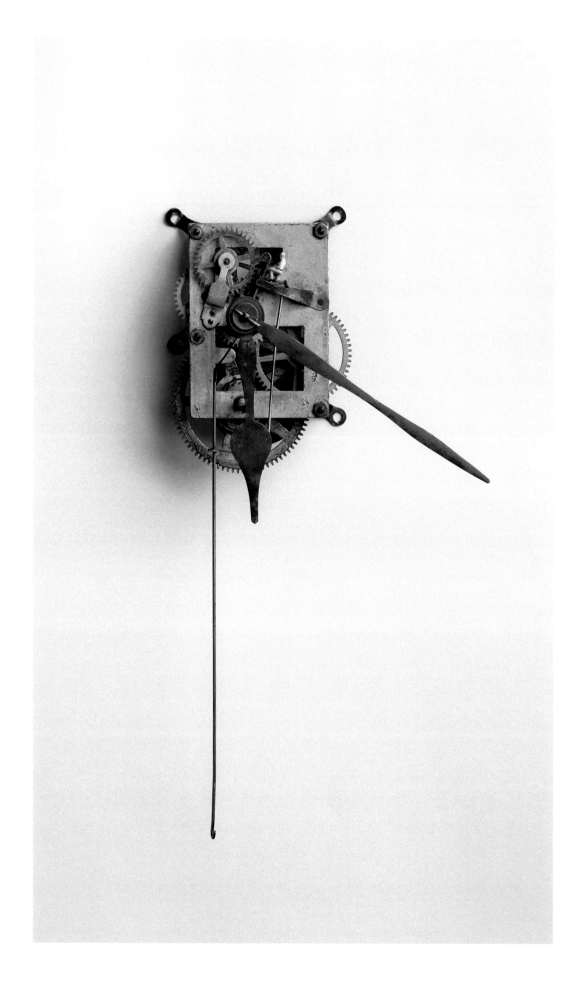

31
Liliana Porter, Argentine, born 1941
To Fix It (Wall Clock II), 2018
metal with figurine
11 × 3 × 4 ½ in. (27.9 × 7.6 × 11.4 cm)
773:2020

32
Liliana Porter, Argentine, born 1941
Disguise, 2000
lithograph with collage
edition: 7/20
printed and published by Tamarind
Institute, University of New Mexico,
Albuquerque
15 ³/₄ × 19 ¹/₂ in. (40 × 49.5 cm)
771:2020

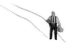

33
Liliana Porter, Argentine, born 1941
The Traveler, 2000
lithograph with collage
edition: 15/20
printed and published by Tamarind
Institute, University of New Mexico,
Albuquerque
13 × 11 ¹/₄ in. (33 × 28.6 cm)
772:2020

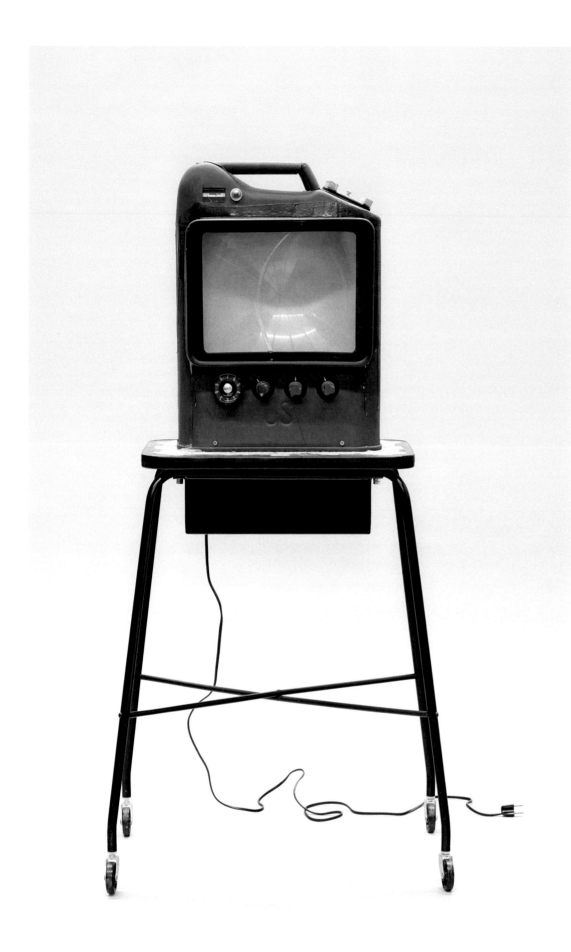

34
Edward Kienholz,
American, 1927–1994
Nancy Reddin Kienholz,
American, 1943–2019
The Jerry Can Standard, 1978–79,
published 1981
gasoline can, epoxy resin, electrical
components, metal and Formica
stand, Fresnel lens system, cassette
player, specially-produced cassette
tapes, automotive paint, and doily
edition: 6/26
published by Gemini G.E.L.,
Los Angeles
with antenna: 66 $^1/_2$ × 22 $^3/_4$ × 16 $^1/_2$ in.
(168.9 × 57.8 × 41.9 cm)
without antenna: 44 $^3/_4$ × 22 $^3/_4$ ×
16 $^1/_2$ in. (113.7 × 57.8 × 41.9 cm)
742:2020a-c

35
Yoan Capote, Cuban, born 1977
Touch, 2008
bronze with metal hinges
closed: 6 ³/₁₆ × 6 × 6 ¹/₈ in.
(15.7 × 15.2 × 15.6 cm)
open: 6 ¹/₂ × 13 ¹/₈ × 7 ¹/₂ in.
(16.5 × 33.3 × 19.1 cm)
460:2020

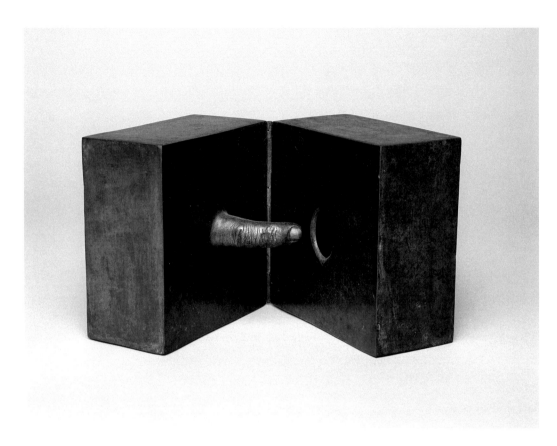

36
Mona Hatoum, Palestinian
(born Lebanon), born 1952
Untitled (meat grinder), 2006
bronze
edition: 3/12
9 ¹/₂ × 8 × 3 ¹/₄ in. (24.1 × 20.3 × 8.3 cm)
620:2020

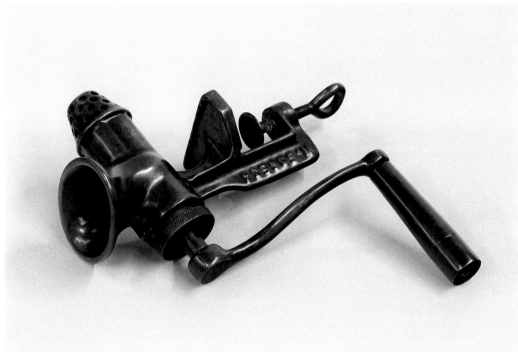

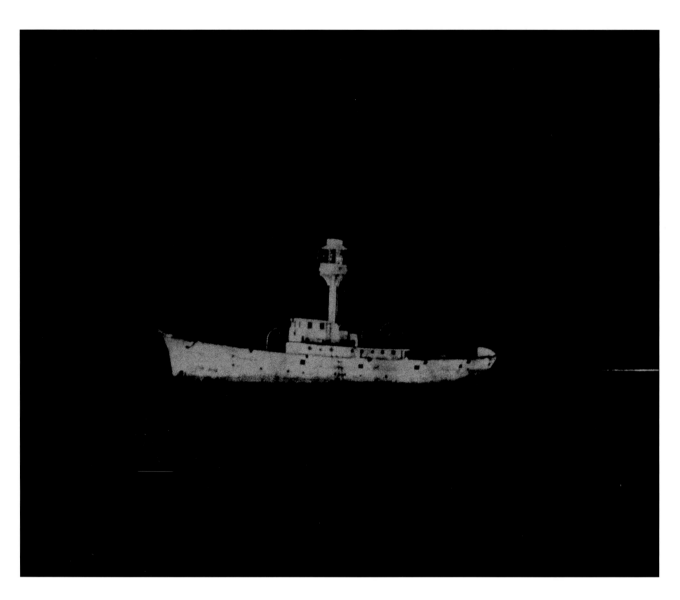

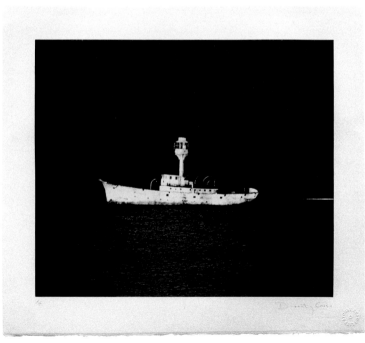

37
Dorothy Cross, Irish, born 1956
Ghost Ship (i), shown with ink
glowing in a darkened room
and in ambient light, 2011
etching with aquatint and
phosphorescent ink
edition: A.P.
printed and published by Stoney
Road Press, Dublin, Ireland
18 3/4 × 21 1/2 in. (47.6 × 54.6 cm)
548:2020

38
Edward Ruscha, American, born 1937
SHIP, 1986
lithograph
edition: 12/30
printed and published by Tamarind
Institute, University of New Mexico,
Albuquerque
45 × 33 $^9/_{16}$ in. (114.3 × 85.2 cm)
777:2020

39–42
Michael Barnes, American, born 1969

Some Things are Best Forgotten, 2020
22 1/2 × 19 1/2 in. (57.2 × 49.5 cm)

Breaking of the Stones, 2020
19 3/8 × 22 1/8 in. (49.2 × 56.2 cm)

Im Garten (In the Garden), 2020
19 1/2 × 22 1/4 in. (49.5 × 56.5 cm)

On the Road to Bremen, 2019
19 1/2 × 22 1/4 in. (49.5 × 56.5 cm)

four lithographs, from the series
Steindruck München
edition: 8/12
printed and published by the artist
419:2020.3, .4, .6, .7

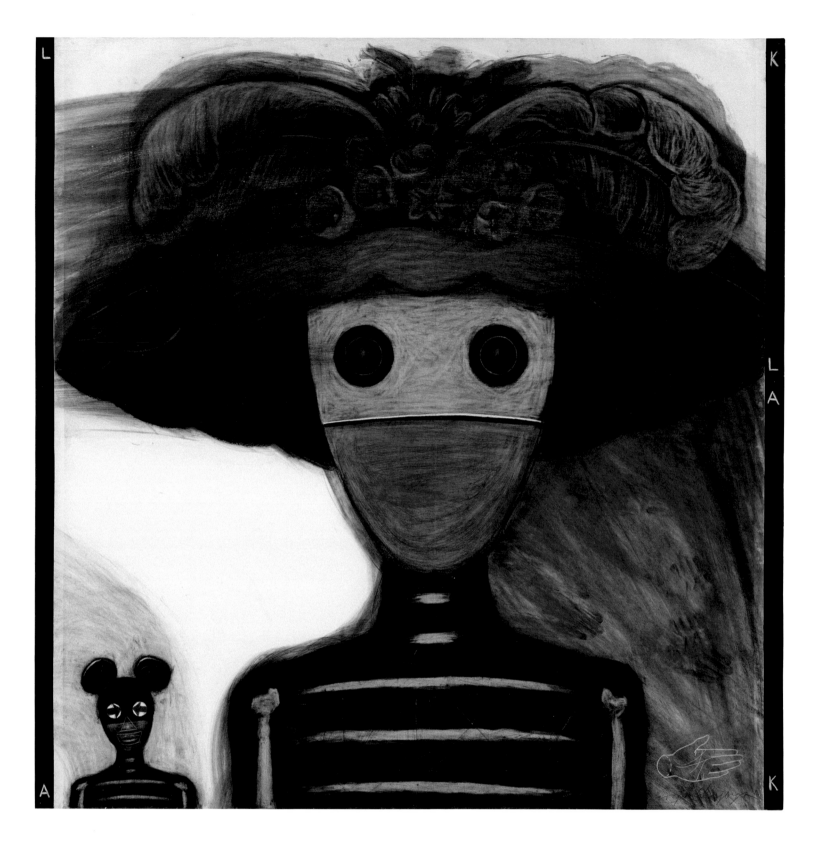

43
Enrique Chagoya, American
(born Mexico), born 1953
La-K-La-K, 1986
charcoal and pastel
80 × 79 ³/₄ in. (203.2 × 202.6 cm)
490:2020

48

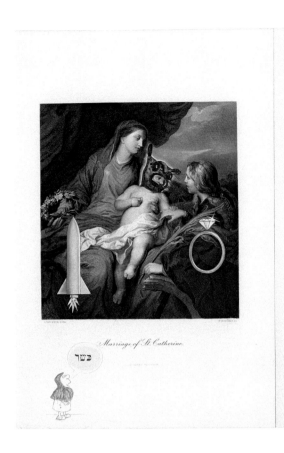

44
Enrique Chagoya, American
(born Mexico), born 1953
The Marriage of St. Catherine, 1997
acrylic paint, water-based oil paint,
and solvent transfer on page
from found 19th-century book
16 1/4 × 21 3/4 in. (41.3 × 55.2 cm)
502:2020

45
Enrique Chagoya, American
(born Mexico), born 1953
**Homage to the Un-Square
and My Cat Frida**, 2009
etching, aquatint, and drypoint
with watercolor additions
edition: 18/23
printed and published by Universal
Limited Art Editions, West Islip, NY
20 1/16 × 22 1/16 in. (51 × 56 cm)
482:2020

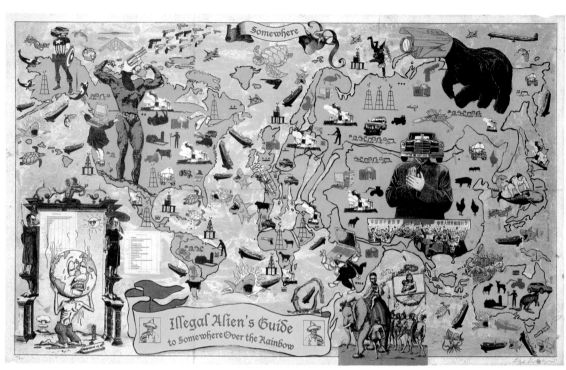

46
Enrique Chagoya, American
(born Mexico), born 1953
**Illegal Alien's Guide to
Somewhere Over the
Rainbow**, 2010
lithograph with chine collé
edition: 10/30
printed and published by
Shark's Ink, Lyons, CO
24 ⁵/₈ × 40 ³/₄ in.
(62.5 × 103.5 cm)
487:2020

47
Enrique Chagoya, American
(born Mexico), born 1953
**Illegal Alien's Guide to
Critical Theory**, 2007
lithograph
edition: 15/30
printed and published by
Shark's Ink, Lyons, CO
24 × 40 ¹/₈ in. (61 × 101.9 cm)
486:2020

48
Enrique Chagoya, American
(born Mexico), born 1953
Everyone is an Alienígeno, 2018
lithograph
edition: 10/30
printed and published by
Shark's Ink, Lyons, CO
22 × 30 in. (55.9 × 76.2 cm)
471:2020

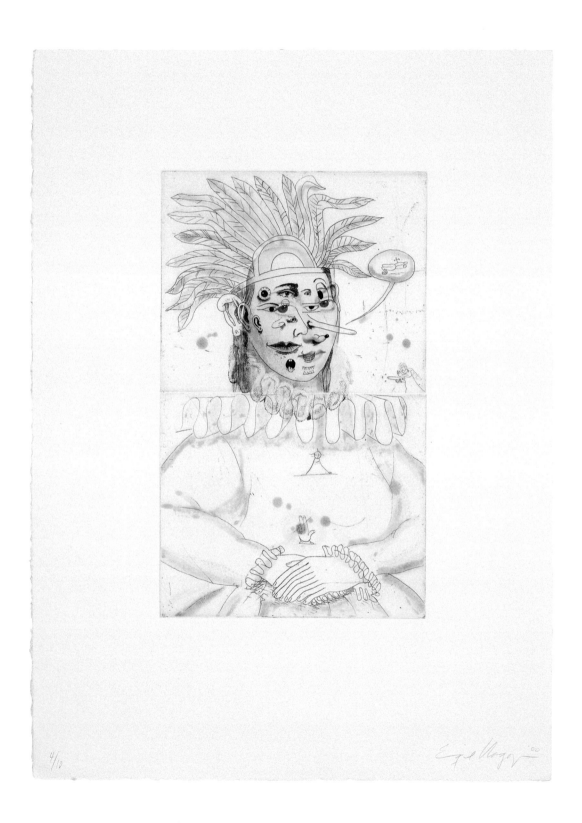

49
Enrique Chagoya, American
(born Mexico), born 1953
Untitled (Pocahontas), 2000
etching, drypoint, aquatint,
and Xerox transfer
edition: 4/10
printed and published by Smith
Andersen Editions, Palo Alto, CA
25 $^7/_8$ × 19 $^1/_8$ in. (65.7 × 48.6 cm)
535:2020

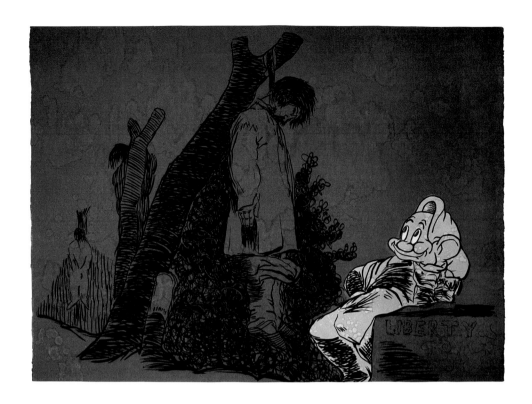

50
Enrique Chagoya, American
(born Mexico), born 1953
Liberty, 2006
monotype
printed and published by Smith
Andersen Editions, Palo Alto, CA
34 ⁵/₈ × 47 ⁷/₈ in. (87.9 × 121.6 cm)
495:2020

51
Enrique Chagoya, American
(born Mexico), born 1953
Liberty Backwards, 2008
photoetching and rubber stamp
edition: 32/60
printed by Magnolia Editions,
Oakland, CA
published by Des Moines Art
Center Print Club, Des Moines, IA
12 ⁵/₈ × 9 ¹/₂ in. (32.1 × 24.1 cm)
496:2020

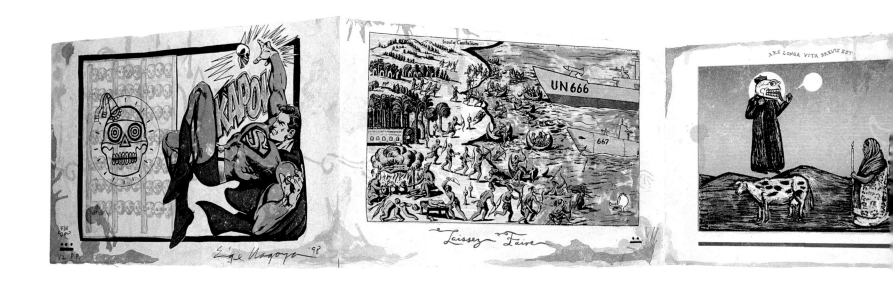

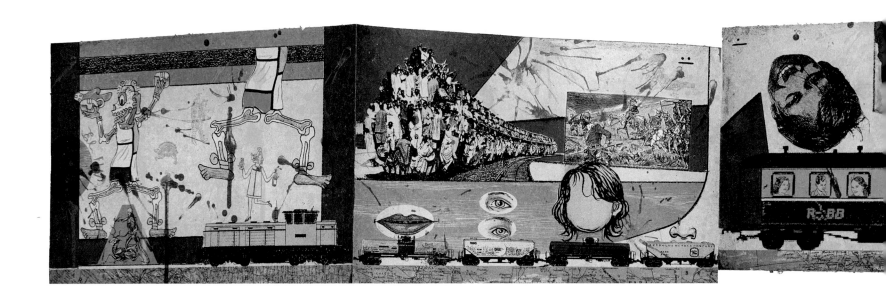

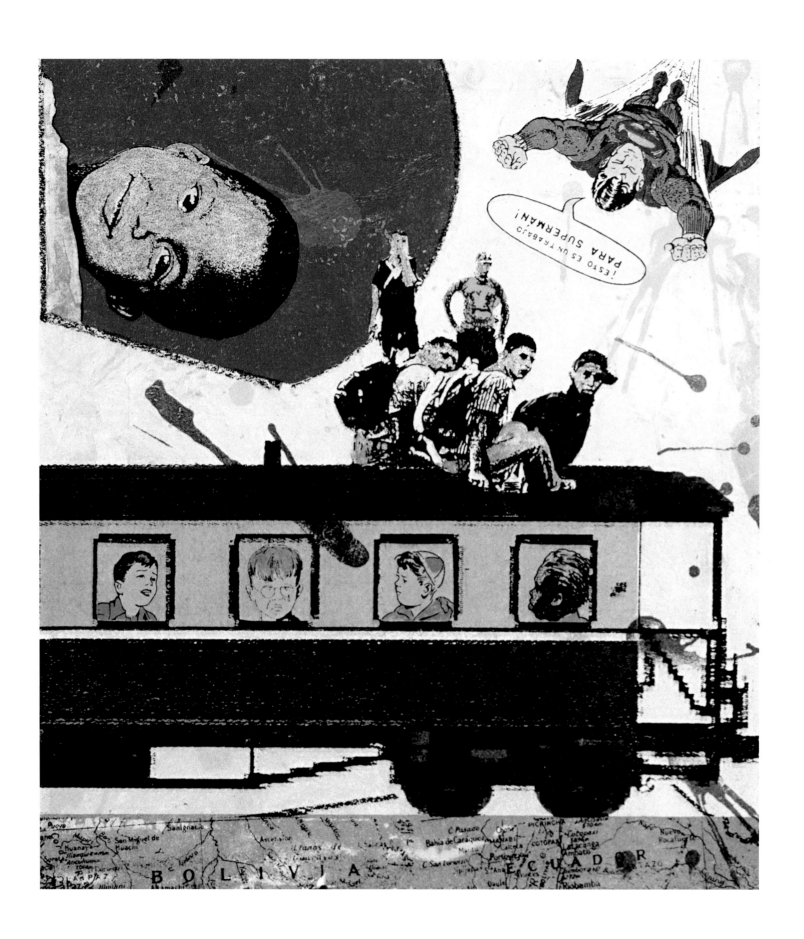

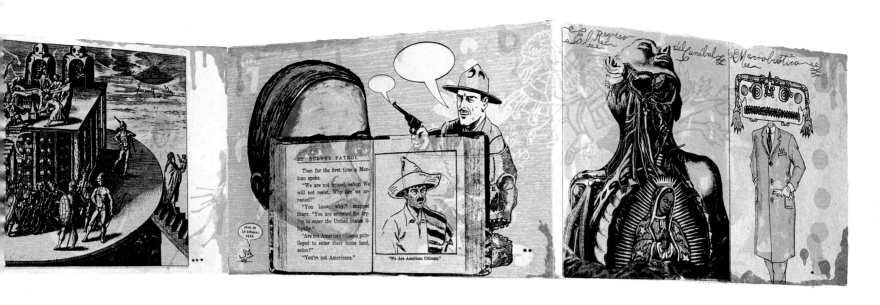

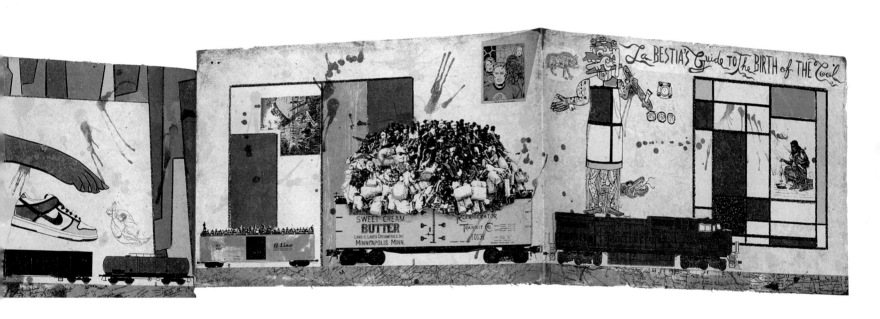

52
Enrique Chagoya, American (born Mexico), born 1953
El Regreso del Canibal Macrobiótico
(The Return of the Macrobiotic Cannibal), 1998
lithograph, woodcut, and chine collé on amate paper
edition: P.P. 1/2
printed and published by Shark's Ink, Lyons, CO
folded: 7 1/2 × 11 9/16 × 3/8 in. (19 × 29.3 × 1 cm)
unfolded: 7 1/2 × 92 in. (19 × 233.7 cm)
467:2020

53
Enrique Chagoya, American (born Mexico), born 1953
La Bestia's Guide to the Birth of the Cool, 2014
lithograph with gold metallic powder
and chine collé on amate paper
edition: 17/30
printed and published by Shark's Ink, Lyons, CO
folded: 8 1/8 × 11 7/16 × 3/16 in. (20.7 × 29.1 × 0.5 cm)
unfolded: 8 1/8 × 92 in. (20.7 × 233.7 cm)
489:2020

54
Enrique Chagoya, American
(born Mexico), born 1953
**Le Temps Peut Passer Vite ou
Lentemente (Time Can Pass
Quickly or Slowly)**, 2009
UV-cured archival pigmented ink
hand-painted with acrylic and
oil on gessoed amate paper
edition: 9/10
printed and published by Magnolia
Editions, Oakland, CA
40 $^7/_8$ × 40 $^{13}/_{16}$ in. (103.9 × 103.6 cm)
493:2020

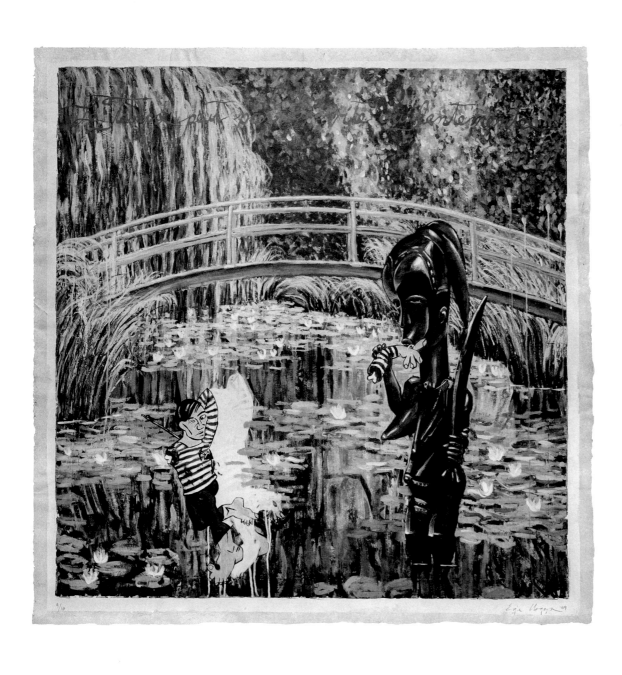

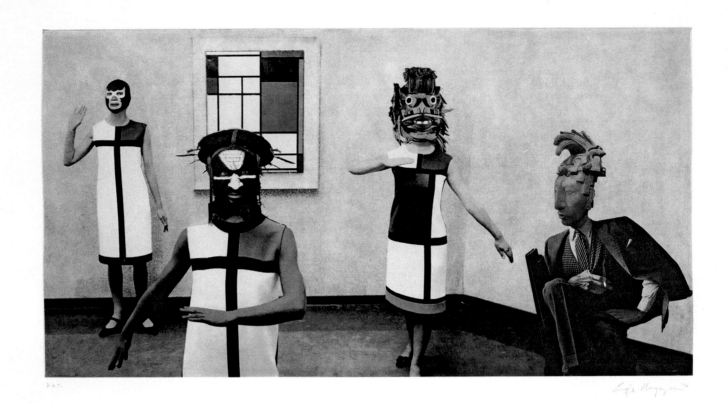

55
Enrique Chagoya, American
(born Mexico), born 1953
Untitled (After Yves St. Laurent), 2016
etching with acrylic
edition: B.A.T.
printed and published by Magnolia
Editions, Oakland, CA
22 $\frac{1}{2}$ × 38 $\frac{1}{4}$ in. (57.2 × 97.2 cm)
529:2020

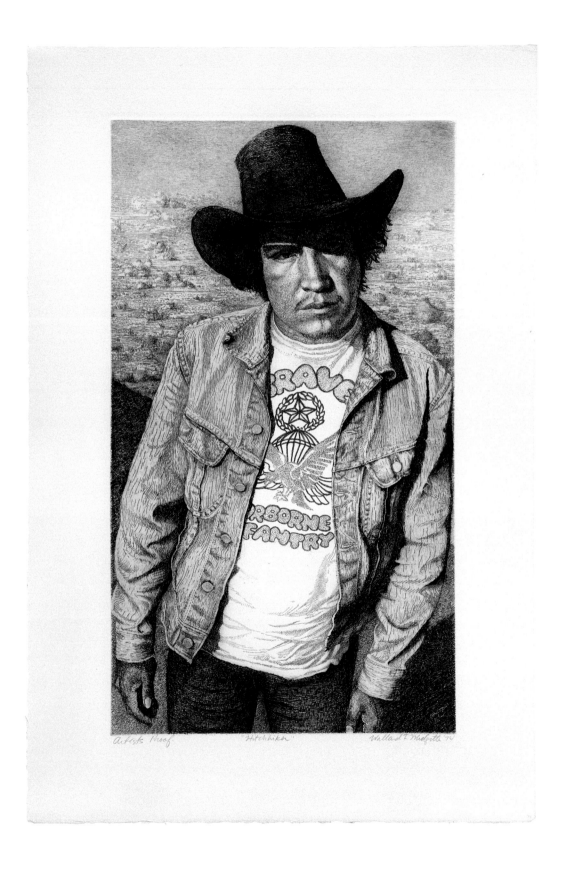

artist's proof "Hitchhiker" Willard F. Midgette '74

56
Willard Franklin Midgette,
American, 1937–1978
Hitchhiker, 1974
etching
edition: A.P.
22 1/4 × 15 1/16 in. (56.5 × 38.3 cm)
744:2020

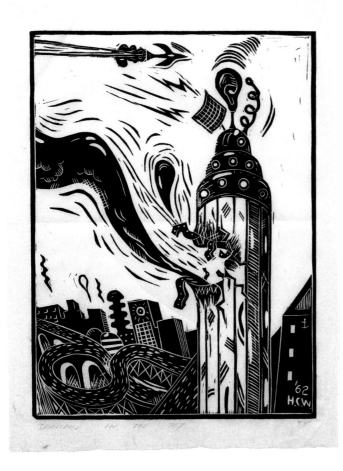

57
H. C. Westermann,
American, 1922–1981
Disasters in the Sky #5, 1962–63
linocut
printed and published by the artist
14 × 10 3/8 in. (35.6 x 26.4 cm)
850:2020.5

58
H. C. Westermann,
American, 1922–1981
Human Cannonball, 1971
pen and black, blue, and red inks
13 3/4 × 16 1/2 in. (34.9 × 41.9 cm)
852:2020

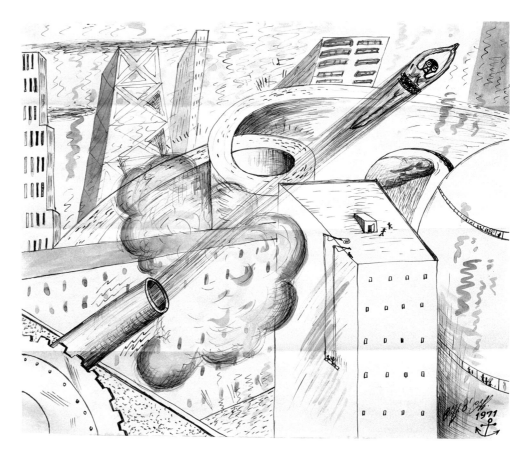

59
H. C. Westermann,
American, 1922–1981
Dust Pan, 30/7, 1972
galvanized sheet metal,
hemlock, and brass
15 $\frac{1}{2}$ × 11 $\frac{1}{2}$ × 5 $\frac{1}{2}$ in.
(39.4 × 29.2 × 14 cm)
849:2020

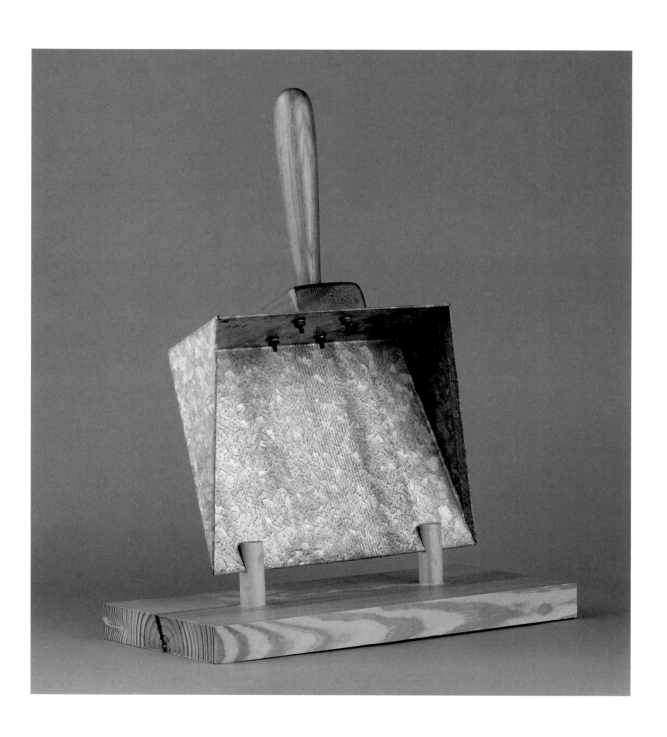

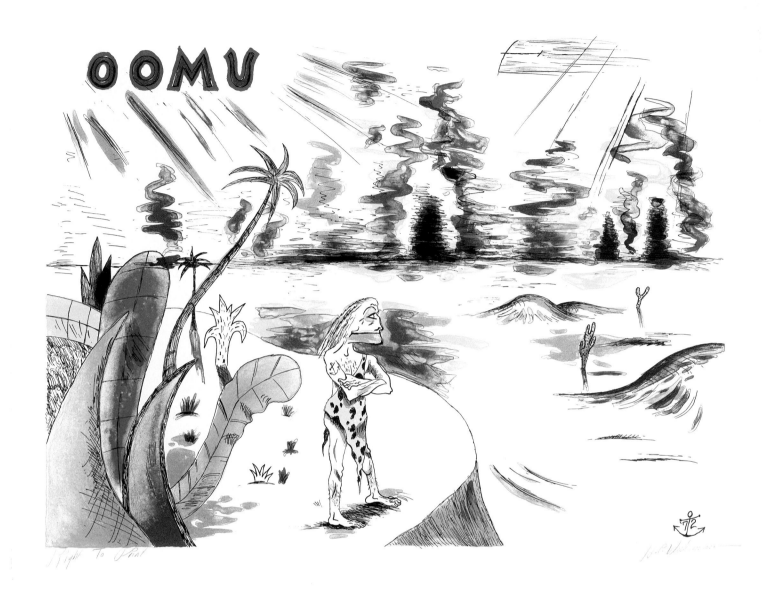

60
H. C. Westermann,
American, 1922–1981
Oomu, 1972
lithograph
edition: R.T.P.
printed by Landfall Press, Chicago
25 × 33 in. (63.5 × 83.8 cm)
854:2020

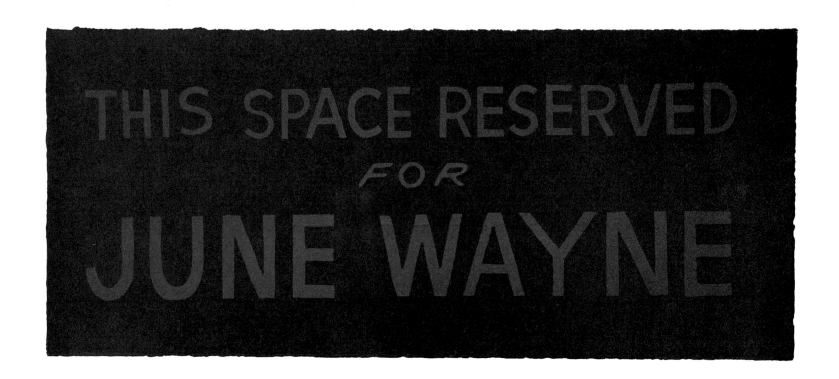

61
Bruce Conner, American, 1933–2008
**This Space Reserved for
June Wayne**, 1965
lithograph
edition: B.A.T.
printed and published by Tamarind
Workshop, Los Angeles
7 1/2 × 17 5/8 in. (19.1 × 44.8 cm)
546:2020

62
Bruce Conner, American, 1933–2008
BOMBHEAD, 2002
inkjet print with acrylic
edition: 6/20
printed and published by Magnolia
Editions, Oakland, CA
35 × 32 in. (88.9 × 81.3 cm)
545:2020

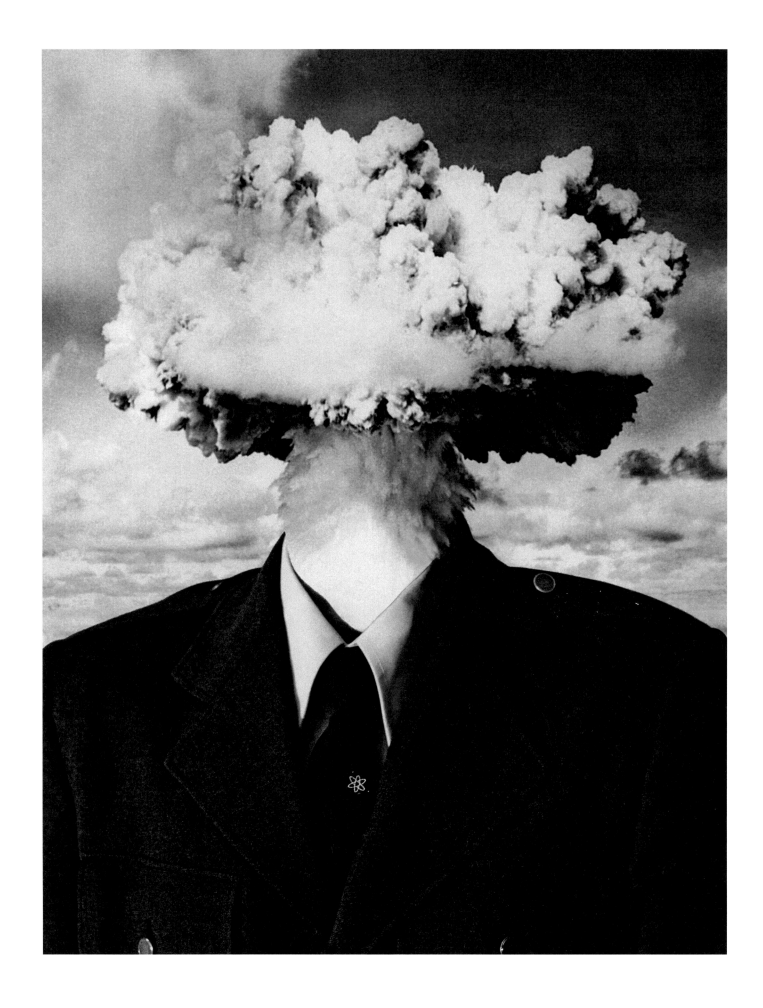

63
Kara Walker, American, born 1969
The Keys to the Coop, 1997
linocut
edition: III/V
printed and published by
Landfall Press, Chicago
46 1/4 × 60 1/2 in. (117.5 × 153.7 cm)
847:2020

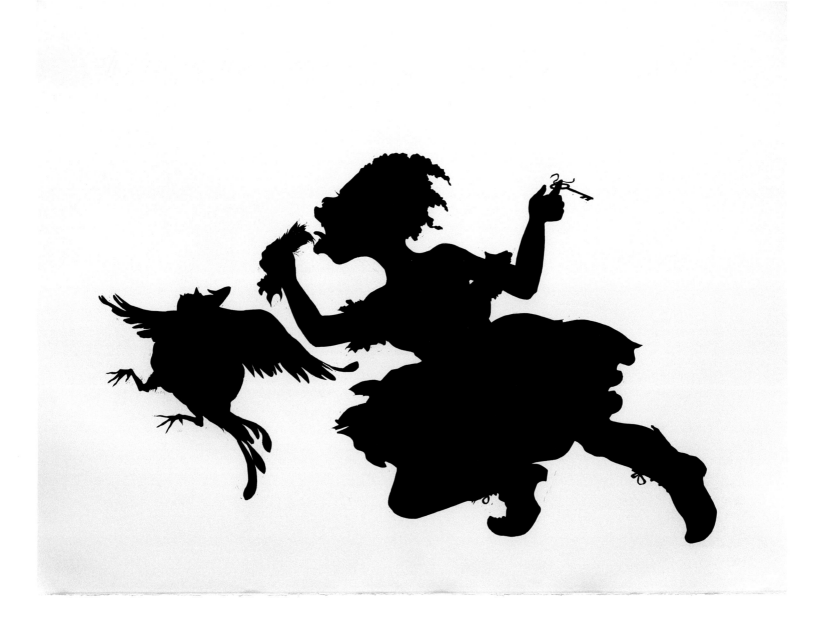

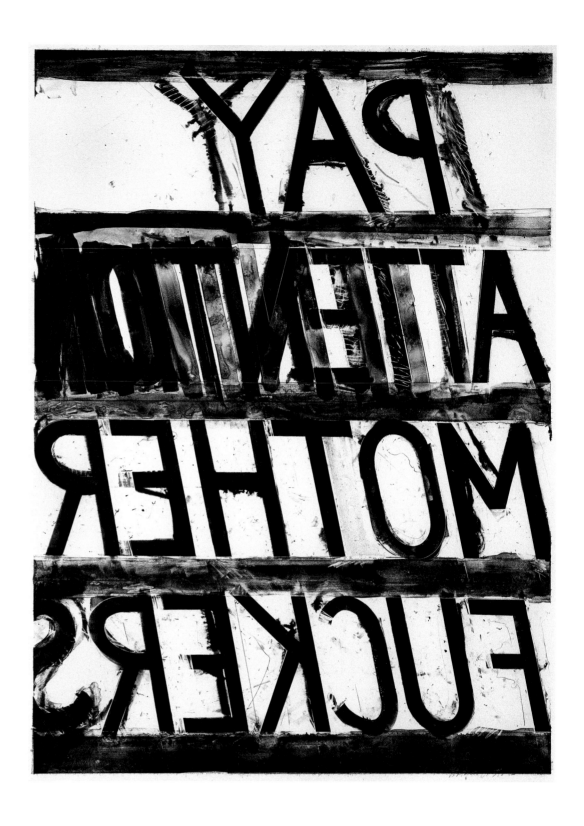

64
Bruce Nauman,
American, born 1941
Pay Attention, 1973
lithograph
edition: 3/50
printed and published by
Gemini G.E.L., Los Angeles
38 $^3/_8$ × 28 $^5/_{16}$ in. (97.5 × 71.9 cm)
750:2020

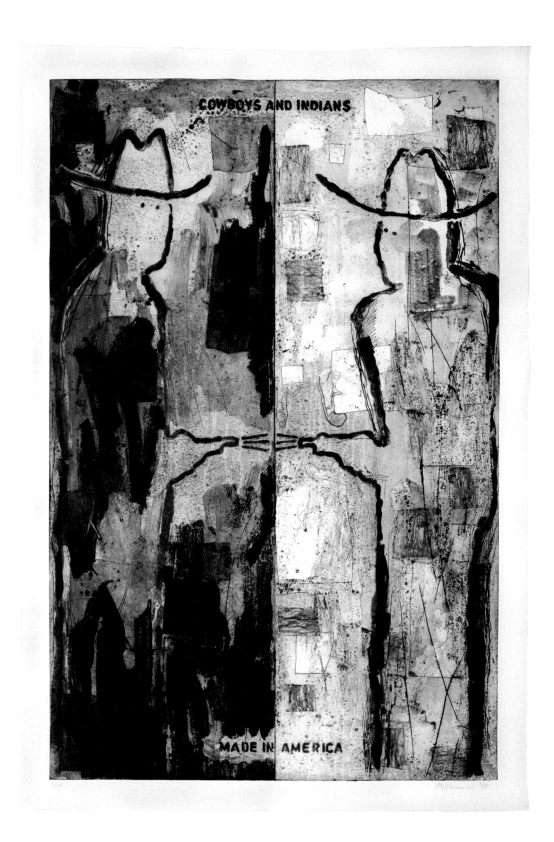

65
Jaune Quick-to-See Smith, Enrolled
Salish, Confederated Salish and
Kootenai Nation, MT, born 1940
Cowboys and Indians,
Made in America, 1995
collagraph
edition: 1/10
printed and published by
Washington University School of
Art Collaborative Print Workshop
(now Island Press), St. Louis
77 ⁵/₈ × 53 ³/₈ in. (197.2 × 135.6 cm)
800:2020

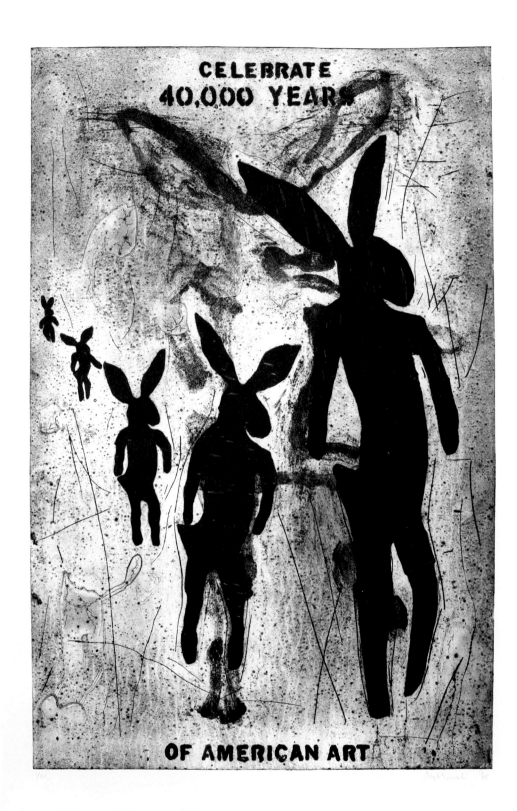

66
Jaune Quick-to-See Smith, Enrolled
Salish, Confederated Salish and
Kootenai Nation, MT, born 1940
**Celebrate 40,000 Years of
American Art**, 1995
collagraph
edition: 1/20
printed and published by
Washington University School
of Art Collaborative Print Workshop
(now Island Press), St. Louis
78 1/8 × 53 3/8 in. (198.4 × 135.6 cm)
798:2020

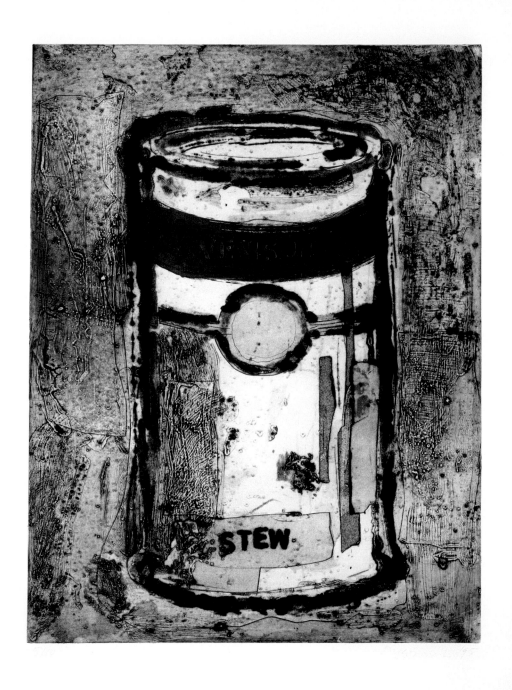

67
Jaune Quick-to-See Smith, Enrolled
Salish, Confederated Salish and
Kootenai Nation, MT, born 1940
Venison Stew, 1995
collagraph
edition: 5/10
printed and published by
Washington University School
of Art Collaborative Print Workshop
(now Island Press), St. Louis
36 × 28 ³/₄ in. (91.4 × 73 cm)
797:2020

68
Michele Oka Doner,
American, born 1945
Tattooed Doll (female), 1968
glazed porcelain with iron oxide
edition: 1/9
12 × 7 × 8 in. (30.5 × 17.8 × 20.3 cm)
554:2020

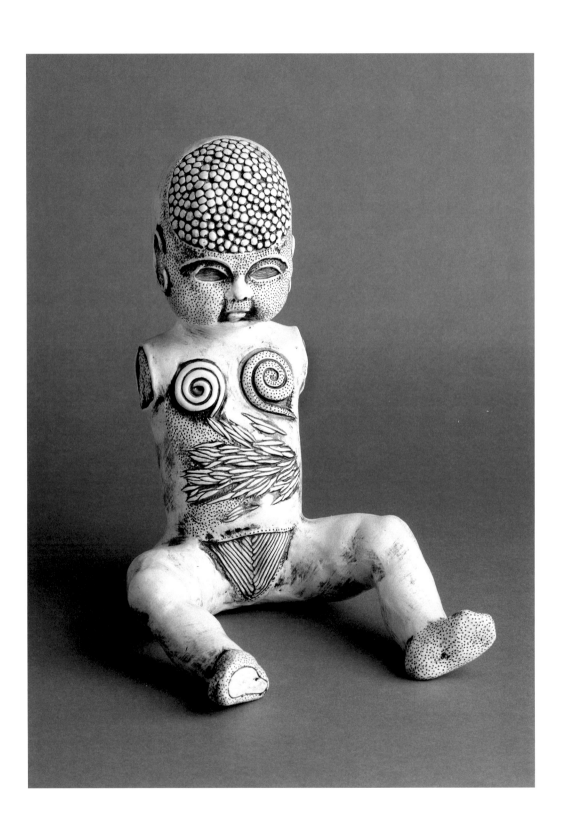

69
Hung Liu, American
(born China), 1948–2021
Trademark, 1992
photolithograph with
attached wooden blocks
edition: B.A.T.
printed and published by
Washington University
School of Art Collaborative
Print Workshop
(now Island Press), St. Louis
22 1/2 × 33 in. (57.2 × 83.8 cm)
743:2020

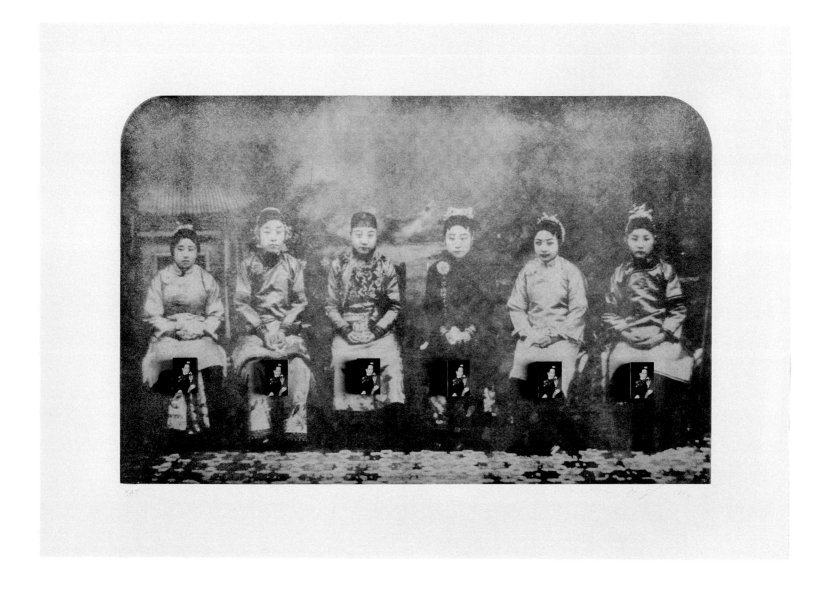

70
Suzan Frecon, American, born 1941
dark red with vermillion (orange) e, 2011
watercolor on ledger paper
9 ³/₈ × 26 ¹/₂ in. (23.8 × 67.3 cm)
613:2020

71
Jasper Johns, American, born 1930
The Dutch Wives, 1977
screenprint
edition: 68/70
printed by Simca Print Artists,
New York
published by the artist and
Simca Print Artists, New York
43 × 56 in. (109.2 × 142.2 cm)
737:2020

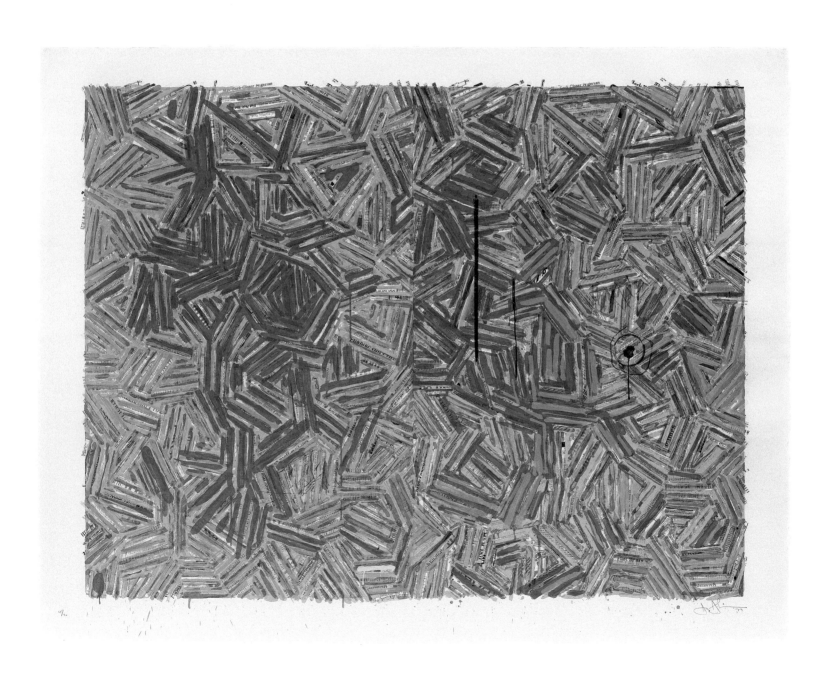

72
Helen Frankenthaler,
American, 1928–2011
Savage Breeze, 1974
woodcut
edition: 21/31
printed and published by Universal
Limited Art Editions, West Islip, NY
31 1/2 × 27 1/4 in. (80 × 69.2 cm)
612:2020

73
Donald Judd, American, 1928–1994
Untitled, 1992
four woodcuts
edition: 14/25
printed by Derriere L'Etoile
Studios, New York
published by Brooke Alexander,
New York
26 1/2 × 39 in. (67.3 × 99.1 cm)
741:2020a-d

74
Al Taylor, American, 1948–1999
No Title, c.1985
acrylic on newsprint
12 ³/₈ × 9 ³/₈ in. (31.4 × 23.8 cm)
835:2020

75
Al Taylor, American, 1948–1999
No Title, c.1985
acrylic on newsprint
11 ⁷/₈ × 9 ⁷/₈ in. (30.2 × 25.1 cm)
836:2020

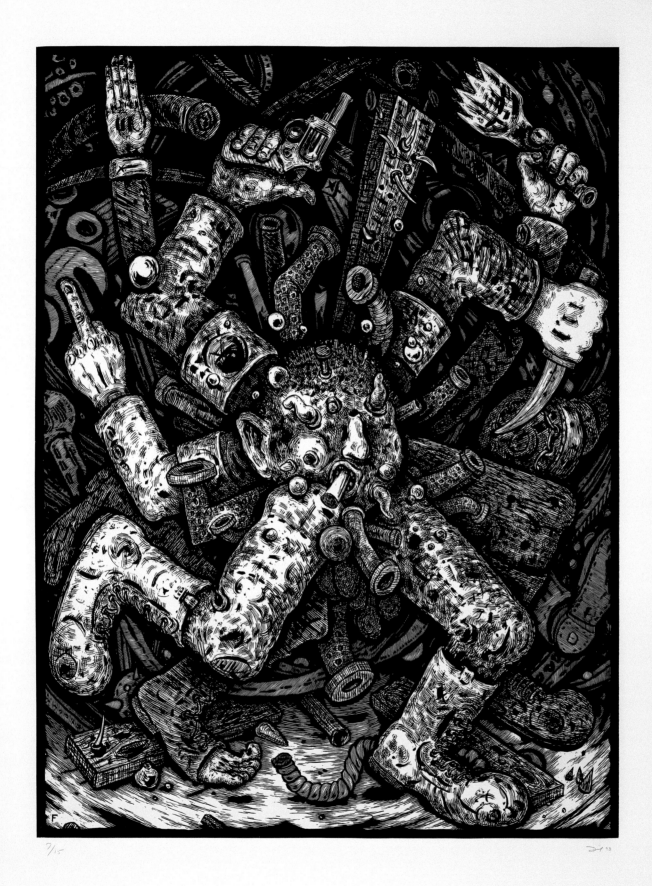

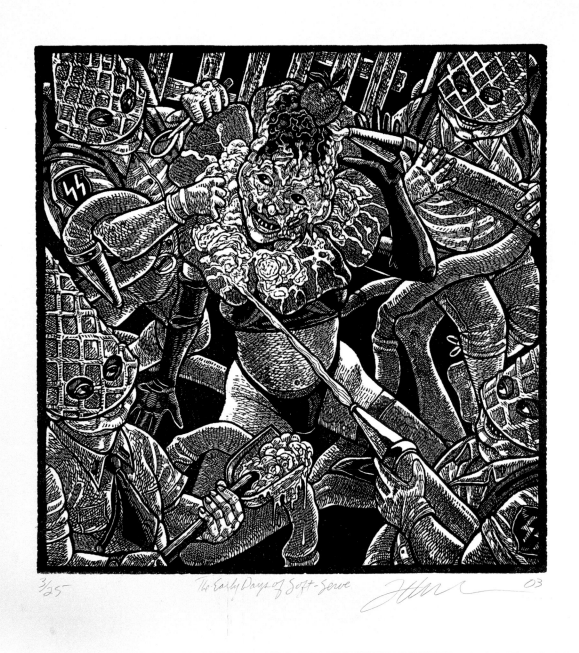

3/25 *The Early Days of Soft-Serve* 03

76
Bill Fick, American, born 1963
Hooligan III, 1993
linocut
edition: 7/15
printed by Perry Tymeson
published by Cockeyed Press,
New York
54 ¹³/₁₆ × 42 ⁹/₁₆ in. (139.3 × 108.1 cm)
556:2020

77
Tom Huck, American, born 1971
The Early Days of Soft-Serve, from
the series **Vintage Junk '04: Fair-y
Tales from the Mississippi Expo**, 2003
linocut
edition: 3/25
printed and published by
Evil Prints, St. Louis
15 ¹/₄ × 15 ¹/₈ in. (38.7 × 38.4 cm)
637:2020.3

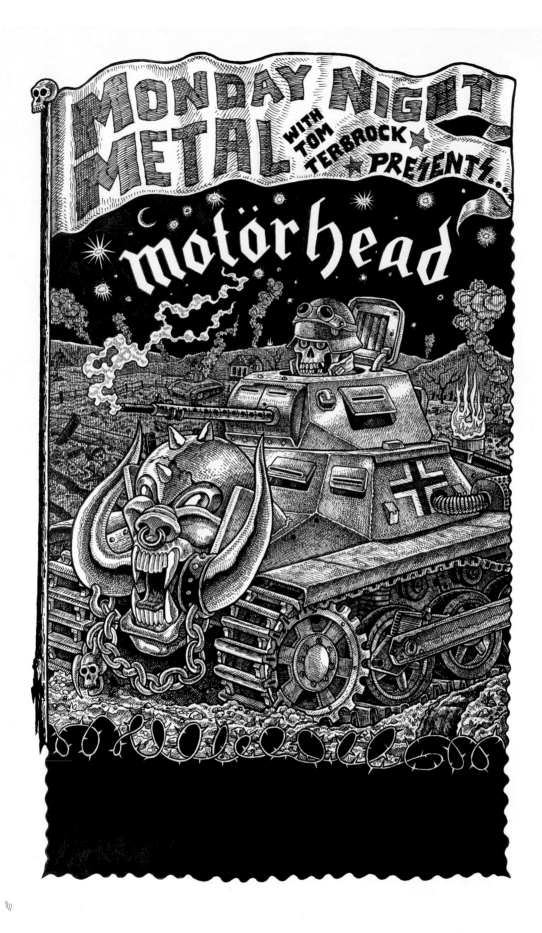

78
Tom Huck, American, born 1971
Preparatory drawing for **Monday Night Metal: Motörhead**, 2008
pen and ink
17 × 13 1/2 in. (43.2 × 34.3 cm)
683:2020

79
Tom Huck, American, born 1971
Monday Night Metal: Motörhead, 2008
letterpress
printed by Crazy Pants Press, St. Louis
published by Evil Prints, St. Louis
20 × 10 in. (50.8 × 25.4 cm)
682:2020

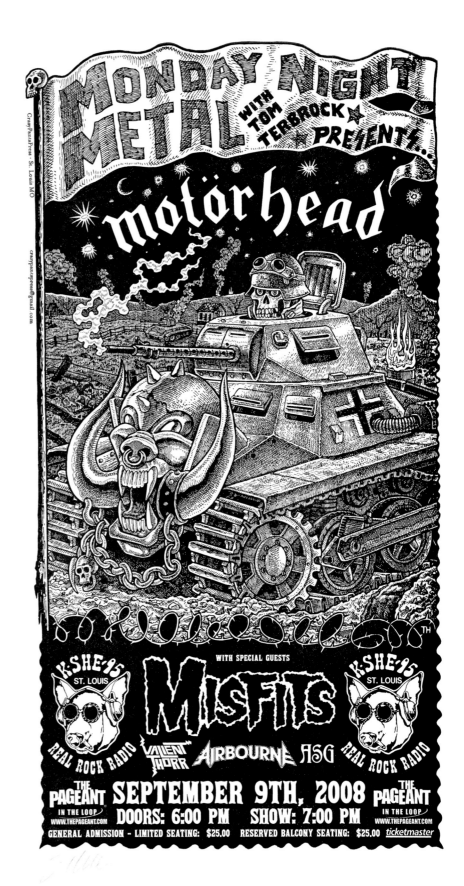

80
Tom Huck, American, born 1971
**The Great War-Madillo
(For A.D.)**, 2017
chiaroscuro woodcut
edition: 3/40
printed and published by University
of Nebraska Press, Lincoln
16 1/2 × 18 1/8 in. (41.9 × 46 cm)
717:2020

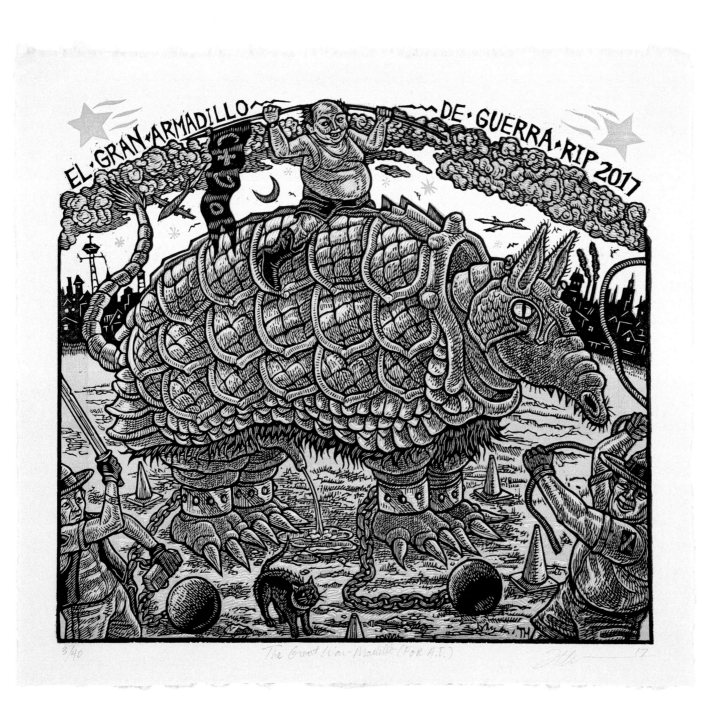

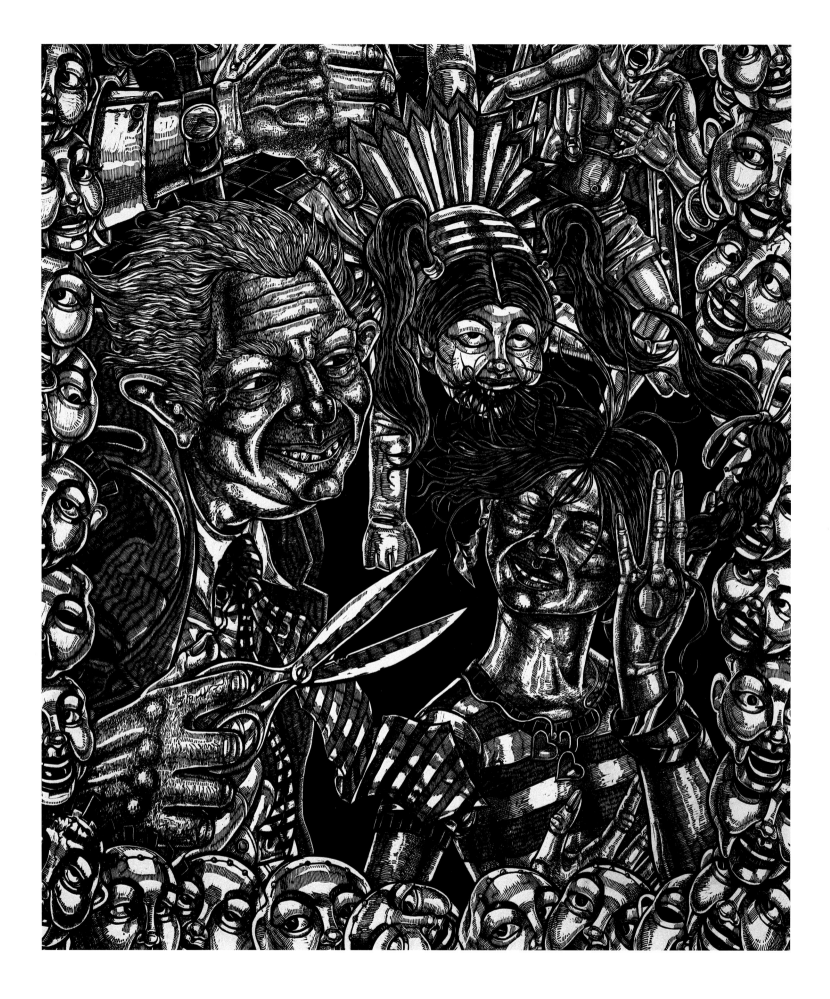

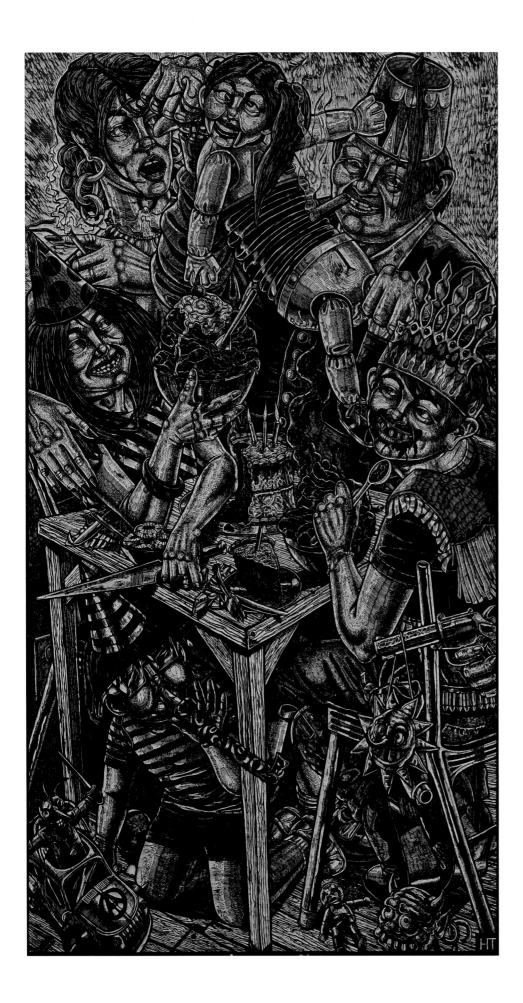

81
Tom Huck, American, born 1971
Snacktime Marcy (left panel), 1999
one of three woodblocks
68 ⅝ × 40 ⅝ in. (174.3 × 103.2 cm)
704:2020b

82
Tom Huck, American, born 1971
Snacktime Marcy, 2000
woodcut printed from three blocks
edition: 4/15
printed and published by
Evil Prints, St. Louis
each, approximately: 68 × 39 in.
(172.7 × 99.1 cm)
703:2020a-c

83
Tom Huck, American, born 1971
Preparatory drawing for
Snacktime Marcy, c.1999
graphite and ink
11 × 8 ½ in. (27.9 × 21.6 cm)
957:2020

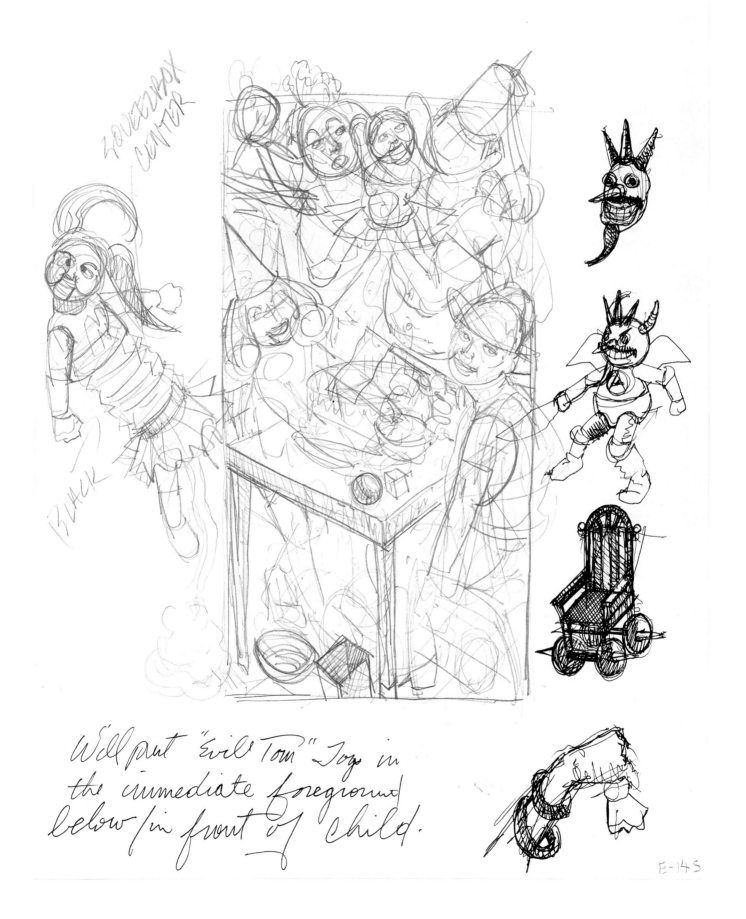

Will put "Evil Tom" Toys in
the immediate foreground
below/in front of child.

E-145

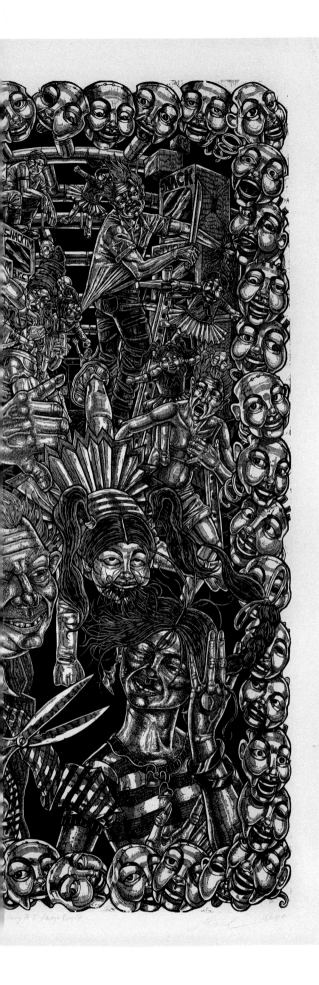

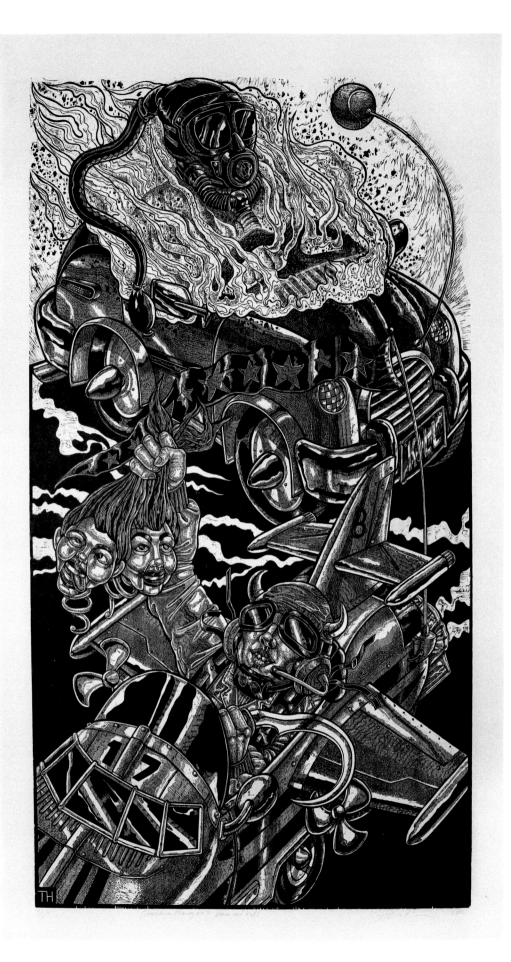

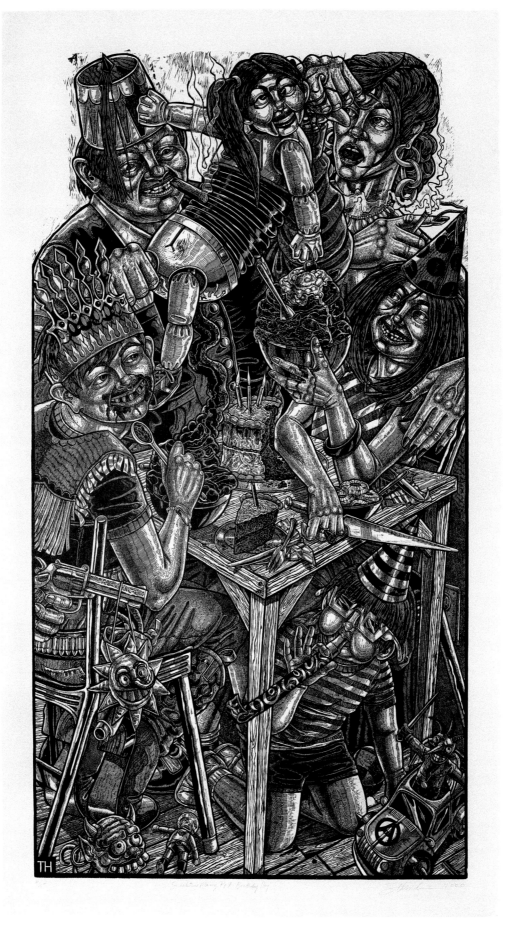

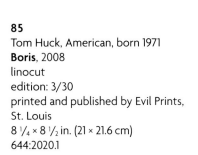

84
Tom Huck, American, born 1971
Apocalypse (War/Four Horseman of the Apocalypse), 2008
ink and graphite
15 3/8 × 8 1/2 in. (39.1 × 21.6 cm)
628:2020

85
Tom Huck, American, born 1971
Boris, 2008
linocut
edition: 3/30
printed and published by Evil Prints,
St. Louis
8 1/4 × 8 1/2 in. (21 × 21.6 cm)
644:2020.1

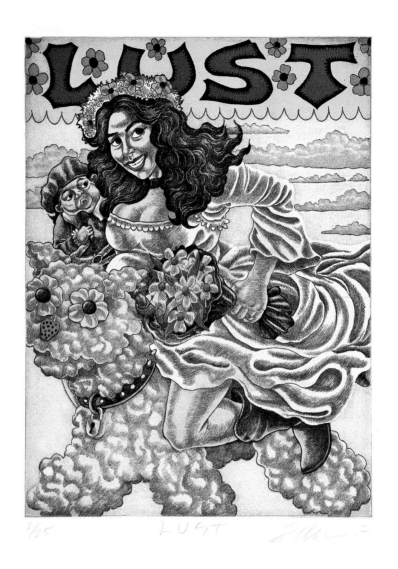

86
Tom Huck, American, born 1971
Lust, from the series
Bridal Sweet, 2001–12
etching
edition: 2/25
printed by White Wings Press, Chicago
published by Wildwood Press, St. Louis
17 × 14 in. (43.2 × 35.6 cm)
638:2020.3

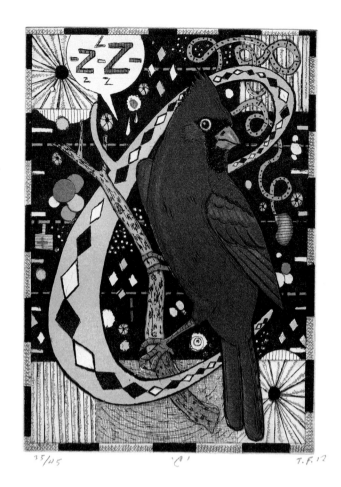

87
Tony Fitzpatrick, American, born 1958
'C,' from the series **Alphabet
of Songbirds**, 2012
etching
edition: 35/45
printed and published by the artist
11 × 9 in. (27.9 × 22.9 cm)
564:2020

88–91
Tony Fitzpatrick, American, born 1958
An Irish Story, 2011
Ass Hopper, 2011
Chicago Mephisto, 2011
Little King, 2011
four etchings
edition: 35/45
printed and published by the artist
each: 6 × 6 in. (15.2 × 15.2 cm)
559:2020, 560:2020, 565:2020,
578:2020

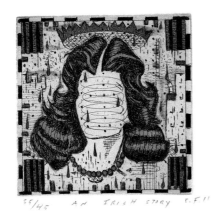

35/45 AN IRISH STORY T.F.11

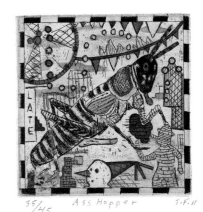

35/45 ASS Hopper T.F.11

35/45 Chicago Mephisto T.F.11

35/45 LITTLE KING T.F.11

92
Mike Bidlo, American, born 1953
**Campbell's Soup Can
(Not Warhol)**, 1984
oil on canvas
20 × 16 ¼ in. (50.8 × 41.3 cm)
457:2020

93
Mike Bidlo, American, born 1953
Print Your Own Jackie!, 1984
screenprint
printed by Lower East Side
Printshop, New York
published by the artist
22 ³/₈ × 17 ³/₈ in. (56.8 × 44.1 cm)
459:2020

94
Wayne Thiebaud,
American, 1920–2021
Candy Apples, 1987
woodcut
edition: 196/200
printed by Shi-un-do Print Shop,
Kyoto, Japan
published by Crown Point Press,
San Francisco
23 ³/₈ × 24 ¹/₄ in. (59.4 × 61.6 cm)
841:2020

pudding

pudding

95
Bruce Nauman, American, born 1941
Proof of Pudding (red), 1975
lithograph
edition: 11/18
printed and published by Gemini
G.E.L., Los Angeles
35 ³/₄ × 42 ¹/₂ in. (90.8 × 108 cm)
751:2020

96
Jane Hammond, American, born 1950
My Heavens, 2004
lithograph with silver mylar and
chine collé
edition: 22/40
printed and published by Shark's Ink,
Lyons, CO
30 ³/₈ × 51 ¹/₄ in. (77.2 × 130.2 cm)
618:2020

97
Jane Hammond, American, born 1950
Spells and Incantations, 2007
lithograph and screenprint
edition: 28/45
printed and published by Shark's Ink,
Lyons, CO
18 ³/₄ × 7 ¹/₂ × 60 ¹/₂ in.
(47.6 × 19.1 × 153.7 cm)
619:2020

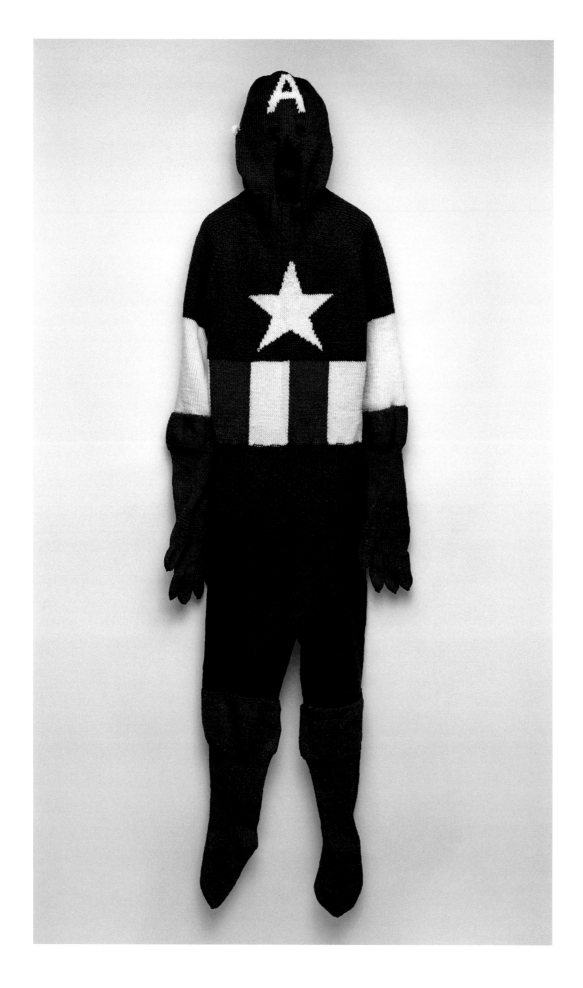

98
Mark Newport, American, born 1964
Captain America, 2007
acrylic yarn and buttons with
wooden hanger
75 × 21 × 2 in. (190.5 × 53.3 × 5.1 cm)
754:2020

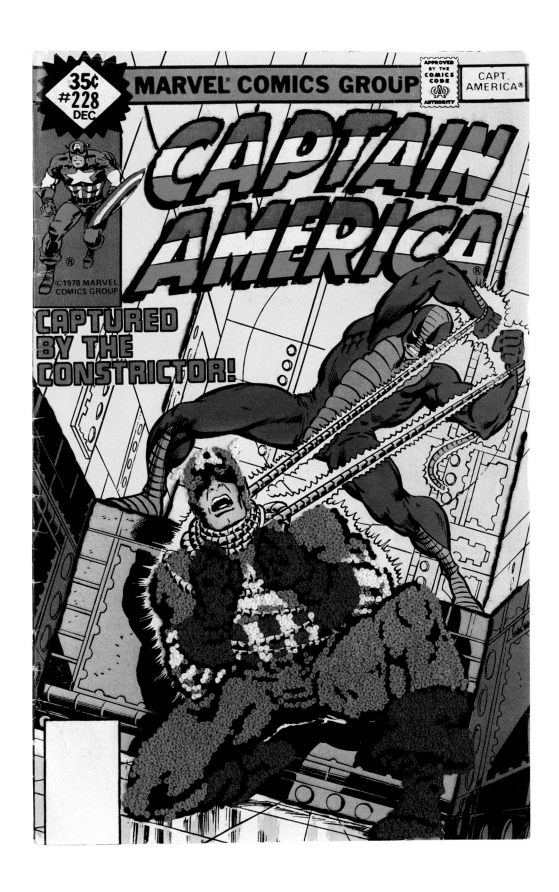

99
Mark Newport, American, born 1964
Sampler: Captain America 228, 2008
embroidered comic book cover
10 × 6 ¹⁄₂ in. (25.4 × 16.5 cm)
763:2020

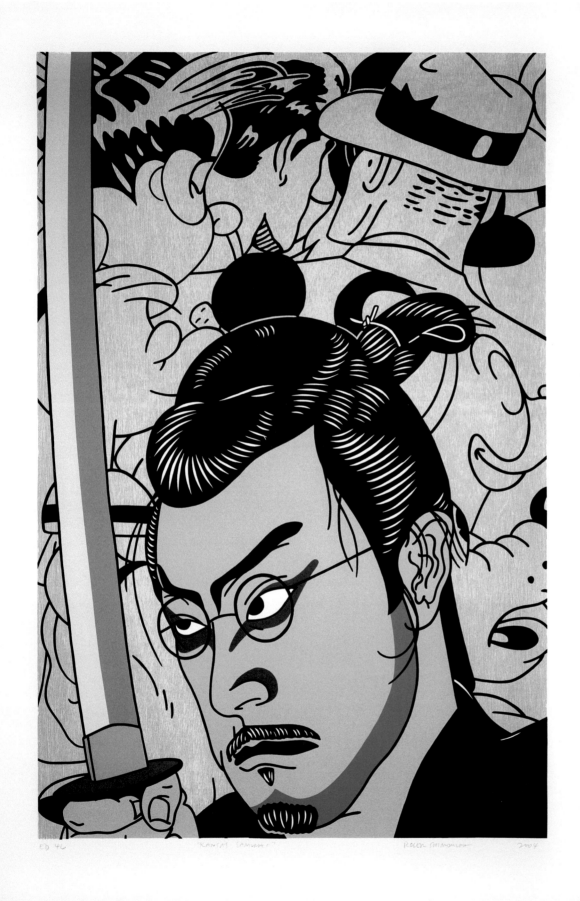

ED 46 "Kansas Samurai" Roger Shimomura 2004

100
Roger Shimomura,
American, born 1939
Kansas Samurai, 2004
lithograph
edition of 46
printed and published by
The Lawrence Lithography
Workshop, Kansas City, MO
44 ³/₄ × 31 in. (113.7 × 78.7 cm)
787:2020

101–104
Roger Shimomura,
American, born 1939
**The Yellow Suite (Zero, White
Wash, Target, Banana)**, 2012
four lithographs
edition: 2/30
printed and published by
The Lawrence Lithography
Workshop, Kansas City, MO
each: 10 × 9 ¹/₂ in. (25.4 × 24.1 cm)
786:2020.1-.4

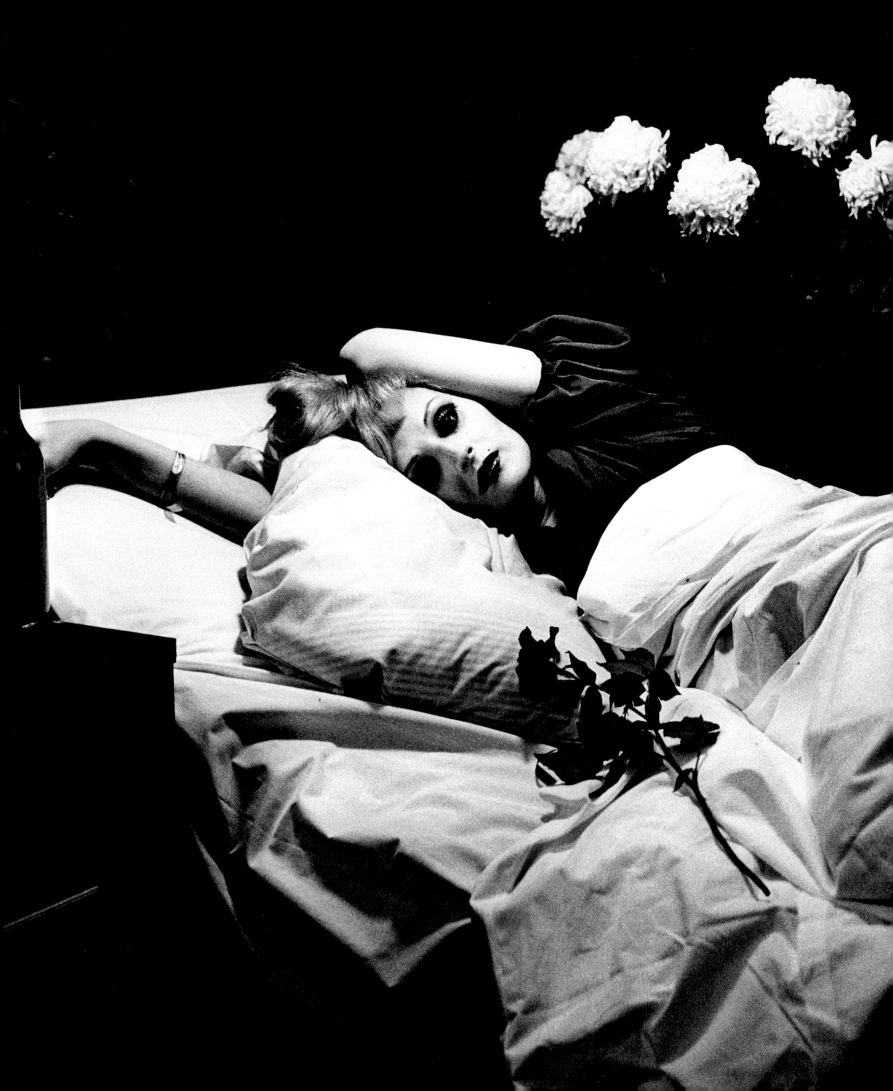

Out of Left Field
Collecting Contemporary Art

The following interview is based on a conversation that took place on June 28, 2021, between the collectors, Maryanne Ellison Simmons and Ted L. Simmons, and Elizabeth Wyckoff, the Saint Louis Art Museum curator of prints, drawings, and photographs. Maryanne Ellison Simmons is an artist and master printer who publishes fine art prints by an international roster of artists at her Wildwood Press in St. Louis. Ted L. Simmons played for the St. Louis Cardinals from 1967 to 1980, and after that for the Milwaukee Brewers and Atlanta Braves. He was inducted into the Baseball Hall of Fame in 2020. The interview has been edited and condensed for publication.

EW: What were your first impulses to collect? Did you both collect as children?

TLS: I was like any very young aspiring athlete. I collected baseball cards, and like every boy in my neighborhood, I collected marbles. Baseball cards and marbles were basically my origin to collecting, and I was pretty avid at that time in my life.

MES: I didn't collect anything. I didn't even collect dolls. I spent most of my time outside.

EW: What was the first thing you collected as a couple?

MES: When we were really young and not making a lot of money, we would visit a little store in St. Petersburg, Florida, where Ted would spring train with the Cardinals. It was called The Straw Goat, and every year we'd buy a Royal Copenhagen cup. We still have those, and we love them.

TLS: Those cups were dated. I think we got about 15 or 16.

MES: Yes, and we went back a little. We went back to 1967, when we were in high school together.

TLS: That was the first joint collection we started, with no aspiration to make it into something large. It's just what we, together, collected really consciously for the first time.

MES: When you're in art school, you trade prints with people. So I have a little gaggle of friends in Ann Arbor whose prints and work I have.

EW: That is especially true in printmaking.

MES: Yes, that's the whole deal.

EW: Could we step back a little more in time? I'd love to learn how you met each other.

MES: Ted and I were in junior high school together, and by 16, when my father would let me date, he was my first date.

TLS: I knew of her through her two brothers, who were both athletes. One was a year older and one was a couple of years younger than myself. But they were always active in the Little League programs, and I was always involved in that and I always knew them. Her father was also kind of the baseball coach in the lower leagues.

MES: Yes, so we've known each other a long time.

TLS: That's how it began to evolve, and then, as she mentioned, by the time we were juniors and seniors in high school, we knew each other well.

EW: Nice. Now, returning to collecting: how do you work together when you're collecting? Do you each have set roles?

MES: One of the early things we decided is that we really don't buy things independently of each other. There were times when we were collecting American furniture and Ted would go to New York or Connecticut when he was traveling and buy things. Likewise, I would take a summer trip to Connecticut, and I think I bought some things at John Walton's, but for the most part, we don't buy each other gifts on birthdays or anniversaries without coming to an agreement about what that could be.

TLS: Yes, even back then when we were talking about furniture, if she was off by herself or I was off by myself, if there was something I felt strongly about, I would notify her immediately, describe it, talk to her about it, and then we would interact based on, "Well, how strongly do you feel about this?" "Is there money enough?" et cetera, et cetera, and then jointly, we would come to the conclusion that, "Yes, go ahead and act on it," or, "Maybe we should wait," or "Maybe you should talk to so and so, they may have another perspective that you might not know about." In that way, if we stumbled upon something, however independently, we would jointly come to a decision and buy it.

MES: And that continues, that's how we do it now.

TLS: Absolutely.

MES: It is great entertainment to rustle through the internet with dealers that we really trust, and say, "Oh, so and so has this, what do you think of this?" "If you were going to buy that for X amount, is there something else out there that we should really be thinking about?" We're constantly struggling to stay on our planned highway, but we get off at exits every once in a while.

TLS: We're still going about it in the same way, though. She stumbles upon something and tells me about it: "I feel really strong about this, we should consider it." I might then react and say, "Well, so and so has an item here that's maybe comparable dollars and cents-wise, but which is more important to bring to the collection, which enhances the collection more?" And then we jointly come to a conclusion about that. So it's still the same process as it was from the very beginning. We don't run rogue on each other.

MES: No, we don't surprise each other.

EW: And at what point did you start asking that question, "Does this work benefit the collection"?

TLS: I think when you start realizing that it is more than just fun and games, and you're assembling something that appears to be growing. Now you realize, okay, first you have to be selective, because it can be expensive, and two, if you're trying to create a collection that's important, whatever you bring to it should in one form or another enhance that.

So if you're collecting just for the sake of status quo, you're spinning your wheels if you're bringing stuff to your collection that's less significant than what you have already; you're going backwards. So, it helps in the evaluation process to say, "This will enhance our collection, and if we can afford it, we should acquire it."

MES: The first advice we got, which was to focus on an artist and focus on that artist's network of fellow artists or friends, was key. That was in our minds at the very beginning in a really profound way, and it was something that really helped the collection. And then the advice to collect our generation was really helpful, and from there, we sort of went crazy.

TLS: If you're looking at an important artist, that artist's associations generally are of a similar ilk. So when you move from one to the other, you're talking about influences that are directly connected to the artists you're focusing on. As you follow that

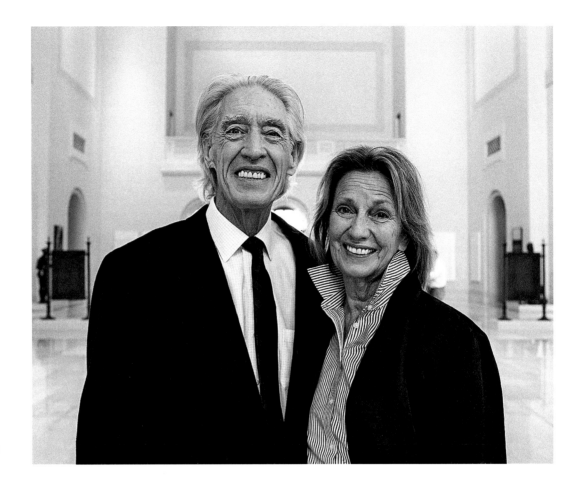

Fig. 1: Ted L. and Maryanne Ellison Simmons

path, you're almost building in an increase in the aesthetic quality of your collection. You're talking about geese go with geese, ducks go with ducks, and you tend to find the same ilk. If you find value in someone you're looking at, the associates that influence them tend to be at least as good or better.

MES: We're of an age that was really profoundly impacted by certain events in history: Vietnam, the AIDS crisis. And as we read about artists and study them, they fit into those places we feel really strongly about that have impacted our lives. I think that was part of "collecting your generation." Although Bruce Nauman says that when he did *Raw-War* (fig. 5) and *Pay Attention* (cat. 64) he did not have the Vietnam War in mind, those two prints were made at the height of the war. And those dates and those works really captured that feeling of when we were younger and feeling the impact of those events.

TLS: Whatever his intent was is of no consequence. The product spoke for itself.

EW: His conscious intent. What he's willing to say now.

TLS: Absolutely.

MES: That's exactly right, you don't know his intention. Likewise, we loved Kiki Smith's work, and then we realized Kiki's association with a sister who had AIDS and all of her friends dying of AIDS—those were really important moments in our lives.

TLS: Which lead you to David Wojnarowicz to Peter Hujar—

MES: Hujar. Paul Thek.

TLS: —Paul Thek and even beyond that. Although they didn't make their way into our collection, Felix González-Torres, Martin Wong, and all these artists living in the Lower East Side at that time dying of AIDS—fabulous artists who were lost. It impacts you.

MES: Yes, and, again, it's just the history of our lives, and people our age are all wrapped up in these visuals. And that's moving to us, I think.

TLS: It drives you; it absolutely drives you.

EW: Before you got the advice to collect in your generation and started collecting the works that are now in the Museum, you were collecting 18th- and 19th-century American furniture. Could you talk about your experience collecting in that really focused area?

MES: Here's the chronology. We got married in Detroit, and Ted had just finished six months of basic training for the Army Reserves. We got married in May, so baseball season was now a month old. He had no spring training. The Cardinals sent him to Triple A in Tulsa, Oklahoma, and I went along because we were just married. He would go on the road, and I'm 20 years old and wandering around Tulsa. I always had an interest in contemporary homes and architecture, but I never found one that I really liked.

And I'm going through this very fancy neighborhood, and I see this little frame house, this little teeny-tiny clapboard house that is a form I've never seen before. Turns out it's a saltbox house, and the woman who lived in it, Beulah Larson, built it to house her collection of American furniture. I'm only interested in the house. And I tell one of the women whose husband runs this team that there's this house, and she knew right away what I was talking about.

So, we're there a month; we come to St. Louis, the house in Tulsa is back there. And three years later, we bought some land and started talking about what we wanted to build, and I said, "Why don't we do that house in Tulsa?" It took a few years, but we talked our way into the house and met Mrs. Larson, and she was just amazing. And boy, oh boy, did she have a collection of American furniture. And so we built the house, and I was ready to put contemporary furniture in it, but Ted said, "What goes in these houses?"

And that's really what started our interest in American furniture. We met Roland and Margo Jester here through our architect, Laurent Torno, and they took us under their wing. Ted started reading, and off we went. And they advised us to find good dealers, and we found them in the East.

EW: The Jesters, for those who don't know about them, were antique dealers and collectors in St. Louis with a special interest in English pottery. They were also important supporters and donors to the Museum.

TLS: They instructed us essentially on who the good dealers were, so we went to visit and I started seeing furniture and realized, "Well, if we're going to build this house, we've got to furnish it with something." And Maryanne's idea of contemporary furniture and decorative arts was a good one. But when you say, "If we're going to do this authentically, we might as well go the whole way. . . ." Then we jointly decided that good is good. And if architecturally that saltbox has survived 250 years in this country, well, their furniture probably would too. And we started collecting the real stuff and brought it to our house. There was probably a period of three or four years that all we had in our sitting room was maybe a couch. Nothing else in the room.

MES: In another room, there was a highboy. Yes, it was awesome.

TLS: It was a beautiful couch.

MES: Our poor kids. We collected a little Staffordshire pottery and that morphed into delftware. Yes, we are incurable.

TLS: Pottery surfaced because in those New England homes, the inhabitants had freshly come from London and various parts of England and they brought their favorite things, which were Staffordshire pottery.

MES: In those houses, there were little cupboards and little shelves for something.

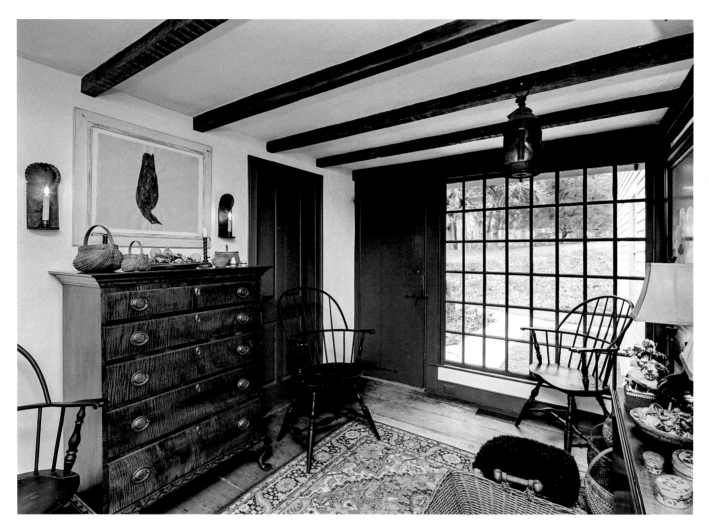

Fig. 2: Kiki Smith, *Untitled (Bird)*, 1995 (cat. 9), in the Simmonses' New England–style saltbox house

TLS: To remind them of where they came from; they were heir-looms. It wasn't unusual to go to a Connecticut house and see Staffordshire pottery on the hearth, so we tried to duplicate that, and it just kept branching. It just kept branching.

EW: That three-year waiting period, that means there was a certain amount of patience in the process.

MES: Oh, we were in an apartment for eight years here before we moved into our house. By that time, we also realized that the chair situation was not going to work, because we had friends who would come over and lean back in a Pennsylvania yellow Windsor. And we realized also there was a concurrent—with the rise in the

cost of these period pieces—cabinet-making movement in America because these pieces were so sought-after, these forms.

TLS: This was the middle and late 1970s.

MES: It's around the time of the Bicentennial, so everybody is hot on this.

TLS: Right, people want this stuff.

MES: Anyway, we replaced our chairs early on, and then we sold, or rather consigned, our collection in 1988 and replaced it with reproduction pieces.

TLS: Although we couldn't afford to collect a Philadelphia pie-crust table—it was a million dollars at that time—we could have one made for a fraction of the cost and have the aesthetic. We couldn't live with the real deal anymore because my economics, well, my aesthetics ran headlong into my economics, and you have to make compromises. And so I said, "I can live with the line and form," and I had them made. Consigned everything back, and it worked perfectly.

MES: And there's a bridge moment between those 18th-century forms and this contemporary world. I was visiting a friend in Connecticut, and she wanted me to go see her friend's house who had some antiques. And I'll never forget this, I walk in, and there was a five-drawer blanket chest painted red, and above it was Andy Warhol's *Marilyn*. I'm a pretty black-and-white person at this point in my life and I think, "Okay, we have to have period things and period aesthetics." And I looked at that *Marilyn*, and I went, "There's a different way. You can do them both."

TLS: It's precisely how our collection evolved from the 18th-century origins of this country to the contemporary art that Maryanne has always had a feel for, and which I subsequently began to learn about, so we combined them.

MES: So David Wojnarowicz's *Untitled (Sometimes I Come to Hate People)* [1992, Art Institute of Chicago] winds up over a Rhode Island lowboy and man, it just sings because, as Ted said, good is good.

TLS: Stops you right in your tracks. You say, "That works." What's Andy Warhol doing with a Benjamin Burnham Connecticut chest of drawers? They'd have been pals, because they understood.

MES: I'm not sure if David Wojnarowicz would have liked us one bit, but that's okay.

TLS: Hey, he might have been mad as heck about it, but, "David, you're going to have to endure certain realities."

MES: "Snap out of it, David."

TLS: "I know it's a big leap for you, but you've got to go there. Other people think it's wonderful."

EW: It's nice just to think about that, the relationship of these artists who maybe aren't with us anymore.

MES: Who we think we know and we probably don't, but yes.

TLS: It's great fun. It's lots of fun to think like that. It really is. You're sitting here saying, "What would David Wojnarowicz think about him hanging above a Benjamin Burnham chest of drawers?"

EW: You've mentioned other types of things. Do you want to talk about other "collections" that you have? Since you call yourselves incurable collectors.

MES: It's ridiculous. I had mentioned the Asante goldweights—

TLS: Oh, yes.

MES: —they're collected for Jon—

TLS: For our kids.

MES: We still have those, and also the rock posters—for Matthew.

EW: Did they express an interest in those things?

MES: Yes, the rock posters. A book came out in the 1980s, *The Art of Rock*, and we gave it to Matthew for Christmas. We said, "Mark some pages of what you might be interested in." Ted's still playing, so he's going to San Francisco, it's the heart of all of that—

TLS: Ben Friedman had a place.

MES: —and met Ben Friedman. I think it's Postermat. He would go see Ben, and they would talk about rock posters. Ted would have certain ones he'd like, and then Ben would show him other ones.

TLS: And then Ben would say, "This was really good, but this one's much better," and the one that's much better might be less expensive. I knew he genuinely was trying to help me make the right selections and educate me, and that's how I dealt with all the dealers, whether it was furniture or anybody.

MES: I think in the end, Ben had purchased the entire inventory of the Avalon Ballroom and also what Bill Graham had left from the Fillmore. We have a complete collection of the Avalon Ballroom posters.

TLS: Right, the Avalon Ballroom—any rock and roller you ever heard of from the 1960s onward, you name it, they were there.

MES: Then there were certain poster artists; they're incredibly famous and they're passing away. David Singer was one of them. He did photo collages for his posters. Today people do that digitally with Photoshop. He did them by hand in the late 1960s and early 1970s, and he did one every week. He was dating Ben Friedman's daughter, and gifted her a complete set. They broke up, and Ben thought it would be a great idea if Ted bought the set from his daughter, which came with the letter and a wooden box that David Singer had made for her.

TLS: The rock posters were clearly from our vintage.

MES: It was great, and the aesthetic was unbelievably beautiful. This is all before we're doing contemporary work.

TLS: Early Who posters from the Fillmore East, Fillmore West, Avalon Ballroom.

MES: Those got replaced by Wojnarowicz, but they were hanging in our house, too. Yes, gosh, that was fun.

TLS: That was an important little buildup, got me to the place where I was sticking my neck on the line with maybe $700 to $1,500 on a rock and roll poster. I'm saying, "Jeez, maybe I should just stick to the baseball cards." They were like practice hoops.

EW: Did the idea of focusing deeply in one area start because you were advised to do that, or was that already your inclination?

MES: We deduced that pretty quickly. We were collecting samples of Staffordshire pottery. We'd have a marble ware and—

TLS: Agateware.

MES: —engine-turned ware and salt glaze—

TLS: Redware.

MES: Those little cupboards were filling up with tiny little—

TLS: Examples.

MES: —examples, encyclopedic examples. Then we started collecting delftware, and then we got serious, going deep in delft instead of buying 10 different samples of Staffordshire teapots. The Staffordshire things went, but the delft collection stayed for a long time.

TLS: Right, and the American redware that we had bought from Bernard Levy, of the venerable New York firm that sells fine Americana. We bought a beautiful redware plate that we had for a while, and that was one of my very first realizations of what could happen. We bought the plate. Then in the middle and late 1970s, when the whole Bicentennial thing was on fire in this country, we were offered a staggering amount of money for it. I looked at Maryanne and said, "We have got to do this." That's when you say, "Jesus Christ Almighty, this actually works."

MES: Backup to Roland and Margo Jester: you never buy for investment; you buy because you love the thing.

TLS: You buy something with the reality that says you're going to be with it your whole life and—

MES: You better love it.

TLS: —you better love it because you may not make a dime in the exchange and you might lose. If you buy it, you better love it.

MES: And when you lose, you say, "My God, I got to appreciate it for so long," so it's good.

TLS: That was one of the first realities I had: "Holy God Almighty, I had no idea something like this could happen." There's Bernard Levy saying, "These people want this plate very, very badly." I said, "You've got to guide me here. I don't know, I've not had experience with this," and he said, "I think you should do it. I think you should do it for you and I think you should do it for me," and I said, "Okey doke!"

He'd been so helpful to us all along the way. It would have been horrible if he had said, "This is for me too" and I had said, "No, I think I'll hold out a while."

EW: Given all those things, what is your definition of a collector?

MES: Early on, when we were maybe 25 and collecting a little bit, we were asked to go to Greenfield Village in Dearborn, Michigan, to do a talk on collecting, which is hilarious in retrospect. We had 12 things.

TLS: 25 years old.

MES: Maybe five things, I don't know. Anyway. So, I made a list of all the things and had no idea we had all this stuff. This is way before we got really serious. I said, there are hunters and there are gatherers, and clearly, Ted and I are from the tribe of gatherers. We just gather, whether it's books, which is a whole other thing that we've done, or Asante goldweights, which were coming in around that time. It's a compulsion and it's incurable.

TLS: A collector—as long as they're lucky enough to ride through their economics and aesthetics jointly, as long as those are in sync—is a man or a woman with an insatiable desire to bring—here we go—truth and beauty alongside one another and stand next to them, and that's what I perceive a collector to be. And I can't help it. When I see beauty, I want to get next to it. When I see truth, I can't help it. I want to get next to it.

And when those two things bring themselves together, I want to get right next to them. There is one other element with those two that makes it absolutely irresistible for me. That's when truth and beauty align themselves with rarity; then I must stand next to those three. I don't know why, other than I must. And so, in one form or another, I think a true collector aligns himself with those three things: truth, beauty, and rarity. It's irresistible, and I'll do whatever I have to and can do humanly possible to bring myself next to those three things.

MES: I think there are people who collect things that don't cost money. My grandfather, who had no money, rented a little place near a gravel pit in Michigan, and he would dig in the gravel pit, and he'd send my mother rocks that she had her whole life. They're sitting in my kitchen in a little bowl. That's no money, but that's really beautiful stuff and some of them are quite rare.

It's the same thing. I would add to that an incurable curiosity about the world that we live in, and the marks that people have made in the past to commemorate this world that they've lived in.

EW: So, what's the Honus Wagner baseball card of your collection, the rare and special object?

TLS: For the real emphasis and meaning, if someone said to me, "You must keep something," I would keep *Black Flag* by Kiki Smith (cat. 1). There are a couple of very, very close seconds and thirds, but in the end, it'd be that.

MES: *Pay Attention* (cat. 64) is the thing. I've loved that from the moment I saw it, and we had been offered it or had seen it several times. And when we were offered the one that's in your exhibition, Ted said a great thing that only Ted could say: "We've been chasing this dog forever, it's time to bring it in the house or let it go." When you seek something that long, and you see it and it still takes your breath away. Because that, to me, is also a statement of "we need to pay attention, everybody, on all

levels." I just love that, and Nauman is so esoteric in his use of language, that that's probably the most straightforward statement he's ever made.

TLS: Well, you can talk for hours on Nauman. I couldn't, but this guy is a huge, huge, huge guy. You can talk about a lot of people in the art world from the turn of the century on, the Cubists, Abstract Expressionists, Minimalists—this guy ranks. I said there were a lot of very close seconds and thirds, and he would certainly have to be in that group of my own. This guy is so diverse and so skilled in so many different mediums and excels every time he steps out there in some new form. Not for everybody, I guess, because it's not easy for the first time to walk up to *Pay Attention*, especially with your kids, but it's really a good lesson.

MES: Even our grandkids get it, and they love it. They love the courage of it, and they love the fact that we love that they get it.

TLS: They get it and that's the whole point that this guy keeps throwing out there all the time, "Hey, get this. Hey, try this on."

EW: "Let's turn it around, let's reverse it, let's make this 2D thing 3D."

TLS: Yes, "Let's see how many ways I can blow your mind. Let me show you how many ways there are." Oh my gosh.

MES: He's something.

TLS: Oh, boy.

EW: I am wondering about the balance between research and spontaneity. How often is it that there's a work like *Pay Attention* that you track over a long time versus something that you see and have to have it?

TLS: I think that research is really paramount when you have identified someone you might be interested in. And then what happens as you begin to learn is that it's on its own timetable. All of a sudden you've learned a little bit, and then all of a sudden

something surfaces that even though you've only researched it a very short time, you recognize it as something that's important. And in the context of spontaneity, you may not fully understand it totally inside and out, but you realize there is something very extraordinary about it, and then you pursue it—in the context of spontaneity.

But I always insist that when you identify an artist that you want to collect, you go to the research first and foremost and find out who this person is and their historical context. Then if something hits you early—bang!—you might be forced to act even before you're ready. That's how I relate to research first, and spontaneity when it happens, it can be very early or very late.

MES: I remember walking into CAM [Contemporary Art Museum] here in St. Louis when Paul Ha was still there [in 2009] and walking right over to *Pay Attention* and turning to Ted and saying, "I love this." I was so excited to see it.

TLS: Spontaneity, that's what you're talking about.

MES: It took a long time to find something available that was in good condition. We had a couple of opportunities but the condition wasn't good. That's the story of bringing the dog into the house.

TLS: Right. That took a long, long time. By that time, we had done the research and knew everything there was to know about Nauman. But when she first identified that print, *Pay Attention*, her reaction was immediate. And at that time I didn't know two cents about Bruce Nauman. We were collecting Kiki Smith; we had one Nauman. But when we saw *Pay Attention*, I wasn't ready to act. It took me a while with Maryanne's help and nurturing to get to the place; "This is a lot of money—wow, are we sure this is the way we should go? We now know a little bit about this person, and we know her or his range, but this is expensive stuff, should we go this deep into an item like this?" It was a while before we even got to the place where we were comfortable saying, "Okay, Nauman, let's go there."

MES: We owned a few pieces already by Nauman, including *Raw-War*, but once we had *Pay Attention* the barn doors just flew open, and we said we're going to go deep here because we really believe in this guy.

TLS: Now you've made the full-on commitment. *Pay Attention* says you are up for anything now. Not simply because of its projectable voice, but because of its expense. Now you're saying if you go all the way in this context you'll get anything he's got, or speaks to you enough, or you feel is important enough. It took a while to get there with Nauman.

MES: And we were building collections. I don't know if it was on purpose, but we tended to go pretty deep in a lot of the people we collected. There are key pieces that either propel you toward that depth or keep you pursuing until those key pieces are part of it.

TLS: It's evident when you look at early Tom Huck that builds into a large collection, to Kiki Smith that does the same, to Chagoya that does the same. There is a reason why those artists represent such a large portion of our collection. They were less expensive, you learned as you went, you liked as you went, you acquired as you went, and pretty soon you say this is really good, this is great, and this is lots of fun and this represents what we've been doing here. But then all of a sudden something splinters, and from Kiki Smith you find yourself looking at Wojnarowicz, and now it is not just fun and games anymore, now it is real serious business. We have to be thorough in our research, we have to be committed with our assets, and now you gotta take this really seriously. And then all of a sudden Hujar comes from that, and then Richard Tuttle comes from that, and Donald Judd comes from that. And pretty soon, the web just spreads out all over, everywhere. Now you're playing the game. Now you're all in.

MES: That research just enriches what the visual is. We got an email from Gracie Mansion—she was one of the first to open a gallery on the Lower East Side in New York in the early 1980s. She saw the notice about the gift later, but she saw the article in the *St. Louis Post-Dispatch* [about the Museum's acquisition of the Simmons collection] and said, "I wrote to the paper and I told them that Ted is the best-read person I have ever known. He tells me stuff that I've lived through that I didn't know."

TLS: She exaggerates, too. I love you, Gracie. But, this is an exaggeration, okay?

MES: No. Yes, and she wasn't even selling anything.

It's unusual, I think. People who are collectors tend to follow one another sometimes, and that's okay because people tend to make decisions in groups, and there's protection there. We're off on tangents that nobody can figure out, including us, but we'll go there. It is always comforting to start tracking the written word about these people and realizing your hunch was correct, that there's not so much at the beginning, but eventually, you find all the written stuff about these people.

TLS: That's what happens, that's how you develop a focus on a certain artist. You keep reading about them, and you say, "Oh, God, they did this between 1943 and 1949," and then you say, "Oh, and much later, they were doing this," or, "Much earlier, they were doing that." You say, "This artist is so important. I think I'd like to collect a sample of their best work in all three of those periods if I can."

Now, you've gotten the best of here, the best of there, and the best of there, and you say, "Man, that is really important to me." Not just that you have them tangibly, but that you fully understand their lifetime of work. And then you say, "This artist is worth focusing on, worth emphasizing, worth telling the world about, however they've overlooked him, however much." God, it's so compelling.

MES: You read about them, and again, it meshes into the history that you know. When I began to realize that the bridge between the Beat Generation and the hippies is H. C. Westermann, right?

TLS: Yes.

MES: Because he participated in both. I thought to myself—because, again, I'm quite black and white about the world—"How do we get from here to there? How do we get from Allen Ginsberg to hippies and Jerry Rubin? How do we do that?" Well, those people were always there, they just didn't pop up in our vision, but they were always there. One of them that we had an interest in is Westermann, and World War II, the Korean War.

TLS: Right, Vietnam.

MES: Yes, Merry Pranksters, and all of a sudden, Westermann is on a bus with Merry Pranksters pulling into Ann Arbor in 1966, and you go, "I get it." That's the continuum that is so intriguing in looking at this.

TLS: You research that period and you find bridges. And if you don't think H. C. Westermann was a bridge between those two periods, then you were living in an attic, and the sad thing is, as far as his career is concerned, people have *been* in an attic, because I said over and over to every person I talked to about H. C. Westermann, "This guy was a great artist, and he was a great American," and he was both. People don't even know who he *is*, and that's what sets fire on me. It *does*. He would've been a good ballplayer.

MES: He would've been an angry ballplayer.

TLS: He might've been an MVP, and he'd be a great player.

MES: A little shortstop.

TLS: He would've been maybe a second baseman, but a little banty rooster no matter where he went.

EW: Shifting a bit, could you each talk about the role of your profession in your collecting. How do you think what you do contributes to your collecting?

TLS: The thing, from a practical perspective, that enabled me to do it was the ability for me to go all over this country, which the baseball industry afforded me to do by playing in the various cities. So if I went to Boston, I could go to the MFA [Museum of Fine Arts] and view the Karolick collection. I could go to Houston, go to Bayou Bend and see one of the finest collections of American furniture there from Miss Hogg. I could go to New York City and go to The Met.

I could go to Jewett City, Connecticut, from Boston, make it early in the morning, see the dealer John Walton, look at furniture, maybe buy furniture, and hightail it all the way back to Boston or New York in time to play that night. My baseball life enabled me to go to the Philadelphia Museum and see the Duchamp collection. It enabled me to do that in a way that, had I been isolated in one city only, wouldn't have afforded me that luxury.

I'd go to Philadelphia, play the Phillies that night, and the docent, who was a baseball fan and got tickets to the game in exchange, was showing me the Paul Revere tankard by eleven o'clock in the morning at Winterthur. That afforded me the ability to go out and then educate myself about what I was trying to learn about and acquire. It was the broadest, what do you call it, a PhD? That's what it was. I saw the finest America could offer in all these varied places, and that's what the baseball industry afforded me in conjunction with my collection.

MES: The same thing. The travel that I did with Ted and our kids, literally, we always wound up at a museum, those poor children, and that was great. Then when I went back to school at 40 here at WashU [Washington University in St. Louis] and became the master printer [at Island Press] and worked with great artists and met the curator of prints at the Whitney Museum, David Kiehl, in that role and sold some of the work that we had done at WashU to The Whitney. Obviously, that was life-altering. So, now I'm in a pattern of printing and going to see people at museums and artist studios. The collecting of contemporary art as a couple really started in 2000, 2001. Ted met David, and David liked Ted a lot better than he liked me.

TLS: Absurd. Absolutely absurd.

MES: Ted went on the Print Committee at The Whitney. I view that as a melding point of our careers and led to really extraordinary relationships, really extraordinary relationships. God, we've been really lucky.

TLS: We were able to get next to really the most important people who could give us access to the most important work, and without that access from those people, whether it was David or whether it was, as I mentioned, John Walton, or Barry Greenlaw, who was at Bayou Bend in Houston at the time . . .

MES: That applied in furniture, and this is the same.

TLS: We got next to the right people who could provide access. I learned somewhere along the line, and I say it often, but you can have everything in the world and afford to buy anything in the world, but if you don't have access, you don't have anything. And I've been told by some very interesting people with some spectacular things that "you may have everything in the world, but I got the goods, and if you don't have access, you don't get the goods. Now, you better behave. If you don't behave, I don't care what you've got, you won't get access to what you want." Those people who have the goods, they've got real good intuitive senses about other people.

MES: Dealers are human beings, and they don't like to be dismissed, and they don't like to deal with unkind people. So, you are courteous and respectful and treat people well and do what you say, and then relationships build. It's just a human interaction.

EW: Not everyone knows how to behave the way the two of you do.

TLS: You just better behave, that's all I've got to say.

MES: Listen, if you've got a great piece of artwork and you're selling to somebody who's going to put it in their beach house in the sun, you're going to be a little reluctant. There are plenty of dealers who are happy to hand off to anybody, but there are really great dealers who really care about the work, who are a little more interested in handing off to somebody who also cares and knows. We always knew from the beginning with the furniture that we are just caretaking here.

TLS: As a collector, you learn very early that you call yourself a collector, but what you are first is a caretaker and you don't get to really own anything. Your role and responsibility as a collector is to conserve whatever item it is. The people who understand that are not enthusiastic about just turning the item over to anybody, because they want to make certain that this item is conserved well. That's what you learn first, because if you're not going to take care of the object, you're wasting everybody's time and energy. Most importantly, if you care about the artist, you're wasting the artist's time, first and foremost.

MES: That's why you see print editions of 50 and you might be lucky to end up with 10 out there. Especially works on paper that are, in the hierarchy of this art-historical categorization of art, pretty low on the totem pole and affordable, because that's why they were made in multiples, so that everybody could enjoy them. They get kicked around and they get badly framed or whatever happens to them.

TLS: Poorly hung.

MES: Yes, and then suddenly the edition of 50? You can't find 10.

EW: What are your criteria for bringing something into your collection? When you are looking at an artist, what makes that object or that selection of objects?

MES: If there's an odd thing. For example, we started looking at Luis Jiménez just recently, and he's odd, and it's not like there are a lot of them in collections out there, and it's not like he goes with anything that we have already, but if you collect deeply in a thing, then suddenly it's an important part of the whole. And the more we know about this person, the more important he becomes to us, and that can be applied to all the

people that we collect. There aren't a lot of one-offs in our world, are there?

TLS: No. I think, for me, after this lifetime of criteria building that you are asking about, it still goes back to what I was saying a little while ago, "What's going to get my attention?" "Oh, that's very beautiful." There are a lot of beautiful things in the world. "Is this artist trying to say something, and is this artist's effort to say something truthful or will it affect me in a truthful way? Is he coming at me genuinely?" Three, again, "Is it rare?"

If two of those things are present, I'm stopping for a long time. And chances are, if what he's saying is genuine and talking to me, I'm staying. Two, if it's rare, I'm staying a long time, and three, it can be God-awful ugly, but I'm going to stay a long, long, long time before I walk away from it, because its truth and its rarity are compelling enough to give that ugly-looking thing staring back at me every benefit of the doubt to fill in that third criterion for me. That's for any collector at any stage: beauty, truth, rarity. If it's 15 cents, pay 20.

EW: You said you don't have many one-offs, but there are some things in your collection that there's just one of, like the Helen Frankenthaler (cat. 72) or Jasper Johns (cat. 71) or the Suzan Frecon (cat. 70). How do those happen?

MES: Rarity and on the recommendation of David, who went to look at something else for us and walked in on the Frankenthaler. It had never seen light, it had never come out of a portfolio that this woman's husband had collected directly from ULAE [Universal Limited Art Editions in West Islip, NY], and he died, and it was never framed. And David tells us, "The Nauman is good, but there's this Frankenthaler." And then the machine starts to work.

TLS: You think of Helen Frankenthaler, and you say, "Okay." When I say even as a print, it's not a Frankenthaler painting for us. But when you see that kind of work and you start saying, "Okay, it's expensive, and how many of these can you afford?," you come to the conclusion that you will probably only have

one of these in your lifetime, or Mary and I may have two out of some strange something or another circumstance, but the likelihood is that we'll have probably only one.

Now, if you come to that crossroad with Helen Frankenthaler and you decide there will only be one likely, you say, "What does this one represent?" You may think there's a better Frankenthaler print out there, and there are those who might argue there is, but you can make a very long argument that this one is as fine as you'll ever see, because it's been tucked away in a portfolio in a flat file, has never seen the light of day, and its color is screaming out loud at you. Now, the one you think may be a more important print by Helen Frankenthaler, unfortunately, is faded.

MES: Sometimes you just run into the best one first. We looked at other Frankenthalers, and we just kept thinking, "This is the best one. This is good. This is okay." We were happy there.

And the Thiebaud (cat. 94). I've seen *Candy Apples* a hundred times, but when [the New York City print dealer] Susan Sheehan says, "It's rare to see them not faded," and this is not faded—

TLS: She said if you see 10 *Candy Apples*, if you see two—two—that aren't faded, that would be a lot.

MES: Yes, and they can't be restored because it's water-based ink. Buy it, stick it in the flat file, and hope for the best that our kids don't grab hold of it when we get run over by a truck tomorrow.

TLS: So one-offs happen that way, or at least did in our collection. Frankly, it has a lot to do with affordability, because otherwise I can think of important Frankenthaler prints, like *East and Beyond*, and you can go to the *Madame Butterfly* series and say, "Well, if I can have them all, I'll just go get them all." So you have to make a choice.

MES: If you don't have a dealer who knows the provenance, and *Madame Butterfly* shows up in Timbuktu, I'm not going to get it. The Frecon—I love that woman's painting, I just love it. I

wanted to print her at Wildwood Press, but she didn't want to print. And the affordable thing to buy were the watercolors.

TLS: Affordably, I'd own a hundred because her work is so beautiful. So we settled upon one. When we brought it to the collection, it enhanced the collection to our perspective. It did. It's enhanced our collection because her work is great.

MES: The Bidlo is similar—I guess we have *Marilyn* and *Jackie* (cat. 93) and the *Soup Can* (cat. 92), but his relationship with Wojnarowicz is really important, too.

TLS: Very, very interesting guy.

Just talking about Gracie, I mean Bidlo painted Jackson Pollock's drip painting, made a dress out of it which she wore that night . . . it's beyond me.

MES: At the opening of her little gallery on the Lower East Side.

TLS: Right. You talk about appropriation artists. We've been doing this for a while. There are others.

MES: If there's not a lot of depth in those kinds of people, there are reasons of availability, we might go off on a Ruscha tangent and you have to choose.

EW: I have a feeling that you two—of the tribe of gatherers— you are still gathering. Who, what, is on your radar now?

TLS: Fred Sandback. He's a guy I stumbled upon when I was reading about Minimalists, and then saw what he did with string, and I said, "God, that is really neat." His whole idea of space and all that other stuff, really special stuff or, Luis Jiménez, whom we stumbled upon.

MES: That was such an interesting thing because we really liked the work, and we kept saying, "Why do we like the work? We've never heard of this guy before." And the more we read about the work, the more we liked the work.

EW: You had great advice right at the beginning and continue to have it. What advice would you have for someone who is thinking, "Could I be a collector?"

MES: The advice for a collector is the same as advice for a young artist: follow your passion, and don't try to be somebody else, just follow your heart. There are collectors who aren't interested in beauty, who are interested in in-your-face confrontation. Great, follow that. There's something for everybody out there, just make sure you're passionate about it.

TLS: I would say find someone or a group of people who know and understand the area that you're developing some interest in as a potential collector, because you can read all there is in the world and get lost in the verbiage. And make yourself vulnerable out there in that world. You have to have someone who can guide you. Maryanne refers to that as a North Star, so when it gets a little foggy, or you have questions that you can't answer from your reading or research, you have to have a go-to person to say, "Hey, put this in perspective for me. What is it I'm missing here?"

Then those people, because of their experience, tend to have context for what your difficulty is and can turn the light on in the room for you, steer you in a direction that will keep you safe as opposed to in a direction that will only make you more vulnerable. This is the real-world stuff out there. When you're talking about collecting, whether it's vintage cars or anything, there are lots of folks out there who would think nothing of taking advantage of you.

EW: I think it's interesting you talked about reading. You can read all kinds of things and some of it is by an art historian sitting in an office surrounded by books. Then there's someone like David Kiehl, who does the book reading and sits in the office but also looks at the objects and also knows the market, or a dealer who has a completely different kind of experience—

TLS: You need that kind of person.

Fig. 3: Enrique Chagoya, American (born Mexico), born 1953; *The Dispersal of Matter into Perceptual Flicker or Implied Motion of the Inner Orgasmic Object*, 2001; lithograph and woodcut with chine collé; 15 ³/₄ × 23 ¹/₂ in. (40 × 59.7 cm); 517:2020

MES: Today, this and that [points to phone and computer] open up a whole different world. There aren't enough pages in books to fill the obscure little factoids that pop up on there that lead you to Luis Jiménez's third wife in Hondo, New Mexico, on a Friday night, she picks up the phone, and you go, "Oh my God, I only meant to leave a message." But there are things about these people that art historians don't write that come in places that are unexpected. The chase is extraordinary, made even more extraordinary by our ability not to just run to Janson's *History of Art* anymore, but to run to the internet. Cautionary tale: not everything on the internet's true. That's the fun part, sorting out what's right and what's not right, and being able to call up David and say, "you know that date was wrong."

EW: One final question, because you very generously decided that this collection would come to the Saint Louis Art Museum. I wonder if you could talk about why the Saint Louis Art Museum, why St. Louis?

TLS: Baseball brought us to St. Louis in the first place, however many years ago. St. Louis is an interesting place in that if you're native, that's wonderful. When an outsider comes, like Mary and I, it takes a while for you to come to grips with being an outsider. That's all fine and good, but this city really gave to Maryanne and me an embrace through this baseball connection that really, as much as an outsider essentially becomes a St. Louisan, they gave that to us.

Fig. 4: Pieter van der Heyden, Flemish, c.1530–after March 1572; in the manner of Hieronymus Bosch, Netherlandish, c.1450–1516; *The Blue Boat*, 1559; engraving; 9 1/4 × 12 in. (23.5 × 30.5 cm); Saint Louis Art Museum, Gift of Julian and Hope Edison 636:2018

We have taken so much from this community over 40 some years now, that by bringing our collection, in essence ourselves, to this institution—SLAM, Saint Louis Art Museum—we have been able to give back to a community that embraced us as outsiders. We have looked at this as an appreciation for that embrace. In this way, it enables us to give back to this community through this institution, which is heralded throughout the world as a major, major institution.

MES: I think it's also important to say that you approached us, and what a spectacular thing for somebody to say, "We like this stuff that you've collected," and to take the whole collection. It

took us a while to actually believe that that was possible. That's a privilege that not a lot of collectors have. Once I came to that at three in the morning, "Not everybody gets to do this. This is extraordinary." Just to see the exhibition layout and to walk through something that's been built over the last 20 years, that's extraordinary. We're so grateful for that.

TLS: Then you realize the magnitude of it. I think it's been a gift all around. Everybody wins here. Everybody's going to win with this: us, SLAM, the community, the Cardinals, everybody wins here. It's an incredible dream.

MES: I think also people like us who collect in our little two-person huddle are insular and maybe not aware there's some other value in what they're doing. That only became clear to us from the *Graphic Revolution* show, when people we've known for as long as we've been here came up to us, "I did not know you collected Westermann; he was a god to us in art school," or, "How have you had all this stuff and us not know?" It made it even more extraordinary that some of the things that we angsted over together late in the night means something to you, too. So, that was pretty great.

TLS: It might inspire someone else who comes through these doors someday and say, "Wow, I never thought about that. I'd never thought about that as an artist." I can say it's a gift to everybody. Everybody gets a little piece of this cake.

MES: And I love the fact that it expands the print collection in a really exciting way. Coming here 50 years ago, I know the focus was on Old Master prints, and that was wonderful. I wanted to see contemporary work, so this is so meaningful, to me, on that level. I love that. The greatest thing, I think, since the gift was made, was the comment you made that if somebody wants to study Chagoya they can come here, and then that gift of Bosch prints—Holy Toledo—and you just go, "Oh my God."

EW: Well, we at the Museum were saying exactly the same things. It's extraordinary. The Museum was buying some contemporary prints starting in the 1960s, but your collection completely dovetails with what was already here—there's really no overlap, so it's a perfect dovetail. About the Bosch prints you mentioned: in 2018, we received the gift of a comprehensive collection of prints relating to Hieronymus Bosch. I was blown away when I saw a print in your collection by Enrique Chagoya, who made his own version of a rather obscure 16th-century Flemish engraving after Bosch (figs. 3 and 4). Not many museums can demonstrate that connection so clearly.

MES: Isn't that crazy? Isn't that just nice?

EW: Now the Saint Louis Art Museum can tell the story of contemporary art in this medium. It's really amazing.

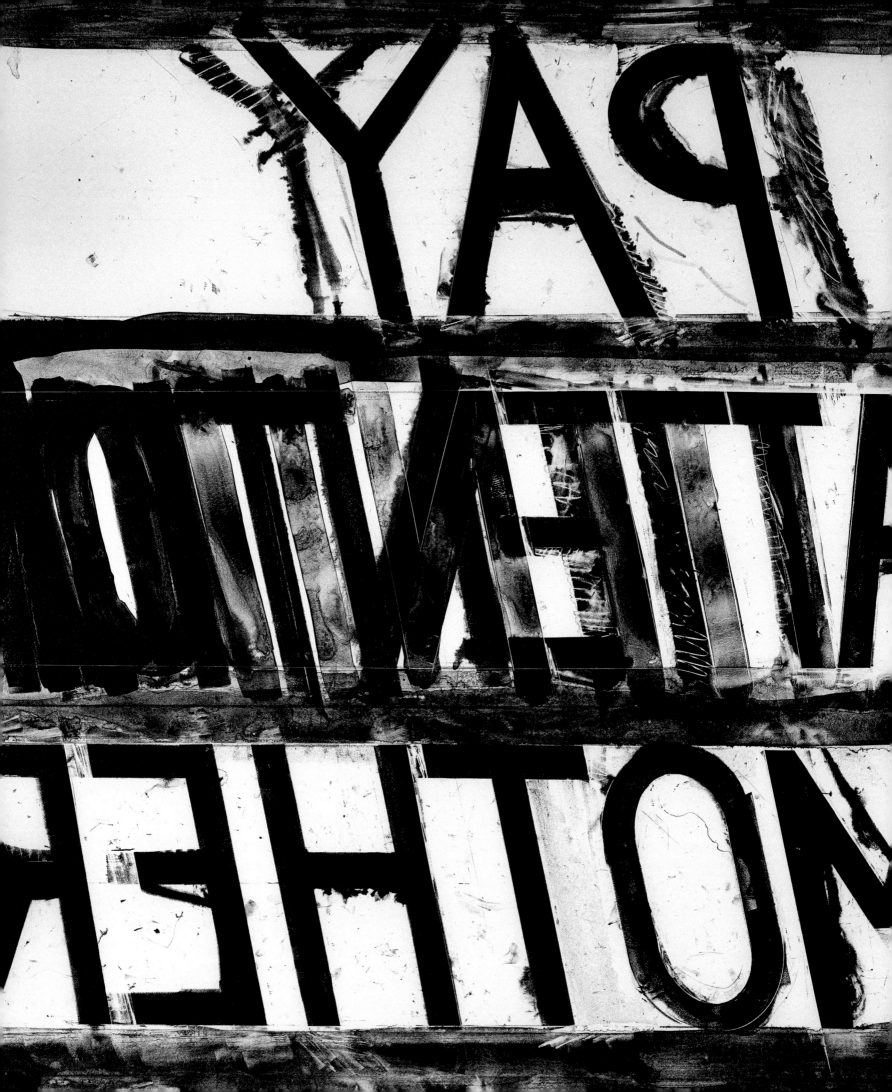

Pay Attention
Art in the Present Tense

Elizabeth Wyckoff
and Andrea L. Ferber

Bruce Nauman's black-and-white lithograph is of imposing scale; its eight-inch capital letters admonish the viewer in a less-than-polite manner to *PAY ATTENTION* (cat. 64). The mirrored text results from the process of printmaking, in which the marks on the matrix—in this case, a lithographic stone—are printed in reverse.[1] Once our brains process this reversal, we begin to wonder: What should we pay attention to? Is the artist making a political statement? There was certainly plenty to pay attention to in 1973, when this work was published: the Watergate scandal, the Vietnam War, the Roe v. Wade decision, and the American Indian Movement at Wounded Knee.

Nauman questions the very nature of art with his practice. He probes the most fundamental precepts of printmaking in order to turn them on their head, all while making brash yet inscrutable statements. In so doing, he participates in a long history of artists who have engaged with printmaking as a means of communication. This essay aims to draw out and contextualize some of the many ways artists have conveyed strong messages in print over the past half century, when the artists included in the collection of Ted L. and Maryanne Ellison Simmons have been active. Indeed, the Simmonses have made a point of collecting art that speaks, in one way or another, to the issues that have impacted their generation. The messages can be strident and direct, as in Nauman's *Pay Attention,* which the collectors see as a key work. Whereas Nauman does not direct us to any particular meaning for his print, other artists, including Kara

Walker, provide a legible context: she places the racial violence of slavery directly before us. Artists' messages can also appear in the form of a forceful assertion of an artistic vision, like that found in Helen Frankenthaler's *Savage Breeze* or Donald Judd's four-part abstraction.

Nauman engages as much with the mechanics of language as with the meanings it generates. In concert with his unconventional approach to printmaking, his prints create an opportunity for a dynamic exchange with the viewer. Traditionally, an artist strives to have the image or text print in the "correct" orientation and therefore draws it in reverse on the matrix. From his very first experience in the printshop, however, Nauman approached this aspect of the medium as something to be queried. In *Raw-War* (fig. 5), for example, it begins with his choice of words: "raw" spelled backwards yields "war," war evokes a feeling of rawness, and the red letters reinforce the emotional impact of the words. In addition, Nauman reversed the "R" in war so that the word can be read as easily forward as backward, and he added an infinity-mirror effect by repeating it in yet another reversal behind the red version of the word. In effect, he created a multidimensional sculpture while paradoxically using the flattest printmaking technique.[2]

Pay Attention also commands its viewers' attention by virtue of its text, most shockingly because it addresses us obscenely with the term "motherfucker." We may not know the artist's

Fig. 5: Bruce Nauman, American, born 1941; *Raw-War*, 1971; lithograph; 22 ¼ × 28 ¼ in. (56.5 × 71.8 cm); 752:2020

precise intention, but the word choice ensures we know the force of that intention. Nauman strengthens his message by acknowledging the physicality of the lithographic process. The heavily articulated letters are messy around the edges, a sign of the greasy crayon and tusche he used to mark the stone. Some letters are echoed with a shadowy outline, and in the word "Attention" repeated layers of writing make the last five letters all but illegible.

The print grabs hold of you in a bodily as well as an emotional way. It removes you from your comfort zone, and makes you think and feel and question, "What am I not paying attention to?" The sculptural aspect of the print, the way the letters are turned backwards and given depth with shadows and repetitive marks, all contribute to this effect. What might be termed Nauman's sculptural thinking is evident throughout his two-dimensional output, including in the Museum's drawing *Love Me Tender* (fig. 6), which takes a potent but simple phrase and samples all of its possibilities ("Love Me Tender" becomes "Move te Lender" by the third line, and eventually "Lo vemete nder" in the last), as though it is a choreographic shorthand for an eccentric love dance.

ARTISTS IN THE STUDIO IN THE LATE 20TH CENTURY

For Bruce Nauman, the studio is a place for acting and thinking. He has stated that he doesn't want to make artworks "to be collected" but rather to investigate "the nature of what art can be."[3]

Catching the Moment includes artists who speak to their places and times but also question the conditions under which they produced their work. Nauman's challenging of traditional studio practices led him to take cues from his own body and daily life rather than the art supply store. In the 1950s, Jasper Johns remained tied to paint and canvas, but he had already begun to turn to a limited set of commonplace things, which soon became his visual syntax. Over and over, in a seemingly endless number of variations, he built his compositions out of letters, numerals, or crosshatches, as in *The Dutch Wives* (cat. 71). These are the building blocks for language, mathematics, and image-making, respectively. *The Dutch Wives*' title is unusual in Johns's oeuvre, however, in that it refers to a salty, off-color term for a board with a hole, or other surrogate for a sex partner.

Artists must develop their own relationship with printmaking, whether they work independently or with the numerous print publishers who have emerged in the United States in the post–World War II era. By the time she was in her early 20s, Helen Frankenthaler had broken the rules of easel painting by pouring liquid pigment onto unstretched canvases spread out on the floor. She worked with the printers at Universal Limited Art Editions on Long Island to make the monumental eight-color woodcut *Savage Breeze* (cat. 72). By 1974 she was already familiar with the routine of collaboration in the printshop, but she struggled to resolve this particular work, arriving at a solution only with the ninth trial proof: "I couldn't get the light I desired. . . . Then I thought—why don't we whitewash the paper first and then print the other colors I'd mixed over it. We did, and it glowed. I think at any other workshop, they might have thought it's impossible to do what the artist doesn't know she wants to do. But they were very patient, and, therefore, I found a solution."[4] Her reminiscence is as noteworthy for its ingenuity as it

Fig. 6: Bruce Nauman, American, born 1941; *Love Me Tender*, 1966; graphite; 38 × 25 in. (96.5 × 63.5 cm); Saint Louis Art Museum, Gift of Mr. and Mrs. Joseph A. Helman 109:1970

is for her taking full credit for the decision, portraying the printers as waiting for her to act.[5]

In the 1960s, Donald Judd, like many of his peers, deliberately abandoned painting, and he began developing a very specific vocabulary for sculptural form that regulated the rest of his output.[6] He continued to pursue printmaking alongside his sculptural work, and it originally hovered between painting and three-dimensional form, providing a launching pad from painting into sculpture.[7] In addition to *Untitled* (cat. 73), published by Brooke Alexander, the Simmons collection includes three early woodcuts that he began in 1961 in that moment of transition.[8]

Fig. 7: H. C. Westermann, American, 1922–1981; *Popeye and Pinocchio*, from the series *The Connecticut Ballroom*, 1976; woodcut; 24 × 30 in. (61 × 76.2 cm); 855:2020.5

For each of these artists, printmaking directly intersected with their work in other media and provided a vital language with which to express their strong artistic personalities. Judd's output was carefully circumscribed within his personal set of rules, and his prints matched that fastidiousness. For Johns, printmaking became a place to rethink problems initiated in his paintings. These works may appear to simply reproduce his paintings, but closer examination reveals a deeper pursuit that involves the transposition of an idea from one site of creation to another. Frankenthaler held onto control even as she consistently sought out the most experimental print workshops, where breaking the rules was paramount. For Nauman, finally, the inherent distance between the mark-making on the printing surface and the resulting print afforded a way to interrogate and redefine reversal, and provide a convenient remove between the artist and his public.[9]

ART IN THE COLD WAR

It is difficult to overestimate the impact of World War II, the atomic bomb, and the Cold War on life in the United States in the 1950s and 1960s. If anti-war sentiment is implied in the work

of Nauman and others of his generation, the effects of living through the early years of this era are unavoidable in the work of H. C. Westermann and Bruce Conner. Westermann, born in 1922, enlisted in the U.S. Marines in 1942, and his gruesome verbal and visual descriptions of his experiences, notably in World War II on the U.S.S. *Enterprise* in the Pacific theater, as well as in the Korean War in 1951–52, are ever present in his art. Conner, 11 years younger, recalled seeing government film footage of the 1946 nuclear tests at Bikini Atoll in a movie theater soon after they occurred. Later, when that footage became available, he created a body of work specifically using those films.

Westermann created a deep and complex narrative of the horrors of war in his prints, drawings, and sculptures, as well as in vividly illustrated letters that reference his experience as an active-duty marine. He was already making drawings before the war, but his art-school experience began afterwards, and he and his work retained an independent streak.[10] He insisted on making his sculptures by hand, including his 1972 *Dust Pans* (see cat. 59), and the same is true for his 1976 woodcut portfolio, *The*

Fig. 8: H. C. Westermann,
American, 1922–1981;
Deserted Airport N.M.,
from the series
*The Connecticut
Ballroom*, 1976; woodcut;
24 × 30 in. (61 × 76.2 cm);
855:2020.4

Connecticut Ballroom.[11] These prints incorporate some of his most enduring motifs that vividly evoke the callous devastation of war, such as the "death ships" inspired by the destructive impact of Japanese kamikazes and an eerie postnuclear desert landscape studded with downed planes (figs. 7 and 8).[12]

Although he wrote about kamikaze attacks he witnessed in the Pacific—including one that hit the *Enterprise* while he was on duty as a gunner—the visual language of Westermann's work is allegorical, not documentary.[13] His drawings and prints read like comics; the forms and details are simplified, and the colors are bright and expressive. His choice to print *The Connecticut Ballroom* on exquisite sheets of Japanese paper with its shimmering fibers, however, contrasts with the raw, cartoonish draftsmanship. This choice might be better understood in combination with his use of the color woodcut technique, which references the Japanese ukiyo-e print tradition, a borrowing particularly evident in *Deserted Airport N.M.*[14] Westermann, who initially signed up for war with a patriotic sense of duty, very quickly experienced the brutality of combat. Was his side-

wise reference to the Japanese print tradition a way of sympathizing with the enemy, who were victims of a war fought by common soldiers on behalf of a distant government machine?[15]

Although Westermann had signed up to fight in Korea despite his experience in World War II, when the Vietnam War came around, he was on the side of the protesters. For the younger Conner, the Cold War, and specifically the threat of nuclear war following the bombing of Hiroshima and Nagasaki, was defining for his consistently anti-war stance. *BOMBHEAD* (cat. 62) is one of many times he returned to the dramatic images of the first underwater nuclear test at Bikini Atoll on July 25, 1946. Most famously, in his 1976 film *CROSSROADS*, Conner collaged views of the blast filmed from a multiplicity of viewpoints by the military and combined them with two contrasting musical scores, played successively.[16] *BOMBHEAD*, printed and published in 2002 by Magnolia Editions in Oakland, replicates a 1989 collage in which Conner used a newspaper image of the 1946 mushroom cloud as the head of a figure in a military-style jacket and tie.[17] It captures the mushroom cloud

Fig. 9: Albrecht Dürer, German, 1471–1528; *The Four Horsemen of the Apocalypse*, c.1497–98; woodcut; 16 × 11 ⁷⁄₁₆ in. (40.6 × 29 cm); Saint Louis Art Museum, Gift of Berenice C. Ballard in memory of her father and mother Mr. and Mrs. James F. Ballard 836:1940

in a single instant, when its anthropomorphic "stem" looks like a long, skinny neck, and its "cap" resembles an imploding brain. Placing this "head" in a military uniform, Conner offered an indictment against the military perpetrators of the test in all its terrible yet mesmerizing beauty.[18]

TOM HUCK: CONFRONTING ART AND LIFE IN PRINT HISTORY

In Western Europe printmaking emerged in the 14th century and has served many purposes, sacred and profane, public and personal.[19] In part because of its varied and malleable functionality, the medium has historically teetered on the borderline between traditional high art, deemed to have aesthetic value, and low or popular art, deemed to lack aesthetic qualities. Since the 1950s

and 1960s, artists have increasingly eschewed the aesthetic even while producing "high art," prioritizing, among other things, ideas and action over traditional beauty.

Nauman's *Pay Attention* and many other prints in the Simmons collection fit this category, including Tom Huck's, though his approach and aesthetic are radically different from Nauman's. Huck openly engages with the early history of his medium, specifically the woodcut. The contrast between high and low is apparent in the powerful visual and verbal messages conveyed by 16th-century German woodcuts from the era of the Protestant Reformation, especially when compared with the prints of Albrecht Dürer (fig. 9), whom Huck claims as his artistic hero. Dürer's model is apparent in Huck's drive to establish himself as a self-published printmaker and technical innovator, but closer parallels to his subject matter can be found in Dürer's contemporaries, including his fellow Nuremberg artist Sebald Beham.

Beham's *Large Village Fair* of 1535 (fig. 10) is a model for Huck's work both in its large scale and subject matter.[20] In this nearly four-foot-long, multiblock woodcut, a broad array of suspect activity unfolds in a festive village scene, including a pickpocket robbing a dental patient, at left; a vomiting drunkard, at the center; and a violent brawl with knives and swords, on the right. In similar fashion, Huck's earliest large-scale woodcut, a triptych called *Snacktime Marcy* (cat. 82), is, if anything, even more densely packed with activity, some of it seemingly fun but much that is troubling. The story revolves around a diabolical toy—inspired by a real-life, malfunctioning "Cabbage Patch Kids" doll—the "Snacktime Kid" that "ate" plastic food but also consumed anything else that came close enough to its mechanical jaws, including children's hair. Three episodes roll out across Huck's three blocks: "Birthday Boy," in which the cross-eyed doll is introduced to an intense-looking family; "Marcy's Revolt," in which multiple Marcys are wreaking havoc, including gobbling the long locks of Girl #1, while a man with a sinister grin approaches with scissors; and "Burn and Kill," in which an avenging figure piloting a plane in a Viking helmet triumphantly holds aloft the heads of two decapitated Marcys.

Fig. 10: Hans Sebald Beham, German, 1500–1550; *The Large Village Fair*, 1535; woodcut from four blocks on ivory laid paper; 14 7/16 × 45 1/4 in. (36.7 × 114.9 cm); Art Institute of Chicago, Mr. and Mrs. Potter Palmer Collection Fund, 1967.491

Huck has channeled many other traditions of satire and caricature, including that of William Hogarth, James Gillray, Honoré Daumier, Max Beckmann, and George Grosz. Nonetheless, the range of responses elicited from contemporary viewers in both cases is strikingly similar. To be sure, it is impossible today to know what the response to Beham's woodcut was in his own time, but the large number of examples of this and similar images suggests they were in demand. The scholarship on the contemporary reception of these and other depictions of undesirable behavior, from Beham's woodcuts of the 1530s to engravings of similarly misbehaving peasants drawn from the work of Hieronymus Bosch and Pieter Bruegel the Elder in 1550s and 1560s Antwerp, to Dutch genre pictures a century later, is diverse and contradictory.[21] There is little agreement on whether viewers were supposed to be shocked, disgusted, or amused.

This confusion arises from the mixed messages presented in the images: activity that would otherwise be deemed inappropriate appears to be celebrated. In the 16th-century examples, it is clearly a lower-class public that is misbehaving, which would serve to legitimate the social order in which the owner of the woodcuts could feel superior to their erring lower-class compatriots.[22]

It is easy to criticize Huck for being juvenile, lewd, and sexist, and some of his work includes tougher examples than *Snacktime Marcy*—see, for example, the leering adolescent gaze in the central panel of *The Tommy Peeperz* triptych, *Ad Oculas* (fig. 11). But couldn't we understand him just as easily to be presenting us with humorous examples of human nature that we should not emulate but that make us simultaneously laugh and feel wise?

NEGATING RACIAL STEREOTYPES

Many contemporary artists address racism and racial stereotypes, and a variety of approaches to this subject can be found in the Simmons collection. Jaune Quick-to-See Smith, Enrique Chagoya, Roger Shimomura, and Kara Walker lean into offensive representations in order to reject them. Stereotypes are constructed by outsiders seeking to oversimplify a particular group of people; as targets of these misinterpretations, these artists repurpose outsiders' one-dimensional caricatures, in effect throwing them back at the dominant culture and, in the process, diffusing their power.

Jaune Quick-to-See Smith has addressed stereotypes of Native Americans for more than 50 years. Three of the prints she produced at Washington University School of Art Collaborative Print Workshop incorporate the phrase "40,000 Years of American Art." This expansive time frame confronts dominant and racist narratives that conceive of U.S. history as starting when Europeans arrived on the continent. Diverse civilizations inhabited the Americas long before contact with Europeans, which Smith acknowledges through her borrowing of imagery from petroglyphs, some of the earliest evidence of these cultures. She appropriated the rabbit figure in her prints from petroglyphs in Ontario, Canada.[23] The rabbit, a trickster in many Indigenous cultures, is at once intelligent, mischievous, and funny. The artist expresses these qualities through her work, revealing her own knowing and sly sense of humor that addresses serious issues.

Fig. 11: Tom Huck, American, born 1971; *Ad Oculas*, **central panel from *The Tommy Peeperz* triptych**, 2010–14; woodcut; 60 × 45 ¾ in. (152.4 × 116.2 cm); 724:2020b

Celebrate 40,000 Years of American Art (cat. 66) provides a useful framework for understanding challenges to accepted historical narratives that have neglected so many experiences and perspectives. Standard histories have traditionally been written from a European, settler-colonial, and predominantly male point of view, a hegemony that creates limited worldviews. Art often provides insight into different ways of thinking about the past, present, and future; the self; and experiences otherwise inaccessible to viewers.

Cowboys and Indians, Made in America (cat. 65), another collagraph by Smith produced at Washington University, depicts two figures wearing cowboy hats who point guns at each other. The title repeats a cliché of American popular culture, most evident in the genre of Western movies. Yet the two figures appear

the same, negating the differences suggested by the title. Smith underscores the humor of the piece in her strategic placement of the guns, which easily read as stand-ins for male anatomy. In this way, her print works to critique stereotypes of both "the West" and masculinity.

Similarly, Roger Shimomura uses humor and popular culture to confront trauma inflicted by racism by grappling with his family's experience in Japanese internment camps during World War II. Some of his print series address the racial slur that refers to Asian people as "yellow." The 18th-century Swedish taxonomist Carl Linnaeus was the first to propose racial categorization by four colors: red, yellow, black, and white.[24] During the civil rights era, marginalized groups co-opted these slurs to reclaim control; in one example, many Asian Americans united under the slogan "Yellow Power," though the term remains controversial today.[25] Shimomura uses bright lemon-yellow ink in works such as *Yellow Suite* (cats. 101–104), in which he presents the color in different contexts—both neutral (a piece of fruit) and offensive (the skin color of a grossly insensitive cartoon face). A white hand painting white over a yellow surface refers to "whitewashing," attempts to conceal facts and center whiteness, such as when a white actor portrays a character of a different ethnic background. *Zero* depicts the Mitsubishi A6M fighter jet flown by the Imperial Japanese Army during World War II. Together, the four images demonstrate the dangers of reducing identity to a color.

Shimomura's imagery often combines icons of Japanese and American culture. *Kansas Samurai* (cat. 100) and *Super Buddahead* (fig. 12) are both satirical self-portraits exploring what it means to exist between cultures. In the former, the artist references a 19th-century Japanese woodblock print, overlaying his signature round eyeglasses onto the painted face of a Kabuki actor. In the background, Popeye, Dagwood, Superman, Dick Tracy, Donald Duck, and Pluto appear to march away from Samurai Shimomura. The title references the artist's adopted home, where he taught at the University of Kansas for 35 years. In *Super Buddahead*, Shimomura substitutes a portrait of him-

self as a middle-aged man onto Superman's chiseled body, creating a cultural hybrid. The elongated vertical format of this print suggests Asian scrolls, and his surprising, even sacrilegious merging of Superman and Buddha brings together idealized icons from the West and the East.

Kara Walker's *The Keys to the Coop* (cat. 63) depicts a young girl chasing a decapitated chicken, whose head she holds to her open mouth. Viewers are made to feel uncomfortable, even disgusted, at both the sexualized violence and exaggerated racial stereotype. This work is a linocut but emulates the aesthetic of a silhouette cut from paper, a genteel 19th-century art form. Walker creates challenging images that force viewers to acknowledge the ways in which racism is built on a foundation of (mis)representations, such as slave caricatures.

Damon Davis takes a different approach to address race. His images of Black subjects are driven by an exploration of family photographs and an elaborate mythological narrative structure inspired by Yoruba religion. The Yoruba are a West African culture who trace their origins to Ile-Ife, an influential city-state that flourished from the 9th to the 12th centuries. Their Indigenous religion consists of hundreds of gods called orisha. Like deities in Greek mythology or the Hindu pantheon, each orisha has different characteristics and controls an aspect of nature. For his project *Darker Gods in the Gardens of the Low-Hanging Heavens*, Davis created his own pantheon of 12 deities, who preside over a universe parallel to our own. The Megadonna created all other deities and realms. As Davis explains, "Her eyes are the sun, the glow and warmth that nurtures the gods and their realms."[26] Shante is the river goddess and Andre is the god of vulnerability in masculinity. Davis represented each deity in manipulated photographs, two of which are in the Simmons collection.

Eyes of Diamonds, Teeth of Gold (cat. 24) and *The Garden and the Guardian* (fig. 13) depict the earth goddess O Ti O Tan. The artist describes her in a poem: "Beneath the soil she sleeps / Tar, soot, soul / Heat pressure coal / Diamonds are her eyes / Teeth made of gold." Davis's images work within the discourse of Afrofuturism, which imagines a Blackcentric past, present, and

Fig. 12: Roger Shimomura, American, born 1939; *Super Buddahead*, 2012; lithograph; 33 ½ in. × 13 in. (85.1 × 33 cm); 789:2020

Fig. 13: Damon Davis,
American, born 1985;
*The Garden and the
Guardian*, 2018; inkjet
print; 64 × 44 ⅛ in.
(162.6 × 112.1 cm); 552:2020

Fig. 14: Kiki Smith, American
(born Germany), born 1954;
Tailbone, 1993; bronze with
silver nitrate; 1 ³/₄ × 6 × 4 ¹/₄ in.
(4.4 × 15.2 × 10.8 cm); 829:2020

future completely liberated from race-based oppression, geno-cide, and derogatory representations by outsiders. The concept exploded in the popular imagination with the 2018 movie *Black Panther* but is rooted in literature by Zora Neale Hurston (1891–1960) and Octavia Butler (1947–2006), as well as cinema and music by Sun Ra (1914–1993) and P-Funk (active since the 1960s), among many others.

WRESTLING WITH RELIGION

Religion in contemporary art is rarely discussed, but it emerges as an important thread in often unexpected and nuanced ways. Work perceived by some as controversial reg-ularly makes headlines, perhaps creating the impression that religion and contemporary art are incompatible.[27] However, religion influences many artists' work subtly, and even the most polemical piece is more complex and multilayered than any initial surface impression.

David Wojnarowicz and Kiki Smith were both raised as Roman Catholics. They first met in 1981 and quickly became very close. While their aesthetics and preferences in materials and process are very different, both artists focus on the body as subject.

Wojnarowicz was pushed to express his rage against the right-wing Christian political forces that damned LGBTQ communi-ties and impeded solutions to the AIDS crisis in the 1980s. In contrast, Smith integrates Catholic iconography without taking a confrontational stance. She remains interested in how the spiritual and psychological manifest visually and physically.

Untitled (One Day This Kid . . .) (cat. 20) is perhaps Wojnarowicz's most transparently political work. In it he reproduces an elementary-school photograph of himself surrounded by an emotional text describing the ways the body is politicized and regulated by external forces. In the passionate yet detached narrative he writes, "One day this kid will begin to experience all this activity in his environment and that activity and informa-tion will compel him to commit suicide or submit to danger in hopes of being murdered or submit to silence and invisibility." In his text, Wojnarowicz expresses anger against the Church, clearly rooted in trauma over rejection and dissonance between theological teachings and his identity as a gay man.

Today, decades after the fact, it is easy to forget the callous and shocking treatment AIDS victims experienced, from total apathy

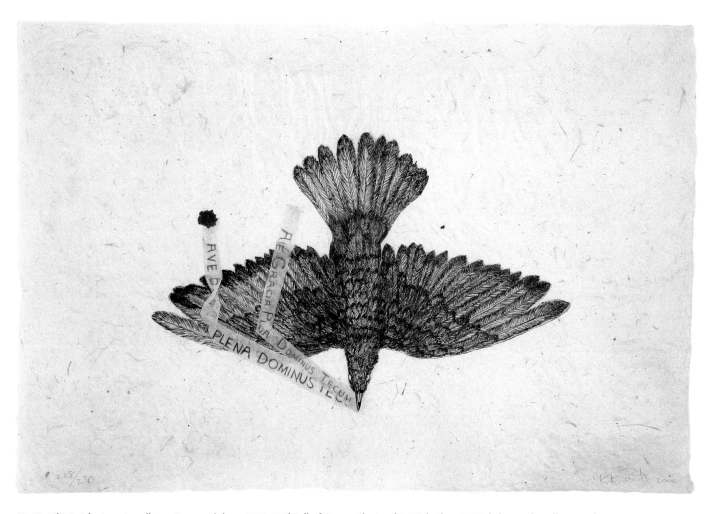

Fig. 15: Kiki Smith, American (born Germany), born 1954; *Hail Full of Grace, The Lord Is With Thee*, 2000; lithograph, collage, and wax stamp; 19 ¾ × 29 ½ in. (50.2 × 74.9 cm); 814:2020

and dismissal to loud political diatribes and flippant but painful remarks. Especially troubling to Wojnarowicz and his friends was the reaction of the Christian right. Smith, Wojnarowicz, Paul Thek, Peter Hujar, and many more in their circle were raised as Christians and taught that God loves everyone. Yet many people professing these same beliefs were also spewing hate, including toward AIDS victims. *Untitled (One Day This Kid . . .)* reflects the artist's inability to reconcile this hypocrisy. As the curator Dan Cameron explains, "his life story became a narrative of one man's attempt to transform the world's disdain into a powerful indictment against intolerance and apathy."[28]

For *Untitled (Face in Dirt)* (cat. 19), Wojnarowicz had himself buried in the dirt. Only a small part of his face is visible, as it

seemingly emerges from or sinks into the earth. While on a road trip with his photographer friend Marion Scemama, Wojnarowicz asked her to take this photograph of him in Chaco Canyon, an ancient site of ancestral Puebloan culture in New Mexico. By this time he had been living with AIDS for five years, and his visual art and writing reflect his thoughts on mortality. He wrote, "the first minute after being diagnosed you are forever separated from what you had come to view as your life or living."[29] Wojnarowicz died the year after this photo was taken. The image brings to mind the cycle of life as described in Genesis 3:19: "for dust you are and to dust you will return."

Direct Catholic references appear in many works by Kiki Smith, most prominently the Virgin Mary and Mary Magdalene. She

has cast life-size representations of both in bronze and plaster, with the standing figure holding her hands out to her sides. Smith has stated, "I'm a big Virgin Mary fan. I was raised Catholic. Lots of my work refers to the Virgin Mary." In a 2003 interview, she elaborated on her relationship with the religion:

> Catholicism and art have gone well together because both believe in the physical manifestation of the spiritual world—that it's through the physical world that you have spiritual life—that you have to be here physically in a body. You have all this interaction with objects, with rosaries and medals. It believes in the physical world. It's a *thing* culture.
>
> It's also about storytelling, in that sense, about reiterating over and over and over again these mythological stories, about saints and other deities that can come and intervene for you on your behalf. All the saints have attributes that are attached to them, and you recognize them through their iconography. And it's about transcendence and transmigration— something moving always from one state to another.
>
> And art is in a sense like a proof: it's something that moves from your insides into the physical world, and at the same time it's just a representation of your insides. It doesn't rob you of your insides, and it's always different, but in a different form from your spirit.[30]

Smith's bronze *Tailbone* (fig. 14) suggests relics, body fragments that are revered as sacred. Her lithograph *Hail Full of Grace, The Lord Is With Thee* (fig. 15) depicts a bird with a message. A streamer of collaged paper carried in its beak bears the Latin phrase "Ave Gracia Plena Dominus Tecum." Smith adapted a phrase ("Hail Mary, full of grace, the Lord is with thee") used by the angel in the biblical account to inform the Virgin Mary that she would give birth to Jesus Christ. Smith omits Mary's name, instead directing this message of God's arrival to all viewers. The red wax seal at its end connotes official origins, while Smith's choice of delicate papers lends a sense of ephemerality to the work.

In her sculpture, installations, and works on paper, Smith neither promotes nor criticizes Catholicism. The imagery and physical objects associated with Catholicism impacted her deeply, yet her position on religion remains ambiguous. Wojnarowicz and Smith do not create "religious art" but do reflect how many people have struggled with the role of religion in history, reconciling familial belief systems with lived experience, yet continue to be enamored by the spiritual.

ART WITH A MESSAGE

The Simmons collection includes many other examples of artists whose work reminds us of our own weaknesses as individuals and as a society, and that teach us about the ways history can inform the present. They often do this with humor and empathy, but they rarely spare us; we are meant to understand, and in the best of cases, to get with the program.

Art may not have the power to change minds, but it has a way of creeping into our consciousness and remaining there. Its visual language can help us to comprehend and process violence. In Westermann's work, it is the violence of war perpetrated by the enemy (Japanese kamikazes blowing up U.S. ships), whereas Conner gives us a means to examine the violence imagined by our own side (the atom bomb). The violence of racism is equally devastating, and Jaune Quick-to-See Smith is as direct as Nauman in her definition of American art as preceding European colonization by tens of thousands of years.

These artists, from Kara Walker to Damon Davis, Jaune Quick-to-See Smith to Enrique Chagoya, and Bruce Conner to Bruce Nauman, all manage to deal with contemporary issues in a way that fosters new traditions even while they borrow and build on existing precedents. That, arguably, is what makes the presence of the Simmons collection in the Saint Louis Art Museum so meaningful, and why it will continue to resonate among its new siblings and with viewers.

1 *Pay Attention* was printed and published in 1973 by Gemini G.E.L. in Los Angeles, a printshop that has been challenging artists to think big and explore beyond the traditional boundaries of printmaking since 1966. Nauman produced 53 editions there between 1973 and 1999. Gemini G.E.L. Online Catalogue Raisonné, accessed October 18, 2021, https://www.nga.gov/fcgi-bin/gemini.pl?view=page&artist=8&pubdate=&words=pay+attention&series=&catnum=&oldgem=&gemnum=&nga=&sort=2.

2 Lithography is a planographic technique, in which the image to be printed is level with the printing surface. This is in contrast to relief processes, in which the image is raised above the matrix, and intaglio processes, in which the image is carved out below the surface.

3 Michael Auping and Emma Dexter, *Bruce Nauman: Raw Materials* (London: Tate Publishing, 2004): 19n7; and Coosje van Bruggen, *Bruce Nauman* (New York: Rizzoli, 1988), 21.

4 Pegram Harrison, *Frankenthaler: A Catalogue Raisonné; Prints, 1961–1994* (New York: Harry N. Abrams, Inc., 1996), 198.

5 The use of a white, or light, base tone in printmaking has been common in lithography since at least the early 19th century. See also on its use in Chagoya's prints in the essay by Sophie Barbisan in this volume, 156–57.

6 Donald Judd, "Specific Objects" (1965), in Flavin Judd and Caitlyn Murray, eds., *Donald Judd: Writings* (New York: David Zwirner Books, 2016).

7 Rudi Fuchs in Jörg Schellmann and Mariette Josephus Jitta, eds., *Donald Judd: Prints and Works in Editions; A Catalogue Raisonné* (Cologne: Edition Schellmann, 1993), 7–9.

8 *Untitled*, 1961–78, woodcut with oil on verso, 739:2020 (Schellmann and Jitta, *Donald Judd*, no. 25); *Untitled (Print "G")*, 1961–67, woodcut, 740:2020 (Schellmann and Jitta, *Donald Judd*, no. 27); *Untitled*, 1961–75, two woodcuts, 738:2020a,b (Schellmann and Jitta, *Donald Judd*, nos. 28–29). For Schellmann and Jitta, *Donald Judd*, no. 25, see Elizabeth Wyckoff and Gretchen L. Wagner, *Graphic Revolution: American Prints 1960 to Now* (St. Louis: Saint Louis Art Museum, 2018), cat. 74.

9 "In printmaking . . . there is an added element of allowing the technique to be a buffer between me and the image. I like that, too—the mechanicalness of it. Sometimes, just because the image is reversed, there is a sense of removal, like I was left-handed." Interview with Christopher Cordes in Janet Kraynak, ed., *Please Pay Attention Please: Bruce Nauman's Words; Writings and Interviews* (Cambridge, MA: MIT Press, 2003), 340.

10 At the age of 16, he was offered a job at Disney Studios based on his submitted drawings; Lynne Warren, "Right Where I Live," in Michael Rooks and Lynne Warren, *H. C. Westermann: Exhibition Catalogue and Catalogue Raisonné of Objects*, exh. cat. (Chicago: Museum of Contemporary Art, 2001), 52.

11 About the *Dust Pans* he wrote: "I made each one of these by hand and by that I mean I did not sub-contract them to a factory or pay some guy to make them for me. Each handle was hand formed and not made on a lathe." Cited in Rooks and Warren, *H. C. Westermann*, 323. And he carved into the colophon block: "The Connecticut Ballroom. I drew the pictures, prepared the pine boards, carved them, + printed each picture with a barren + the back of a wooden spoon. The paper is Natsume #4007."

12 Dennis Adrian and Richard A. Born, *See America First: The Prints of H. C. Westermann* (Chicago: David and Alfred Smart Museum of Art, 2001), 152–55.

13 See David McCarthy, *H. C. Westermann at War: Art and Manhood in Cold War America* (Newark: University of Delaware Press, 2004), 100.

14 Westermann made numerous color lithographs of a similar scale to *The Connecticut Ballroom*, and a number of smaller black-and-white woodcuts, but the absence of any other color woodcuts reinforces his choice in this series.

15 McCarthy, *Westermann at War*, 69–73, discusses Westermann's gradual move from

volunteer marine to anti-war convert by the time of the Vietnam War, when his son followed him into the Marine Corps; see also Robert Storr, "The Devil's Handyman," in Rooks and Warren, *H. C. Westermann*, 17–19.

16 For example, a 1963 line drawing, *MUSHROOM CLOUD, 2313 E. KELLOGG ST. WICHITA, KS* (collection Jacqueline Humphries), illustrated in Rudolf Frieling and Gary Garrels, eds., *Bruce Conner: It's All True* (San Francisco: San Francisco Museum of Modern Art, 2016), 71, fig. 390, and three other digital prints produced at Magnolia Press in 2003: *PUFF*; *VIEW FROM BIKINI ATOLL*; and *BAKER DAY, JULY 25, 1946*.

17 The collage is *BOMBHEAD*, 1989, cut-and-pasted printed paper on printed paper, Museum of Modern Art, New York, 327.2018.

18 Magnolia Editions notes that the suit was worn by Conner in a photograph by Edmund Shea. They also mention Conner "accidentally hand painted the drop of blood on the atomic symbol on the tie with acrylic paint." Accessed August 30, 2021, https://www.magnoliaeditions. com/artworks/bombhead/.

19 For discussions of contemporary printmaking in historical context, see Christophe Cherix, "Print/Out," in *Print/Out: 20 Years in Print* (New York: Museum of Modern Art, 2012), 14–27.

20 Keith Moxey, *Peasants, Warriors, and Wives: Popular Imagery in the Reformation* (Chicago:

University of Chicago Press, 1989); and Allison Stewart, *Before Bruegel: Sebald Beham and the Origins of Peasant Festival Imagery* (Aldershot, UK: Ashgate, 2008).

21 For introductions to these debates, see Wayne Franits, *Dutch Seventeenth-Century Genre Painting: Its Stylistic and Thematic Evolution* (New Haven: Yale University Press, 2004); Walter S. Gibson, *Pieter Bruegel and the Art of Laughter* (Berkeley: University of California Press, 2006); Eddy de Jongh and Ger Luijten, *Mirror of Everyday Life: Genreprints in the Netherlands 1550–1700* (Amsterdam: Rijksmuseum, 1997); Elmer Kolfin, *The Young Gentry at Play: Northern Netherlandish Scenes of Merry Companies 1610–1645* (Leiden: Primavera Press, 2005); Moxey, *Peasants, Warriors and Wives*; Benjamin R. Roberts, *Sex and Drugs Before Rock 'n' Roll: Youth Culture and Masculinity during Holland's Golden Age* (Amsterdam: Amsterdam University Press, 2012); and Stewart, *Before Bruegel*.

22 Moxey, *Peasants, Warriors and Wives*, chap. 3. It is important to note that even if woodcuts were less expensive than either paintings or engravings, a large print like Beham's would have been out of reach of peasants.

23 Joan M. Vastokas and Romas K. Vastokas, *Sacred Art of the Algonkians: A Study of the Peterborough Petroglyphs* (Peterborough, ON:

Mansard Press, 1973), 133, pl. 26. On trickster characters, see Matt Dembicki, ed., *Trickster: Native American Tales; A Graphic Collection* (Golden, CO: Fulcrum Publishing, 2010).

24 Carl Linnaeus, *Systema naturae*, 10th ed. (Stockholm: Impensis L. Salvii, 1758). Linnaeus derived these categories from the "four humours": sanguine (blood), choleric (yellow bile), melancholic (black bile), and phlegmatic (phlegm).

25 See Kat Chow, "If We Called Ourselves Yellow," National Public Radio, September 27, 2018, https://www.npr.org/sections/ codeswitch/2018/09/27/647989652/if-we-called-ourselves-yellow.

26 Damon Davis, "Darker Gods in the Garden of the Low-Hanging Heavens." (St. Louis, MO: The Luminary, 2017). Exhibition brochure.

27 For example, *Piss Christ* (1987) by Andres Serrano and *The Holy Virgin Mary* (1996) by Chris Ofili.

28 Dan Cameron et al., *Fever: The Art of David Wojnarowicz* (New York: Rizzoli, 1998), 3.

29 David Wojnarowicz in Wojnarowicz and Lucy R. Lippard, *David Wojnarowicz: Brush Fires in the Social Landscape* (New York: Aperture, 1994), 18.

30 Kiki Smith, "Learning by Looking—Witches, Catholicism, and Buddhist Art," https://art21.org/ read/kiki-smith-learning-by-looking-witches-catholicism-and-buddhist-art/.

Elevating Doodles, Obfuscating Clarity

Liliana Porter, Robert Gober, and Enrique Chagoya

Clare Kobasa

The collection of Ted L. and Maryanne Ellison Simmons provides rich ground for the exploration of printmaking practices in the United States from the 1960s to the present, as the contemporary artists represented showcase a wide range of approaches.[1] Liliana Porter, Robert Gober, and Enrique Chagoya, for example, engage with the communicative potential not just of printmaking but of printed matter itself. In different ways, these artists upend expectations of narrative reliability and structure. Their printmaking is informed by practices, or at least habits, of collecting, whether the objects are tchotchkes, scraps of paper, or images from historic documents and popular culture. These artists are attentive to how objects circulate in the world, which shapes their technical and conceptual handling of their prints. The technical challenges of printmaking, which raise issues of replication, reproduction, multiplicity, and authority, invite collaboration. Chagoya, Porter, and Gober all work with printer-publishers to bring their visions into existence, whether in lithography, wood engraving, intaglio, or a combination of methods. These investments in collaborative work shape the relationship between thought and process; the printer, in some way, is the first viewer. And the narratives each artist communicates are very conscious of a viewer.

All three are thinking about existing texts, images, and objects and the narratives they invite. By reengaging these in print, they participate in a long tradition of printmaking that insists on understanding a work's creation and function in relationship to the source material.[2] Prints can be made in multiples, which allows the same image to circulate, setting up a wider network of conversation by the promise of shared encounter.

LILIANA PORTER

Liliana Porter works across media, but printmaking plays a fundamental and continuing role in her practice, particularly in her investigations of the links between objects, viewers, and artworks.[3] She learned printmaking in her birthplace of Buenos Aires and continued to explore the medium in Mexico City, where her family moved when she was 16. After arriving in New York in 1964, Porter, along with Luis Camnitzer and José Guillermo Castillo, helped found the New York Graphic Workshop (NYGW), a pioneering print collective.[4] The NYGW emphasized conceptual ideas, like the correlation between multiplicity and market value, over technical proficiency. Their artistic process did not just encompass the making of prints; it extended to the acts of publishing and distributing them as well. In so doing, they invited artists and viewers to think more critically about the systems in which such pieces circulated and to create new ones.

Porter continued to incorporate printmaking into her art with a focus on its potential reception. She presented the works as objects to be set into motion or interacted with, for example

Fig. 16: Liliana Porter,
Argentine, born 1941;
Mail Exhibitions, 1969;
one of four offset prints
and envelopes; card:
4 ¹/₄ × 5 ³/₈ in. (10.8 × 13.7 cm),
envelope: 5 × 6 in.
(12.7 × 15.2 cm)

by instructing the viewer to crumple a sheet of paper printed to look already crumpled or to add an olive to its printed shadow (fig. 16). She began to conceive of printmaking as gestural on the part of the viewer, and, when she sent work directly through the mail, she saw the viewer as recipient. This shift in the significance of the artist's activity onto that of the viewer reoriented the supposed "completion" of the piece.

The Simmons collection includes three works by Porter that show her wit and sometimes disorienting sense of play: *Disguise* and *The Traveler*, both lithographs with collage made at the Tamarind Institute in New Mexico, and a small sculpture, *To Fix It (Wall Clock II)* (cats. 32, 33, and 31). June Wayne founded Tamarind Lithography Workshop in Los Angeles in the 1960s with the goal of reinvigorating lithography in the United States.[5] The workshop moved to the University of New Mexico in

Albuquerque in 1970 and changed its name to Tamarind Institute. By the time Porter arrived in 2000, she had spent almost a decade focusing on small figurines that she had collected. She was inspired by these toys and other objects, which she then used in her photography, film, paintings, and installations.[6] *The Traveler* and *Disguise* are the first examples of her use of toys in her prints. Porter's work at Tamarind continued her earlier explorations of reproduction and presence in printmaking. She focused less on technical manipulations of the lithograph itself; instead, the figurines challenge the expected flatness of the print and introduce new perceptual horizons.

Disguise features two rabbits on lined notebook paper laid side by side; on the right-hand sheet, the rabbit is masked with a three-dimensional tiger's head that has been attached to the image. By disguising itself as a tiger, the rabbit hides in the per-

136

Fig. 17: Liliana Porter, Argentine, born 1941; *Oh, #I and #II,* 2002; woodcut with litho chine collé; 30 × 22 in. (76.2 × 55.9 cm)

sona of a bigger, stronger animal. From whom or what, though, is it hiding? In Porter's work, the rabbit represents vulnerability. In *Oh, #I and #II* (fig. 17), a more menacing tiger confronts a small rabbit in a display of strength. The power dynamic demonstrated between the masked figure—the rabbit—and the mask chosen—the tiger—suggests the significance of external relationships or perceptions in shaping choice about self-presentation. The rabbit in *Disguise* appears to be drawn with a marker onto notebook paper. Its shape is slightly subversive, as it cuts across the lines of the page, which also set up a narrative direction. We "read" the sheets from left to right, and the rabbit "puts on" the head of the tiger between one image and the next.

The Traveler features a figurine of a small man holding a picnic basket, who is positioned on the sheet between two short lines

that look as if they have been drawn in pencil. These lines indicate that he is following a path, a narrative expectation emphasized by the title. Where he is going or where he has come from is not indicated. Here, Porter again plays with a recurring motif. The traveler also appears in a 2013 drawing in which the figure's path, this time drawn in graphite, crosses multiple sheets of notebook paper (fig. 18). In that work, the paper serves as the support for the path that curves and turns back in on itself, inviting the traveler to follow the trace of the artist's hand. In *The Traveler*, the bright white of the paper reads as emptiness, and the sparse print instead leaves the path open for the viewer. As Porter characterized it, "At this point I know that white space is essential in my work. It takes the object out of any and all contexts and temporalities. I don't know if this is entirely possible, but I'm trying to eliminate the distraction between 'oneself' and the thing."[7]

Fig. 18: Liliana Porter, Argentine, born 1941; *Traveler*, 2013; graphite and figurine on paper; 24 ³/₄ × 37 ¹/₂ in. (62.9 × 95.3 cm)

With the addition of a three-dimensional object to the print, Porter's interest in whiteness as space rather than flatness or support prompts the question of what is real and what is an image. She turns surface into space. In these two prints, space can extend both narratively and dimensionally, and is limited only by the marks of a finished work—the date, title, and signature. The lithograph approaches something like a stage set, one that both dictates and invites the play of narratives that commences with the addition of an object.

For Porter, collage becomes a means of combining and recontextualizing objects to challenge the viewer's expectations, both of the collected objects she incorporates and their setting. This is seen in her prints and other work. In her sculptural assemblage *To Fix It (Wall Clock II)*, a tiny man among the metal gears and hands of a clock is overwhelmed by the challenge of its repair.

This assemblage draws attention to the role of anticipated movement in the prints. The fixity of the three-dimensional objects—whether the gears, the empty space, or the mask—contrasts with their potential for action. The men seem mobile; the mask could move from side to side. They do not, of course, but the dimensionality of the added elements provides an expectation of what might come next.

This sense of open-ended storytelling rather than a predetermined narrative emerges in Porter's often-humorous engagement with the meaning inherent in the toys. Her dialogues recognize each of those stories but also set them off in new directions tinged with playfulness. Referencing her shift toward setting up deliberate encounters between the figures in her work, Porter remarks, "I think the humor came about unconsciously. Confrontations between objects, even when they are

138

Fig. 19: Robert Gober, American, born 1954; *Untitled*, 2010–11; photoetching on copper, hand-printed on Shikoku paper, hand-distressed; printed by Rob Swainston at Prints of Darkness, Brooklyn, NY; published by Skowhegan School of Painting and Sculpture, Madison, ME; 1 1/4 × 1 3/4 in. (3.2 × 4.4 cm); 614:2020

old objects, occur in the present, while in my previous paintings it seemed that the elements couldn't extricate themselves from the past."[8] The objects engage with the surface to mark a distinction between the real and the represented. In her photos of toys against white backgrounds, the dimensionality of the space is captured or reflected. In prints, that space is not represented but becomes continuous with that of the viewer. This continuity introduces a distinction between a sense of movement and a sense of directionality in her work. In fact, that loss of instruction turns the viewing experience back in on itself. She does not tell you where to go, but softens the potential disturbance found in that lack of direction.

ROBERT GOBER

Robert Gober's work is represented in the Simmons collection by a wood engraving and four intaglio prints. Made between 2000 and 2011, the subjects are easily identifiable at a glance: a receipt, torn corners of newspapers and magazines, an advertisement. However, Gober has reproduced them in such a way as to recast the viewer's expectations of the seemingly trivial by elevating the

crumpled paper into sculptural form as the edges of image and object overlap. Like Porter, Gober is also a collector, in his case of scraps. He works primarily on sculptures and installations, and first gained notice in the 1980s with a series of sinks that channel the intimacies and precarities associated with cleanliness.[9] From carefully constructed dollhouses to wax legs, bags of cat food, and cellar doors, Gober subtly recreates the familiar. In his installations, the interactions between such pieces require the viewer to pay attention to the nuances of meaning.

Gober's prints reflect this same dedication to manufacture, and they raise questions about the bounds of context, evoking as they do the site of their sources' collection, the space of the print workshop, and the eventual location for display. *Monument Valley* (2007), a wood engraving printed on Legion interleaving paper, fastidiously reproduces a receipt from a visit to a national park he made during a cross-country trip in 2006 (cat. 30).[10] A portfolio of three intaglio prints on paper made by Meagan Moorhouse at Dieu Donné (a specialized paper workshop), all untitled, were created as a fundraiser and as part of

Gober's installation for the American Pavilion at the 2001 Venice Biennale (cats. 27, 28, and 29).[11] They include an advertisement for cat-sitting services and two partial clippings, one from a 1998 *New York Times* article entitled "Bomb Suspect's Brother Mutilates Himself," and the other from a *New Yorker* column, "The Political Scene," with the quote, "the different variations nature plays on the theme of human existence will delight, not frighten, us." Finally, *Untitled* (2010–11) is a photoetching of a 2005 newspaper clipping from the *New York Post*'s police blotter under the heading "Brooklyn" (fig. 19).

In these prints, Gober does not return to the media that produced the source texts but rather transforms them into images using ones that capture their look. Gober chose techniques that offer precise replication with little trace of the line associated with etching, engraving, or even woodcut. The nature of the print technique is less important to Gober than making an object that passes for another and, as in these prints, has a different level of permanence. This predicted longevity is a result of both their materials' physical durability (at least in comparison with their sources) and how they are ultimately collected because of that transformation: as framed artworks by Robert Gober. Consistent with Gober's studio-based, collaborative approach, he sought out quality raw materials and experienced printmakers for these projects. The printing took place with Leslie Miller at The Grenfell Press for *Monument Valley*, Todd Norsten for the Venice Biennale portfolio (both self-published), and Robert Swainston at Prints of Darkness in Brooklyn for *Untitled* (2010–11), which was published as part of a portfolio to support the Skowhegan School of Painting and Sculpture. For Gober, making is about a conviction in crafting rather than a display of trompe l'oeil, a concern with the made-ness of the thing rather than a delight in the trick.

The printing technique and the paper offer these prints increased stability over the original sources and challenge the expectations of ephemerality suggested by the subject. Gober deliberately and uniformly introduces the tiniest of tears and rips in all impressions of an edition in a mimicked preservation not only of the source object but also of the transformations that mark it as read, crumpled, and consumed. He also either produces or designs the frames, emphasizing the presentation of the scraps. When framed and hung on a wall, the crumpled prints cast shadows made more prominent by their vertical orientation. The prints become strange through the importance granted to their familiarity. Gober's prints call attention to histories of use and interaction with printed materials with all their disposability and ubiquity. This question of context is more clearly dictated for the Venice Biennale portfolio. In 2001, Gober represented the United States with an installation that evoked the fragility of memory, material consumption, and the human body. Two of the three prints were presented in multiples: two impressions of the *New York Times* article and four impressions of the cat-sitter advertisement. The multiplicity of print was made visible on the wall in the display, presenting that understood condition of the print—there is more than one—explicitly to the viewer. Such visibility presents multiplicity as another factor to be manipulated by the artist rather than as an intrinsic quality of the work.

Gober recalled meeting Alice Neel in art school, where she "[told] them that they will never be good artists unless they read the newspaper and know what is going on in the world: 'a piece of advice that I still take to heart.'"[12] The newspaper and, more broadly, mass media, become source and subject in several of his prints. Earlier explorations of the newspaper form included folded stacks of newspapers wrapped in twine. Unlike the approach described here, in those works Gober combined disparate articles and advertisements, or created entirely new content, thus exerting an artistic presence through invention rather than selection. Here Gober's fidelity to the source material facilitates identification with the origin of the information based on the typeface, whether of the *New York Times* or the *New Yorker*. The receipt and the hand-lettered sign are both more ubiquitous. Typeface thus marks a division, one based on previous knowledge or familiarity with the sources that tracks with a particular kind of media consumption associated with socioeconomic status and education. Again, the seeming disposability of his subject matter necessitates further thinking about the privileging of visible modes of communication.

The expansion of newspaper and media distribution transforms the opportunities for people to gather information about the world. In doing so, communities of writers and readers can shift the borders of knowledge and the kinds of narratives thought worthy of circulation. These are the materials that are often used to write histories. Gober's receipt for Monument Valley Navajo Tribal Park is a link to a memory, whereas the others are scraps of paper that caught his attention. There is something intensely personal about this collection, but by sourcing it from materials widely available, Gober also evoked the broader publics in which these types of texts circulate. The prints invite reflection on how we narrate our lives, what texts and objects get through, and which are overlooked or rendered irrelevant. These prints are not found objects; they are saved and created objects. Their existence, while dependent on a receipt or a scrap of paper, is due to a process of making that isolates the unpredictability of their sources' circulation by presenting them as works of art. Receipts, newspaper clippings, and street advertisements are often disposable, both because of their function and quality of materials, but Gober's transformation of them into prints extends that lifetime in a different sphere.

The texts are legible but not complete, giving us at least a clue to their sources. The *New York Times* article includes the title, while the *New Yorker* clipping features only the top section of a column begun on a previous page. The blotter, too, is edited from a longer list. In all three, the combination of the positioning of the piece on the original page and the cropping by Gober results in a deliberately pruned offering. The question of attention is primary here. Like Porter, Gober, by thinning out the overwhelming mass of potential inputs, directs our focus to the commonplace, not in the sense of the ordinary, but in the sense of offering a shared experience, one that he curates.

While Gober celebrates or at least acknowledges printmaking as a medium productive for its communicative potential, his approach to printmaking rethinks the technical strategies linked to this quality as he substitutes complete narrative accounts with wrinkled, torn bits that have been remade for a new, critical context of consumption and display.

ENRIQUE CHAGOYA

As a child, Enrique Chagoya was captivated by the various forgeries of international currency that his father, who worked for a bank, kept in the office.[13] This identification of the medium with its potential to tell a counternarrative—one that was convincing in its appearance but held a tenuous relationship to its source—appears in many of Chagoya's print projects.[14]

One example of this engagement is the artist's responses to Francisco José de Goya y Lucientes (1746–1828), starting in 1987 with prints after Goya's *Desastres de la guerra* (1810–20, published 1863) and continuing with individual prints and series such as *Los Disparates*, printed at Kala Art Institute in 2015 (after Goya's series of the same title of c.1815–19) (figs. 20 and 21). The Spanish painter and printmaker Goya was celebrated for his perceptive take on the social upheavals of 18th- and 19th-century Spanish life.[15] Chagoya describes a fascination both with Goya's sharp visual commentary and the tangibility of ink in his etchings and aquatints, which he first encountered during a visit to the Achenbach Foundation for Graphic Arts at the Fine Arts Museums when he was a student at the Art Institute of San Francisco.[16] Chagoya attempted to replicate that technique and feel of the print while inserting his own voice into contemporary social, political, and artistic discourses. The bulls of Goya's Spain intermingle with Jeff Koons's balloon dogs (first released in 1993). He committed to the role of the artist as commentator and critical eye on the priorities of the present, and as a counter to the people who enact violence and do harm in society. By aligning himself with Goya's distinguishable style, he investigates the "how" of asking someone to pay attention—in this case, by making an argument that traditions of recognizable mark-making can convey both meaning and authority.

This interest in prints of the past and visual means of communication also extends to works that Chagoya painted onto pages from the 1890 Spanish-language edition of an 1886 American portfolio, *La Galería Internacional* (*The International Gallery*), featuring biographical sketches and reproductions of works by famous European artists. Chagoya adopts the titles

6/30

Fig. 20: Enrique Chagoya, American (born Mexico), born 1953; *Disparate de toritos* (*Little Bulls' Folly*), from the series *Los Disparates*, 2015; etching, aquatint, and rubber stamp; 16 ⁵/₁₆ × 19 in. (41.4 × 48.3 cm); 500:2020.1

of the paintings for his own works, such as *The Marriage of St. Catherine* (cat. 44). This spread features an engraving of Anthony van Dyck's c.1630 painting of that subject; the adjacent page begins a description of the painting with a biography of the artist. Chagoya intervened with paint and transfers, obscuring much of the text with a skull wearing a nun's coif and veil, labeled "La Santa" or "The Saint." His interest here is not technical but conceptual: how do these prints contribute to a narrative of canon formation, and what can an artist do to disrupt that account? He uses the printed portfolio as the surface on which to build; instead of collecting sources to adapt them, here they are submerged. By manipulating the very surfaces that privileged and transmitted knowledge about art history and making, Chagoya elevates the classroom doodle to obfuscate the clarity of those supposedly established messages.

Fig. 21: Francisco José de Goya y Lucientes, Spanish, 1746–1828; *Little Bulls' Folly*, from the series *Disparates*, c.1815–19, published 1877; etching, aquatint, and drypoint; 11 ⁵⁄₈ × 17 ¹⁄₁₆ in. (29.5 × 43.3 cm); The Metropolitan Museum of Art, New York, Bequest of Grace M. Pugh, 1985; 1986.1180.900

Pursuing another vein of this concern with the role of image-making in the telling of history, Chagoya embarked on a remarkable series of works in 1992: codices in the model of those made in Mesoamerica before the colonial violence that ruptured memory and tradition by the eradication of drawn and written records.[17] Following their targeted burning, only about a dozen preconquest codices are known, and almost all are held outside the communities in which they were originally produced.[18] Spanish colonizers pursued their destruction after the fall of Tenochtitlán in 1521, motivated by a concern with societal integration and determined to quash any alternative to the hegemonic approach to government, religion, and culture that they introduced.[19] Chagoya brings this conversation into the present by surfacing the instability of historical enterprises, whether

based on texts or images, and the loss that occurs when a society's own accounting is erased or, in the best case, displaced. Chagoya has returned to the codex format, an accordion screenfold, over many years; the 14 codices in the Simmons collection include *El Regreso del Cannibal Macrobiótico* (cat. 52), *Escape from Fantasylandia: An Illegal Alien's Survival Guide* (fig. 22), *Illegal Alien's Meditations on el Ser y la Nada*, and *La Bestia's Guide to the Birth of the Cool* (cat. 53). Bud Shark, of the printer-publisher Shark's Ink, took on the challenge of printing the codices on amate paper made from the bark of fig trees, one of the traditional codex supports.[20] Amate paper's rough texture and its tendency to expand under pressure required adaptations; Shark ran the paper through the press multiple times and sometimes reinforced the surface with gesso or chine collé. The

original Mesoamerican codices would have been handwritten and painted, but much of the source material that Chagoya draws on in his compilations was printed. Chagoya's introduction of the codex into the world of print maintains a link to those sources through their making, but his repositioning of the images and their meaning throws into question any presumed authority of that medium.[21]

Each codex tells a story about Chagoya's own process of historical engagement alongside the personal, communal, and political nature of narrative. Many respond to specific contemporary events that feature in the news (immigration, economic collapse, natural disasters), but Chagoya's visual approach is to combine direct references with images that evoke the ongoing nature of the disruptions that subject populations to exploitation and disaster. In *Escape from Fantasylandia: An Illegal Alien's Survival Guide*, for example, a watery-looking plumed serpent, the Mesoamerican deity Quetzalcoatl, extends along the entire length of the codex when unfolded. Below, Chagoya intermingles illustrations from the 1792 book by the Franciscan priest Joaquín Bolaños, *La portentosa vida de la Muerte* (*The Astounding Life of Death*), with Mayan hieroglyphics, Japanese cartoons, and U.S. dollars.[22] *Escape from Fantasylandia* also contains percentages and other indicators that refer to the economic collapse, while cartoon characters take on the role of updating the historic imagery. Reading from right to left, the

codex begins with a title page that features Bolaños's skeletal queen of death, whose face is replaced by that of Lois Lane (a DC Comics character who works as a journalist and is Superman's love interest).[23] The scene is overlaid with imagery taken from the Madrid Codex—a likely 15th-century Mayan collection of almanacs and ritual practice—including a scene representing a New Year's ceremony with a deity, a turtle, and Mayan glyphs.[24] The golden outline that frames each panel is also a borrowing from the Madrid Codex. The interweaving of these meditations on ritual time, death, and narrative format draw attention to the establishment of both norms and subversions in cultural production, and the mutual illegibility not only of individual images but also of motivation.

The codex format's association with book history creates a context for understanding the images Chagoya gathers from a seemingly haphazard variety of sources. The promise of knowledge he reveals in this format is counter to the logic of unfolding narrative and instead focuses on vignettes, capturing moments of encounter that redefine an established dynamic. In printed form, Chagoya maintains the style or technique in which his source images were originally presented; the disjunctures of the sources are not material but communicate a visual history of making and consumption. The relationships are meant to unsettle, to be provocative and humorous. Some images will be more legible than others to viewers, and Chagoya

Fig. 22: Enrique Chagoya, American (born Mexico), born 1953; *Escape from Fantasylandia: An Illegal Alien's Survival Guide*, 2011; lithograph with gold metallic powder on amate paper; unfolded: 9 ½ × 80 in. (24.1 × 203.2 cm); 468:2020

challenges us: Which references do you understand, and what does that say about your own awareness and knowledge of historical narratives?

In using images from the canon of European art or American consumerist media, Chagoya's deliberate unreading and mystifying of those images denies them the locus of power that they have long held. Chagoya's project is not intended to convey specific messages about historic Mesoamerican culture; instead, he presents the broad existence of a more multifaceted history than has generally been recognized. Chagoya's own practices of collecting images inform the creation of these works. The process of selection becomes a visible manifestation of the artist's hand. The dislodging and layering of images results in an accretion that invites the viewer to understand the component images relationally. Chagoya has termed his practice "reverse anthropology" or "reverse modernism," a reorientation of who feeds on another society or culture's production, but one that ultimately maintains the practice of consumption.[25] The pain of the exploitation that necessitates this reorientation is also met by the humor that Chagoya evokes, a creeping awareness that what was familiar may not have been so comfortable after all.

Porter, Gober, and Chagoya all turned to printmaking in conceptually creative ways, putting the practice in direct conversation with other means of making and communicating (about) images. Their varied engagement with the technical sides of the process results in a transformational sense of what print does to an object, a text, or an image, such that the resulting work maintains a tension related to their material identity. All three of these artists negotiate the potential offered by print and printmaking in relationship to concerns about space—the space of the composition and the space the resulting object takes up in the world. By drawing attention to the sheet, the piece of paper, or the book, Porter, Gober, and Chagoya shift the perception and interpretation of the found and manipulated materials upon which they draw. Toys, receipts, cartoons, newspapers, and historic sources all reorder our relationship to artmaking through the work of these three artists; the prints function as a means of challenging our sense of the variety and multiplicity of what we encounter or ignore on a daily basis. As in a collection of works of art, an artist's collection reflects their own priorities and interests, and success lies in convincing us they should be our priorities, too.

1 Jennifer Roberts, "Contact: Art and the Pull of Print," The 70th A. W. Mellon Lectures in the Fine Arts, Center for Advanced Study in the Visual Arts, 2021, https://www.nga.gov/research/casva/meetings/mellon-lectures-in-the-fine-arts/roberts-2021.html; Ruth Pelzer-Montada, ed., *Perspectives on Contemporary Printmaking: Critical Writing since 1986* (Manchester: Manchester University Press, 2018); and Susan Tallman, *The Contemporary Print from Pre-Pop to Postmodern* (New York: Thames and Hudson, 1996).

2 Peter Parshall, "Imago Contrafacta: Images and Facts in the Northern Renaissance," *Art History* 16, no. 4 (1993): 554–79; and William Ivins, *Prints and Visual Communication* (Cambridge, MA: Harvard University Press, 1953).

3 Liliana Porter, Inés Katzenstein, and Gregory Volk, *Liliana Porter: In Conversation with Inés Katzenstein* (New York: Fundación Cisneros/Colección Patricia Phelps de Cisneros, 2013); and Florencia Bazzano-Nelson, *Liliana Porter and the Art of Simulation* (Aldershot, UK: Ashgate, 2008).

4 Gabriel Pérez-Barreiro, Ursula Davila-Villa, and Gina McDaniel Tarver, eds., *The New York Graphic Workshop, 1964–1970* (Austin: Blanton Museum of Art, the University of Texas at Austin, 2009).

5 Marjorie Devon, Bill Lagattuta, and Rodney Hamon, *Tamarind Techniques for Fine Art Lithography* (New York: Abrams, 2008); and Marjorie Devon, ed., *Tamarind: 40 Years* (Albuquerque: University of New Mexico Press, 2000). See also cat. 61, Bruce Conner's commentary on Wayne's impact.

6 David Getsy, ed., *From Diversion to Subversion: Games, Play, and Twentieth-Century Art*, Refiguring Modernism (University Park: Pennsylvania State University Press, 2011).

7 Porter, Katzenstein, and Volk, *Liliana Porter*, 40.

8 Porter, Katzenstein, and Volk, *Liliana Porter*, 70.

9 Ann Temkin, ed., *Robert Gober: The Heart Is Not a Metaphor* (New York: The Museum of Modern Art, 2014); Theodora Vischer, *Robert Gober: Sculptures and Installations, 1979–2007* (Göttingen: Steidl, 2007); and Brenda Richardson and Robert Gober, *A Robert Gober Lexicon* (Göttingen: Steidl, 2005).

10 Leslie Miller and David Storey, "Voices in Print: Grenfell Press," *Art in Print* 6, no. 1 (2016): 31–35; and Robert Gober, Brad Epley, and Jan Burandt, "Robert Gober," Artists Documentation Program, April 18, 2013, http://adp.menil.org/?page_id=830. See the essay by Sophie Barbisan, this volume, 150–51.

11 Eva Kernbauer, "Arbeiten an der Symmetrie. Robert Gobers US-Pavillon an der Biennale von Venedig 2001," *Zeitschrift für Kunstgeschichte* 75, no. 4 (2012): 547–66; and Robert Gober, James Rondeau, and Olga M. Viso, *Robert Gober: The United States Pavilion, 49th Venice Biennale, June 10–November 4, 2001* (New York: D.A.P., 2001).

12 Temkin, *Robert Gober*, 112.

13 Jennifer Samet, "Beer with a Painter: Enrique Chagoya," *Hyperallergic* (blog), August 20, 2016, http://hyperallergic.com/318318/beer-with-a-painter-enrique-chagoya/; and Enrique Chagoya and Paul Karlstrom, "Oral history interview with Enrique Chagoya," Archives of American Art, August 25, 2001, https://www.aaa.si.edu/collections/interviews/oral-history-interview-enrique-chagoya-12495.

14 Patricia Hickson, ed., with Daniela Pérez and Robert Storr, *Enrique Chagoya: Borderlandia* (Des Moines, IA: Des Moines Art Center, 2007); Geno Rodriguez, Moira Roth, and Enrique Chagoya, *Enrique Chagoya: When Paradise Arrived* (New York: Alternative Museum, 1989); and Blanca de la Torre, *Palimpsesto caníbal* (Vitoria-Gasteiz: Artium, 2013).

15 Mark P. McDonald, with Mercedes Cerón-Peña, Francisco J. R. Chaparro, and Jesusa Vega,

Goya's Graphic Imagination (New York: The Metropolitan Museum of Art, 2021).

16 Sarah Kirk Hanley, "The Recurrence of Caprice: Chagoya's Goyas," *Art in Print* 3, no. 2 (2013), https://artinprint.org/article/the-recurrence-of-caprice-chagoyas-goyas/.

17 Maarten E.R.G.N. Jansen, Virginia M. Lladó-Buisán, and Ludo Snijders, eds., *Mesoamerican Manuscripts: New Scientific Approaches and Interpretations* (Leiden: Brill, 2019); Sarah Kirk Hanley, "Visual Culture of the Nacirema: Chagoya's Printed Codices," *Art in Print* 1, no. 6 (2006), https://artinprint.org/article/visual-culture-of-the-nacirema-chagoyas-printed-codices/; and Enrique Chagoya, "A Lost Continent: Writings Without an Alphabet," in Virginia M. Fields and Victor Zamudio-Taylorm, *The Road to Aztlan: Art from a Mythic Homeland* (Los Angeles: Los Angeles County Museum of Art, 2001), 262–73.

18 The Centre for 21st Century Humanities, The University of Newcastle, Australia, "Precolumbian Codices Overview," accessed August 31, 2021, https://c21ch.newcastle.edu.au/treeglyph/codices.php; and Maarten Jansen and Gabina Aurora Pérez Jiménez, "Renaming the Mexican Codices," *Ancient Mesoamerica* 15, no. 2 (2004): 267–71.

19 Galen Brokaw and Jongsoo Lee, eds., *Fernando de Alva Ixtlilxochitl and His Legacy* (Tucson: University of Arizona Press, 2016); Alvaro Félix Bolaños and Gustavo Verdesio, eds., *Colonialism Past and Present: Reading and Writing about Colonial Latin America Today* (Albany: State University of New York Press, 2002); Serge Gruzinski, *Images at War: Mexico from Columbus to Blade Runner (1492–2019)* (Durham, NC: Duke University Press, 2001); and Miguel León Portilla, ed., *The Broken Spears: The Aztec Account of the Conquest of Mexico* (Boston: Beacon Press, 1992).

20 Enrique Chagoya and Bud Shark in a conversation with Sarah Kirk Hanley and Judy Hecker, May 14, 2020. See the essay by Sophie Barbisan, this volume, 156–57.

21 Lorraine Daston and Peter Galison, *Objectivity* (New York: Zone Books, 2007); and William B. MacGregor, "The Authority of Prints: An Early Modern Perspective," *Art History* 22, no. 3 (1999): 389–420.

22 Joaquín Bolaños, *La portentosa vida de la Muerte* (1792; repr., Frankfurt am Main: Vervuert, 2015).

23 For more context on the use of comic book characters, see Alejo Benedetti, *Men of Steel, Women of Wonder: Modern American Superheroes in Contemporary Art* (Fayetteville: The University of Arkansas Press, 2019).

24 Gabrielle Vail and Victoria R. Bricker, comps., "New Perspectives on the Madrid Codex," *Current Anthropology* 44, no. S5 (December 2003): S105–12, https://doi.org/10.1086/379270.

25 Enrique Chagoya, "Collection Talk | Enrique Chagoya," Sheldon Museum of Art, University of Nebraska-Lincoln, October 27, 2016, https://www.youtube.com/watch?v=WnW765A7KxM; and Mel Watkin and Manuel Ocampo, *Utopian Cannibal: Adventures in Reverse Anthropology* (St. Louis, MO: Forum for Contemporary Art, 2001).

Deceiving Prints
The Challenges of Visual Analysis for Contemporary Printmaking Techniques

Sophie Barbisan

Printmaking has undergone a renaissance since the 1950s and 1960s, when new publishers began to spread across the United States. As these printer-publishers invited artists into the printshop, the rules of the craft were broken and "happy accidents" became part of the creative process.[1] In addition to traditional relief, intaglio, and planographic processes, which carry their own complexities, digital printmaking was added to the artists' toolbox in the 1990s. This new genre has initiated a generation of composite images and presents unique challenges for curators and conservators. Identifying techniques is now trickier than ever, even when examining the prints under the microscope or through digital imaging. To ensure the long-term care of these artworks, it is crucial that the materials and the techniques used in their creation are identified. The collection of Ted L. and Maryanne Ellison Simmons, which includes a rich diversity of artists and their processes, provides a prime opportunity to advance the technical study of contemporary prints.[2] Combining visual analysis and interviews with printers and artists, this essay strives to provide a more thorough understanding of their methods.[3]

RELIEF PRINTMAKING: AN OLD TECHNIQUE FOR CONTEMPORARY PURPOSES

Relief printing, the oldest form of printmaking, continues to be attractive to contemporary artists, in part for its accessibility and affordability. A relief print is made by carving away the negative areas of an image from wood, linoleum, stone, or metal.

An oil-based ink is then applied to the raised surface, and the ink is transferred to paper through pressure. Woodcuts, the most common form of relief printing, are made by carving the plank side of the wood. *Snacktime Marcy* (cat. 82), created in 2000, is the first large-scale woodcut triptych by Tom Huck. He explains: "There is something about the graphic quality of the line, woodcut is an inherently expressive medium. It's a struggle to carve the wood, and that struggle heightens the emotional impact of your image."[4] The artist, who is prolific in the technique, carves his blocks himself, and frequently prints and publishes his own artworks.

Huck developed his personal woodcut process in the late 1990s. He draws the final design on the block, which enables him to improvise, as the process of enlarging reveals compositional weaknesses. The block is then stained red, and he cuts away the red parts. Huck disdains electric tools, preferring to hand carve the design with Japanese gouges. For *Snacktime Marcy* he used birch plywood, which is soft enough for hand carving but durable enough to hold up through the printing process. He has since switched to higher-quality cherry wood, on which he creates a variety of textures by using black lines, white lines, stippling, or crosshatching.[5]

Huck has used various oil-based inks over the years, such as Daniel Smith Relief Ink.[6] For *Snacktime Marcy*, certain areas of the block were not inked, leaving the image without a border.

Fig. 23: Tom Huck; *Snacktime Marcy* (detail of cat. 82, in raking light, third panel, upper right quadrant), 2000; 703:2020a-c

Under raking light, the print shows strong embossing (fig. 23), which could lead one to think it was printed with an etching press. Rather, the print was hand pulled after burnishing the back of the paper with wooden spoons. The embossing derives from the use of Okawara paper, a soft, thin Japanese paper, which Huck selected for its translucency and creamy tone.[7] This paper has been known to develop foxing and staining, however, conditions now visible on *Snacktime Marcy*.[8] When informed about this issue, Huck exclaimed, "This is one of the best things I've heard in a while."[9] The creamy color of the Okawara paper was the very reason the artist selected this support, in the hope of emulating the discoloration found in old prints. He concludes: "I want my stuff to look like it was printed in the 1500s."[10]

The work of Robert Gober presents a distinct contrast to that of Huck. For his print *Monument Valley* (cat. 30), Gober used

both traditional printmaking methods and new technologies. The artwork, which resembles a crumpled receipt, is the result of his collaboration with printer Leslie Miller at The Grenfell Press. "I generally don't like prints," says Gober, "I tend to be interested more in . . . using printmaking to make an object rather than to make a traditional print."[11] *Monument Valley* is a cross between a sculpture and a print. Gober saved a receipt after a visit to the national park, which had left a profound impression on him. The artist contacted Miller and asked her to create a print of the receipt. In order to emulate the fine details of this small object, she chose wood engraving. This technique, common during the 19th century, used the end-grain of the wood for better precision. Boxwood, which was chosen for the block, is traditionally used for wood engravings because of its hardness and durability. However, the end-grain of boxwood would have been extremely difficult to carve by hand, which

150

led Miller to consider new technologies.[12] The receipt was digitized and the image file was sent to a contractor, who performed a laser engraving. Laser cut, along with the use of Computer Numerical Control machines, has spread in the printmaking world over the past 25 years. The technology has been available since the 1970s but outside the realm of fine art printmaking.[13] The level of detail needed for the project made this postdigital printmaking technique ideal.

After the block was refined by hand, it was printed with a Vandercook press.[14] The primary support is Legion interleaving paper, which is thin enough to imitate that of a receipt.[15] The inks were mixed by hand to achieve the perfect color of a faded receipt roll.[16] The areas of the print that were not engraved and printed in a solid tone were cut and removed to create the shape of the object. Gober's studio crumpled the paper, hand tearing it with a jig, and the print was framed according to the artist's specifications.

Monument Valley tricks viewers into believing they are looking at a common, disposable object, although it is, in fact, a fine art print. The illusion can only be broken by looking at the artwork through a microscope (fig. 24). The accumulation of ink along the edges of the text is the only indication of the relief technique, which is distinguishable from the direct thermal printing of an original receipt (fig. 25).[17] The pixelated aspect was rendered perfectly thanks to laser cutting, making this print a successful blend of a traditional 19th-century technique and contemporary technologies. Gober explains: "I think that the materials can be metaphors, that they can help you understand the piece when you know what it's made of."[18]

THE PAINTERLY EFFECTS OF INTAGLIO TECHNIQUES

Intaglio, which comes from the Italian *intagliare*, meaning to carve, is an umbrella term for a range of processes. It relies on ink that has been transferred under pressure from the recessed areas of a metal plate. In engraving, the plate is incised directly with a tool. Drypoint lines, for example, are

Fig. 24: Robert Gober; *Monument Valley* (detail of cat. 30, photomicrograph), 2007; 615:2020

Fig. 25: Photomicrograph of a receipt, as a comparison between a direct thermal print and the wood engraving *Monument Valley*

scratched with a needle, which produces a rough metal burr that creates a velvety appearance when printed. Today, artists have many tonal and linear intaglio processes at their disposal. The printmaking renaissance of the late 1950s and early 1960s resulted in numerous innovations in intaglio techniques, particularly etching.[19] That technique depends on acids to incise, or bite, the metal. A ground is applied to the plate, then drawn through with an etching needle. The plate is submerged into an acid bath, which bites the lines into the exposed metal. Soft-ground and hard-ground etching enable different visual effects. Hard ground allows for fine and detailed lines, while soft ground can be impressed with various textures or drawn on directly through paper. While line etching techniques were developed centuries ago, certain tonal etching processes are more recent.

Fig. 26: Kiki Smith; *Pool of Tears II (after Lewis Carroll)* **(detail of cat. 11, photomicrograph), 2000; 825:2020**

Fig. 27: Kiki Smith; *Pool of Tears II (after Lewis Carroll)* **(detail of cat. 11, photomicrograph), 2000; 825:2020**

Aquatint, which was invented during the 18th century, offered new developments during the 20th century, such as spit bite, sugar lift, and soap ground. To produce tone, rosin is dusted onto the plate, resulting in areas with a pitted texture when bitten by acid. Traditional aquatint relies on step etching.[20] Certain areas are masked with a stop-out varnish, which with different biting times create lighter or darker tones. Spit bite, on the other hand, is an alternative to bath etching; the acid is painted directly onto the plate. The combination of old and new techniques results in rich and extremely complex images that are difficult to reverse engineer.

"All my work comes from printmaking," says Kiki Smith, who has been prolific in this medium.[21] *Pool of Tears II (after Lewis Carroll)* (cat. 11) presents several etching techniques. This sizable print,

executed at Universal Limited Art Editions (ULAE), was created on the largest copper plate that the publisher could accommodate.[22] The artwork demonstrates Smith's mastery of hard-ground etching, which was executed in custom oversized trays.[23] The size also guided the choice of Arches paper, which was cut from a roll.[24] Smith employed step etching, which enabled her to achieve a variety of textures. For example, the pattern of the monkey's fur, a combination of line work and stippling, was achieved by using different bite times (fig. 26). The stippling marks were left in the acid longer than the delicate line work to create larger, fuzzy dots. A flat bite technique was also used to obtain a darker outline around the animals, giving the illusion that they are swimming in water. The figures were protected with a stop-out varnish, with only the water area exposed. The plate was placed in the acid, without any rosin on its surface. The result is a heavy, fuzzy line, because the ink held along the edge formed by the differential thickness of the two areas.[25] This accumulation of ink along the edges of the shape is a hall-mark of flat bite.[26]

Come Away from Her (after Lewis Carroll) (cat. 8), like *Pool of Tears II*, shows "background noise," which gives the print a less pristine appearance. These marks were both intentionally made with a wire brush and unintentionally the product of damage to the hard ground during storage of the plate. Smith likes working with sandpaper, which she calls "the poor man's aquatint."[27] The different grits enable a range of effects. A coarse sandpaper was used to scratch the plate in the grass area of *Come Away from Her*, while a finer grit shows in the cheeks of Alice in *Pool of Tears II*.

In addition to sandpaper, Smith selected spit bite aquatint for the shadows to complement her line work. Brushing the acid directly onto the plate allowed her to create watercolor-like effects with ease. Spit bite typically requires a wetting agent for the acid to spread evenly on the plate.[28] Smith intentionally omitted the wetting agent to achieve a unique texture. The acid beaded up on the plate, creating a smoky effect that appears under magnification as little islands where the acid did not bite (fig. 27).

20000 µm

Fig. 28: Kiki Smith; *Still* (detail of cat. 5, photomicrograph), 2006; 828:2020

Pool of Tears II and *Come Away from Her (after Lewis Carroll)* were hand colored, according to the artist's directions. The hand-coloring is so pervasive that these artworks straddle the line between prints and watercolors. By contrast, Smith explored the possibilities of color aquatint in *Still* (cat. 5), published by Crown Point Press.[29] The artist wanted to achieve the appearance of the rainbow iridescence in oil slicks.[30] The first experiments were done on an aquatint ground, where a mixture of ferric chloride and asphalt were poured onto the plate and allowed to flow, creating a marbleized look. The first marks looked promising, so she created two other plates, for two other colors.

When proofing the print, however, Smith found the colors to be too strong. Emily York, master printer at Crown Point Press, suggested printing the back of the plates, which contained a wealth of visual information. When the acid was moved around, some had collected on the absorbent paper used to protect the table and had etched the back of the plates where they rested. This created a different set of marks that were flat bitten. The three plates were inked in yellow, magenta, and blue, resulting in subtle blotlike shapes (fig. 28). These marks were delicate and needed steel facing in order to be strengthened and preserved through the printing process.[31] Steel facing also protected the inks from becoming dull and muddy during the wiping process. The chine collé Gampi paper allowed for the details to be printed beautifully, thanks to its smooth and reflective surface.[32]

While the color plates were being made, Smith labored tirelessly over the feet of the figure. The delicate shading gives the print an almost lifelike aspect (fig. 29). The artist started

Fig. 29: Kiki Smith; *Still* (detail of cat. 5), 2006; 828:2020

Fig. 30: Jaune Quick-to-See Smith; *Celebrate 40,000 Years of American Art* (detail of cat. 66), 1995; 798:2020

with a simple hard-ground drawing, creating a fine outline.[33] Very light tones of aquatint were added to the figure to create the overall shades. These were lightly etched and followed with gentle passages of spit bite aquatint. Smith went back in with a fine jeweler's sandpaper to create the subtle passages of tone, and the highlights were burnished. To create the details in the dress, the artist pressed a piece of lace into a soft ground to imitate its texture.[34] At the last minute, Smith added small tattooed stars on the woman's legs, in reference to her own tattoos.[35]

IN BETWEEN RELIEF AND INTAGLIO: COLLAGRAPHS

Collagraphs are a relatively recent printmaking invention. The term was coined in the 1950s by Glen Alps, a printmaking professor at the University of Washington.[36] Stemming from the Greek terms *kolla* (glue) and *graphe* (writing), collagraph plates are made in the manner of a collage. Textural elements such as paper or fabric are cut and glued onto a stiff support. Due to the differential thickness and texture of the plate, the end result is an image printed in both intaglio and relief. Jaune Quick-to-See Smith's collagraphs are a prime example of the technique. In 1995, the artist was invited to the Washington University School of Art Collaborative Print Workshop, now called Island Press. *Celebrate 40,000 Years of American Art* (cat. 66), which was created with the assistance of print department chair Peter Marcus and master printer Kevin Garber, was designed as a "succinct comment on colonial thinking."[37]

The primary material for the plate was Sintra®, a type of expanded polyvinyl chloride (PVC). Smith achieved the background texture by applying Rhoplex™, an acrylic adhesive, onto the plate and letting it drip. Some areas received a thicker application, which created cracks as the medium dried. Additional texture was created by scorching the Sintra® to form engraved lines. The rabbits, a reference to the Peterborough petroglyphs in Ontario, Canada, were cut from a thick canvas (fig. 30) and glued onto the plate. Carborundum, an abrasive grit used to polish lithographic stones, was used to create additional textural effects. The powder was mixed directly with the Rhoplex™ to form a paste that could be painted on the plate for the shadows of the rabbit's ears. In other areas, carborundum appears to have been simply dusted onto the wet media. The title of the artwork, *Celebrate 40,000 Years of American Art*, was added using a stencil. The acrylic adhesive was painted through it, with the carborundum dusted on top. Once the plate was dry, it was inked and printed with an etching press on Somerset paper.[38]

Venison Stew (cat. 67), printed on the same paper, followed a similar process. Blue tape and pieces of shelf liner were used on the left area of the can. The acrylic adhesive was applied in a thick impasto that held bubbles and drippings. The outline of the can was made with carborundum dusted on the wet adhesive. Smith wanted to add a color, which would usually require another plate. Instead, a bright red Createx™ ink was brushed onto the paper directly (fig. 31).[39] Because of its fluidity, the ink immediately sank into the paper. However, it was still opaque

enough to obscure the word "venison." This problem was resolved by stenciling directly on the print with an acrylic paint. These painted additions give each impression in the edition its own character. Both prints were issued in an edition larger than 10, even though collagraph plates start to degrade after about 10 passages through the press. These differences were welcomed by the artist. Maryanne Ellison Simmons, a master printer herself who assisted during this project, explained: "accidents are part of the deal."[40]

LITHOGRAPHY WITHOUT *LÍTHOS*: CONTEMPORARY PLANOGRAPHIC TECHNIQUES

Lithography, a 19th-century planographic technique, is very popular with publishers and contemporary artists. It does not rely on the physical characteristic of the matrix but instead on the chemical principle that water and oil repel each other. Lithography has long attracted artists for its ease of use, because the design is drawn directly on the matrix. Drawing is traditionally done on limestone using an oily material such as lithographic crayon or tusche. The stone is then treated with a mixture of acid and gum arabic. The exposed areas are etched, which enables them to retain water. When an oil-based ink is applied, it is repelled by the water and sticks to the design. In contemporary lithography, metal plates have mostly replaced limestone, ever since aluminum became readily available and relatively inexpensive in the United States during the late 1940s.[41] These plates were ball grained, which imitates the texture of the limestone at a much lower cost. Photolithography came about shortly after, in the 1950s.[42] This technique uses a photosensitive coating to reproduce drawings executed on transparent films. Its flexibility has made photolithography the standard for professional fine art print studios.

Michael Barnes is an avid proponent of stone lithography, for which he has a passion. "Lithography is my painting medium," says Barnes, who also self-publishes.[43] This is apparent in his *Steindruck München* series (cats. 39–42), which he developed during his residency at the Lithografiewerkstatt Steindruck München studio. This was a lithographic pilgrimage for Barnes,

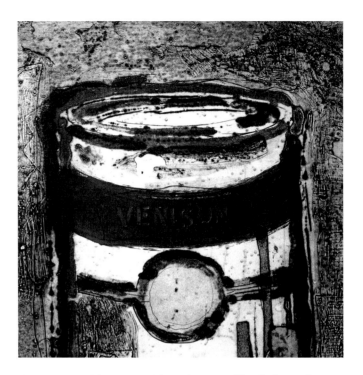

Fig. 31: Jaune Quick-to-See Smith; *Venison Stew* (detail of cat. 67), 1995; 797:2020

as Munich was the city where Alois Senefelder invented and developed the technique in 1798. The German studio is equipped with an array of high-quality lithographic stones and promotes traditional methods. Barnes drew his key images directly on the stones with a lithographic crayon and printed them in black ink. He selected a German lithographic paper, Zerkall Litho, well-suited for the technique with its smooth surface.[44] Once Barnes returned to the United States, he worked on adding the colors over the next two years.

Switching to contemporary lithographic methods, Barnes used photolithographic aluminum plates for the additional colors. He placed the printed key image underneath a textured film to emulate the stone grain, which enabled him to draw directly on it with crayons. The films were then registered onto the photolithographic plate, which was exposed and developed. Registration of the colors during printing is important to Barnes, who selected a punch registration method, typical in the use of photolithographic plates. To achieve the desired effect, the paper is printed dry and registration tabs are added to the printed key images. With the addition of colors, papers tend to expand due to the added moisture, which can misalign the registration. Barnes ran the

Fig. 32: Michael Barnes; *On the Road to Bremen* (detail of cat. 42, photomicrograph), 2019; 419:2020.7

Fig. 33: Roger Shimomura; *Kansas Samurai* (detail of cat. 100, photomicrograph), 2004; 787:2020

By contrast, the colors of *Kansas Samurai* by Roger Shimomura (cat. 100) were planned. The seven-color lithograph was printed at The Lawrence Lithography Workshop (TLLW), thanks to the expertise of master printer Michael Sims. Shimomura and Sims have a long-standing relationship from teaching together at the University of Kansas. This knowledge and trust enabled Shimomura to work mostly from his own studio instead of at TLLW. The artist provided the key image in the form of a cartoon. This drawing was then reproduced on a transparent film, which was used to expose a photolithographic aluminum plate.

Shimomura hand colored a black-and-white trial proof to create a guide, with which the plates for subsequent color were made. These colors show an intended flatness, close in appearance to screenprints. This is no coincidence, considering the influence of Warhol's silkscreens on Shimomura, who practiced the technique himself in the beginning of his career. This has led to confusion and misidentification of Shimomura's lithographs. These solid colors were obtained by the use of opaque tusche when creating the films and the plates.[47] The influence of Japanese woodblock prints on Shimomura is referenced not only in the imagery used but also in the background of *Kansas Samurai*.[48] The wood grain was reproduced by inking wood, transferring the grain onto a film, then exposing a plate with it.

The order of printing can be challenging to identify visually, and it is not always documented by publishers.[49] In the case of *Kansas Samurai*, certain inks were layered on top of each other to create new tones.[50] For example, the guard of the sword was created by layering three colors: first a blue layer, followed by red to obtain a dark maroon; the purple highlight was achieved by adding a light transparent gray (fig. 33). This light gray was also laid on top of the blue in the blade of the sword, creating a softer tone than the blue in the face of the figure. The white highlights were obtained simply by leaving the paper exposed.[51] However, printing a white ink layer is another way to form highlights.

This is the case for most of Enrique Chagoya's lithographs created at Shark's Ink. These artworks were printed on amate paper, which is naturally a cream color. In order to make the inks

papers through the press several times to calendar, or smooth them, and thus avoid the issue. After the printing was complete, the registration tabs were trimmed.

For *On the Road to Bremen* (cat. 42), the artist created six additional plates, one for each color. When viewed under a microscope (fig. 32), the black ink appears to be sitting on top of the subsequent colors, despite having been printed first. This effect is produced by the addition of modifiers to the inks, which enable Barnes to print translucent layers.[45] He begins with the warmer tones, such as ochres and browns, and then proceeds with the cooler ones. Barnes explains: "this process is my way of painting or drawing, as I'm building the layers. I print one color at a time and then will draw the next color. I'm really responding to what is on the print, I don't lay out all the colors ahead of time."[46]

Fig. 34: Enrique Chagoya; *Illegal Alien's Guide to Critical Theory* (detail of cat. 47), 2007; 486:2020

Fig. 35: Enrique Chagoya; *Illegal Alien's Guide to Critical Theory* (detail of cat. 47, ultraviolet-induced visible florescence imaging, lower left quadrant), 2007; 486:2020

stand out, the white was laid down first. These highlights are visible under ultraviolet light (UV), as the pigment in the ink absorbs UV (figs. 34 and 35). This is a characteristic of titanium dioxide, often found in lithographic inks.[52]

Chagoya has been collaborating with Shark's Ink for more than 20 years. Bud Shark explains: "This is one of the longer relationships that I've had. We started with Enrique in 1998, with at least one print a year. It's a great relationship."[53] Lithographs at Shark's Ink were created with a mixture of hand-drawn and photolithographic processes. The artist traveled to Shark's Ink with suitcases of collected images. The ones selected were scanned and printed directly onto transparent film. Chagoya cut them and assembled them on a larger film with transparent pressure-sensitive tape to create the key image. Details were added with an opaque medium, such as black acrylic paint, for better precision.

Chagoya's lithographs show a wide range of colors. The 10 colors in *Illegal Alien's Guide to Somewhere Over the Rainbow* (cat. 46) were printed with 10 aluminum plates. The artist painted his design directly on a textured film with a toner wash.[54] This medium enabled subtle transitions with an appearance similar to a watercolor wash, as in *Everyone is an Alienígeno* (cat. 48). In *Illegal Alien's Guide to Critical Theory* (cat. 47), the swirls in the blue background were painted with a brush and toner wash diluted in different ways. In order to get a gradient of colors, this plate was inked with a rainbow roll, with several colors blended on the roll during one inking passage. In the

same print, Chagoya varied textures by using a Stabilo™ pencil on the frosted film for certain colors (fig. 34).

Over the years, Shark developed an order of printing to achieve a specific aesthetic. The white ink was laid down first for the highlights and to make the subsequent colors stand out.[55] In order to give an appearance of wear and staining, Chagoya splattered a film with toner washes to create an aluminum plate printed in transparent brown. A very thin layer of transparent gray was printed overall, furthering the worn effect. The black ink was printed last.

Chagoya's reference to Mesoamerican art is present not only in his subject matter but also in the paper. Amate is a type of bark paper, which was used for codices in ancient Mexico. During the Spanish conquest its production was banned, but the tradition endured.[56] Today, amate paper is mainly produced by hand in San Pablito and other villages of the Sierra Norte de Puebla. Amate is traditionally made with bark from the Ficus tree family. The bark is soaked and boiled with ashes, lime, or caustic soda. Once the fibers are softened, they are arranged on a wooden board in a grid, then beaten with a volcanic rock to form a sheet. Printing on amate presents a challenge, because the bark paper has an uneven texture and flatness. At the insistence of Bud Shark, they imported samples. Before printing, the amate paper was run through the press three times dry and three times dampened. This calendaring made it more dimensionally stable and enabled the ink to sit on top and not immediately sink

Fig. 38: Enrique Chagoya; *Le Temps Peut Passer Vite ou Lentemente* (detail of cat. 54, photomicrograph), 2009; 493:2020

Fig. 36: Bruce Conner; *BOMBHEAD* (detail of cat. 62, photomicrograph), 2002; 545:2020

Fig. 37: Bruce Conner; *BOMBHEAD* (detail of cat. 62, specular light imaging), 2002; 545:2020

into the paper. Certain prints, such as *Illegal Alien's Guide to Somewhere Over the Rainbow* (cat. 46), show pieces of chine collé applied to vary the texture and create transparent effects.[57]

THE "NEW" WORLD OF DIGITAL PRINTS

Technology's impact on printmaking has been an ongoing conversation within the field. Early explorations in digital art required collaboration between engineers and artists, leading to the first Experiments in Art and Technology (E.A.T.) event in 1966.[58] The introduction of the imaging software Adobe Photoshop in 1989 further impacted the development of digital art, as its layer system represented a familiar approach for printmakers. With the technology of inkjet printers, digital studios became a reality by the late 1990s.

Certain publishers, such as Magnolia Editions, decided to invest early in the equipment to widen printmaking horizons for artists. *BOMBHEAD* (cat. 62) by Bruce Conner was created by scanning the original negative of an Edmund Shea portrait of Bruce Conner and a National Archives photograph of an atomic explosion.[59] The scans were then digitally edited in Photoshop by Conner and Donald Farnsworth at Magnolia Editions. The printing was done on an Epson 9600 piezo printer using pigment-based inks. Piezo is a type of drop-on-demand (DOD) inkjet, which generates an ink droplet only if ordered to do so by an electronic signal.[60] DOD can be distinguished by the randomized dot pattern, as opposed to a clear dot placement for continuous inkjet.

Although the image appears to be black and white, black, magenta, and blue inks, which create depth, can be seen when it is observed under the microscope (fig. 36). Printers preferred pigment-based inks for their lightfast properties, as fading of dye-based inks was apparent early on. Pigment-based inks are recognizable thanks to a phenomenon called colored bronzing (fig. 37) when viewed under specular light. This visual characteristic is especially noticeable with pigmented inks on glossy coated paper, as in *BOMBHEAD*, which was printed on an Epson Premium Luster, a type of Resin Coated (RC) paper.[61] Finally, Conner completed the work by adding a drop of red acrylic paint to the tie near the atomic symbol.

Since the 1990s, inkjet technologies have developed significantly. *Le Temps Peut Passer Vite ou Lentemente (Time Can Pass Quickly or Slowly)* (cat. 54), published by Magnolia Editions,

Fig. 39: Damon Davis; *Graduation 1* (detail of cat. 25, photomicrograph), 2019; 551:2020

shows the possibilities of UV-curable inks. These inks contain liquid acrylic monomers, which polymerize to form a solid film when exposed to a short burst of UV light. With the introduction of flatbed inkjet printers, large-format printing became possible. The amate paper used for *Le Temps Peut Passer Vite ou Lentemente* was modified with a layer of gesso to create a substrate that could receive the ink and provide a white background that would permit true rendering of colors. Chagoya first painted the overall layout separately, which was then scanned. The image was modified digitally in Photoshop, printed, then completed by the artist with hand-painted additions in acrylic (fig. 38). UV-curable inks tend to sit on the surface of their substrate, almost forming a separate layer, which can help in their identification.

With the expansion of commercial options, artists are also choosing to print without the aid of a publisher. This was the case for *Graduation 1* (cat. 25), a digital collage created by Damon Davis, which he constructed from family photos that he scanned after his mother died in 2019: "I went through these photos and tried to piece together her life and the family I came from before my birth."[62] The high resolution of the scans is apparent when looking at the print under a microscope (fig. 39). The paper used is a Kodak Professional Smooth Fine Art Paper, a matte coated fine art paper, which shows apparent fibers and no differential gloss.[63]

Dye-based and pigment-based inks are difficult to differentiate, particularly with recent advances in dye and pigment technologies and the lack of clear characteristics on matte paper. This information is crucial for preservation of the work, because it informs the quantity of light exposure to which the art may be subjected. Reaching out to the commercial printer Velham, who was contracted by Davis, was key in getting confirmation that the ink used was indeed pigment-based.[64] The randomized dot pattern indicated a DOD thermal liquid inkjet, which was printed on a Canon ImagePROGRAF PRO-4000 printer.

Today, modern innovations can be combined with traditional methods, increasing the artist's expressive potential. The variety of techniques described above demonstrates the need for better documentation, as materials and technologies gain increasing complexity. Visual analysis, a useful tool for conservators and curators, is still a valuable methodology, but the privilege of being able to reach out directly to publishers and artists should not be taken for granted. The visual language of printmaking has evolved. Interviewing stakeholders needs to become a standard approach of institutions that collect contemporary prints. The diversity of the Simmons collection, both in terms of the artists collected and their printmaking techniques, informs us about these current practices.

The author is immensely grateful to the artists and publishers who took the time to share their knowledge: Tom Huck, artist; Leslie Miller, master printer and owner of The Grenfell Press; Brian Berry, master printer and studio manager at ULAE; Valerie Wade, director, and Emily York, senior master printer, at Crown Point Press; Maryanne Ellison Simmons, master printer and owner of Wildwood Press; Michael Barnes, artist; Michael Sims, master printer and owner of The Lawrence Lithography Workshop; Bud Shark, master printer and owner of Shark's Ink; and Donald Farnsworth, director of Magnolia Editions. At the Saint Louis Art Museum, a debt of gratitude is owed to Cathryn Gowan, head of digital assets, Ann Aurbach, photography manager, and Shae Henderson, digital imaging specialist, for their assistance during photography. The author is grateful for the support of the conservation department during this project.

1 See Elizabeth Wyckoff and Gretchen L. Wagner, *Graphic Revolution: American Prints 1960 to Now* (St. Louis: Saint Louis Art Museum, 2018), 24–37.

2 Artists and publishers hold the keys to fully understand the printmaking processes, yet documentation sheets from publishers often use imprecise terminology or lack the details to describe processes fully. The term "intaglio," for example, is often used alone, although it encompasses aquatint, soft- and hard-ground etching, engraving, and drypoint, as well as more unconventional interventions on the plate. With the acquisition of the collection of Ted L. and Maryanne Ellison Simmons, the Saint Louis Art Museum has an ideal opportunity to reach out to publishers and artists to gather thorough documentation. The Simmonses, who are deeply involved in the contemporary printmaking world, and Maryanne, in particular, as a master printer herself, were an invaluable resource for technical research.

3 Digital documentation for this project included ultraviolet (UV)-induced visible fluorescence; infrared (IR) reflectography; and raking, specular, and transmitted light. Photographs were acquired with a Nikon D800 and a modified Nikon D300S for UV and IR images. Photomicrographs were obtained with the digital microscope Hirox RH-2000. Each image has a scale in micrometers to inform

about magnification. Macrophotography was performed in the photo studio of the Saint Louis Art Museum.

4 Tom Huck, interview with the author, July 26, 2021.

5 See Bill Fick and Beth Grabowski, *Printmaking: A Complete Guide to Materials and Processes*, 2nd ed. (London: Laurence King Publishing, 2016), 84.

6 Daniel Smith Relief Ink Traditional Black #79, now discontinued. Recently, the artist was approached by Gamblin Artist Colors and developed Tom Huck's Outlaw Black Relief Ink.

7 Okawara paper is a type of Japanese paper made with a blend of sulfite process pulp, Thai kozo, and Manila hemp. It is available as a roll, generally at 60gsm, and is currently manufactured by Hidaka Washi in Kochi, Japan.

8 Okawara paper was originally made by Takaoka Mill in Kochi. Foxing on these papers became an issue in the 2010s. The cause was traced back to the poor quality of the Thai kozo and not thoroughly cleaning the fibers and machinery. Yuki Katayama, email to the author, August 25, 2021.

9 Huck interview.

10 Huck interview.

11 Robert Gober, Brad Epley, and Jan Burandt, "Robert Gober," Artist Documentation Program, April 18, 2013, http://adp.menil.org/?page_id=830.

12 Leslie Miller, interview with the author, August 5, 2021.

13 Paul Catanese and Angela Geary, *Post-Digital Printmaking: CNC Traditional and Hybrid Techniques* (London: A&C Black, 2012), 16–18.

14 A Vandercook press is mostly used in letterpress. It was particularly well-suited for the project, with its adjustable bed allowing for perfect impressions.

15 Legion interleaving is a 60gsm paper, made with 100% high alpha cellulose.

16 Miller used Van Son rubber-based inks. This type of ink presents a slower drying time than oil-based inks, ideal for letterpress printing.

17 Direct thermal is a technique in which heat is applied pixel by pixel to a paper with a heat-sensitive coating. The heat causes dyes to develop and become visible. See Martin C. Jürgens, *The Digital Print: Identification and Preservation* (Los Angeles: The Getty Conservation Institute, 2009), 208.

18 "Robert Gober," Artist Documentation Program.

19 Phil Sanders, *Prints and Their Makers* (New York: Princeton Architectural Press, 2021), 85.

20 Step etching involves repeating biting and stopping-out procedures to achieve different thicknesses in lines. See Catherine Brooks, *Magical Secrets about Line Etching and Engraving: The Step-by-Step Guide to Incised Lines* (San Francisco: Crown Point Press, 2007), 111.

21 Claire Barliant, "'If you can outlive most men, all of a sudden you can be venerated'—an interview with Kiki Smith," *Apollo*, October 26, 2019, https://www.apollo-magazine.com/kiki-smith-interview/.

22 Printed with the assistance of Brian Berry, Stephanie Porto, Douglas Volle, and Craig Zammiello.

23 Brian Berry, interview with the author, August 4, 2021.

24 Arches Lavis Fidelis / En-Tout-Cas is a wove machine-mould paper, 220gsm, gelatin sized, and contains 25% cotton and an alkaline reserve, without brightening agents.

25 ULAE was using the Gamblin Portland Black as their main etching ink at the time.

26 Emily York, *Magical Secrets about Aquatint: Spit Bite, Sugar Lift, and Other Etched Tones Step-by-Step* (San Francisco: Crown Point Press, 2008), 206.

27 "Kiki Smith: Printmaking," Art21, YouTube, filmed in 2002, accessed August 17, 2021, www.youtube.com/watch?v=2LHQBzkjwx8&ab_channel=Art21.

28 For example, ULAE uses soap.

29 Printed with the assistance of Emily York and Catherine Brooks.

30 York, *Magical Secrets about Aquatint*, 211–15.

31 Steel facing is a form of electroplating, in which a thin layer of pure iron is electrodeposited on a copper plate.

32 The Usuyo Gampi Natural is a 100% Japanese Gampi paper, 15gsm, and machine-made in Kochi, Japan. Chine collé is done by printing on a tissue-thin paper, cut to the size of the printing plate, that is adhered to a thicker support paper during printing.

33 Emily York, interview with the author, July 30, 2021.

34 Brooks, *Magical Secrets about Line Etching*, 133.

35 Kathan Brown, "Overview: Kiki Smith," *Crown Point Press Newsletter* (Summer 2006).

36 Fick and Grabowski, *Printmaking*, 143.

37 Jaune Quick-to-See Smith, "Celebrate 40,000

Years of American Art," *Frontiers: A Journal of Women Studies* 23, no. 2 (2002): 154–55.

38 Somerset is a wove machine-mould paper made with 100% cotton. The paper is produced by the St. Cuthberts Mill in England.

39 Createx™ Colors are water-based monotype inks.

40 Maryanne Ellison Simmons, interview with the author, July 19, 2021.

41 Dwight W. Pogue, *Printmaking Revolution: New Advancements in Technology, Safety, and Sustainability* (New York: Watson-Guptill Publications, 2012), 19.

42 Sanders, *Prints and Their Makers*, 185.

43 Michael Barnes, interview with the author, July 21, 2021.

44 The Zerkall Litho, manufactured by Papierfabrik Zerkall, is a machine-mould paper. It contains 100% high alpha cellulose. It is buffered with calcium carbonate and internally sized.

45 Barnes uses a transparency base, called Tint Base Litho Ink from Hanco. He generally creates a mix of 50% Tint Base to 50% ink. The amount of Tint Base can be augmented up to 80% for certain background colors.

46 Barnes interview.

47 Michael Sims, interview with the author, July 21, 2021.

48 *Kansas Samurai* is a self-portrait, which references a print by Natori Shunsen (1886–1960) from the series *Thirty-six Kabuki Actors Portraits.*

49 TLLW includes the order of printing in their documentation sheet, as follows: yellow ochre, medium warm thalo blue, tan, red, medium cool thalo blue, light transparent gray, grayed black.

50 TLLW uses Hanco inks, among others, such as Charbonnel.

51 Arches Cover White, torn from a roll. Wove paper, machine-mould, 100% cotton, internally sized, alkaline reserve, and no optical brighteners.

52 Marilyn Laver, "Titanium Dioxide Whites," in *Artist's Pigments: A Handbook of Their History and Characteristics*, ed. Elizabeth West Fitzhugh (Washington, DC: National Gallery of Art, 1997), 3:308.

53 Bud Shark, interview with the author, July 26, 2021.

54 Mixture of Xerox toner powder, water, and Liquitex Matte Medium.

55 The inks used at Shark's Ink are generally from the brands Hanco and Charbonnel.

56 Rosaura Citlalli López Binnqüist, "The Endurance of Mexican Amate Paper: Exploring Additional Dimensions to the Sustainable Development Concept" (PhD diss., University of Twente, 2003), 89.

57 The chine collé pieces are White Thai Mulberry, adhered with sprayed Rhoplex™.

58 Fick and Grabowski, *Printmaking*, 36.

59 Donald Farnsworth, interview with the author, August 11, 2021.

60 For a description of digital printmaking technologies, see Jürgens, *Digital Print.*

61 This paper is made with a polyethylene-coated RC base.

62 Damon Davis, artist's website, accessed August 25, 2021, https://heartacheandpaint.com/Graduation.

63 This 315gsm paper is made with 100% cotton rag.

64 Jim Robbins, Velham, email to the author, August 19, 2021.

Bibliography

Adrian, Dennis, and Richard A. Born. *See America First: The Prints of H. C. Westermann*. Chicago: David and Alfred Smart Museum of Art, 2001.

Adrian, Dennis, and Michael Rooks. *H. C. Westermann*. New York: Harry N. Abrams, 2001.

Alyea, Ginny van. "A Man Walks Into a Museum. For Tony Fitzpatrick, 2021 is a Return to More Than Before." *Chicago Gallery News*, August 23, 2021. Accessed August 30, 2021. https://www.chicagogallerynews.com/news/2021/8/a-man-walks-into-a-museum-for-tony-fitzpatrick-2021-is-a-return-to-more-than-before.

Anderson, Reynaldo, and Clinton R. Fluker, eds. *The Black Speculative Arts Movement: Black Futurity, Art+Design*. New York: Lexington Books, 2019.

Archer, Michael, Guy Brett, Catherine de Zegher, and Nancy Spector. *Mona Hatoum*. London: Phaidon, 2016.

Art Against AIDS: An Art Sale in New York City, June through December, 1987, for the Benefit of the American Foundation for AIDS Research (AmFAR). New York: The Foundation, 1987.

Art21. "Kiki Smith: Printmaking." Filmed in 2002, New York, NY. YouTube video, 4:56. www.youtube.com/watch?v=2LHQBzkjwx8&ab_channel=Art21.

Ash, Nancy, Scott Homolka, Stephanie Lussier, Rebecca Pollak, and Eliza Spaulding. *Descriptive Terminology for Works of Art on Paper: Guidelines for the Accurate and Consistent Description of the Materials and Techniques of Drawings, Prints, and Collages*. Edited by Renée Wolcott. Philadelphia: Philadelphia Museum of Art, 2014. https://www.philamuseum.org/doc_downloads/conservation/Descriptive TerminologyforArtonPaper.pdf.

Ault, Julie, David Deitcher, Andrea Fraser, Lewis Hyde, Lucy R. Lippard, Carole S. Vance, Michele Wallace, Coco Fusco, David Wojnarowicz, and Douglas Crimp. *Art Matters: How the Culture Wars Changed America*. Edited by Brian Wallis, Marianne Weems, and Philip Yenawine. New York: New York University Press, 1999.

Auping, Michael, and Emma Dexter. *Bruce Nauman: Raw Materials*. London: Tate Publishing, 2004. Exhibition catalogue.

Baker, Kenneth, Nicholas Fox Weber, Karen Wilkin, and John Yau. *Wayne Thiebaud*. New York: Rizzoli International Publications, 2015.

Bangma, Anke. *Paul Thek: The Wonderful World that Almost Was*. Rotterdam: Witte de With, Center for Contemporary Art, 1995.

Barliant, Claire. "'If you can outlive most men, all of a sudden you can be venerated'—an interview with Kiki Smith." *Apollo*, October 26, 2019. https://www.apollo-magazine.com/kiki-smith-interview/.

Barrette, Bill. *Letters from H. C. Westermann*. New York: Timken Publishers, 1988.

Bazzano-Nelson, Florencia. *Liliana Porter and the Art of Simulation*. Aldershot, UK: Ashgate, 2008.

Benedetti, Alejo. *Men of Steel, Women of Wonder: Modern American Superheroes in Contemporary Art*. Fayetteville: The University of Arkansas Press, 2019.

Berkson, Bill, and Robert Flynn Johnson. *Vision and Revision: Hand Colored Prints by Wayne Thiebaud*. San Francisco: Chronicle Books, 1991. Exhibition catalogue.

Bloom, Ken, and Elizabeth Culbert. *A Silent Unity of Gazes: The Photographic Vision of Luis Gonzáles Palma*. Duluth, MN: Tweed Museum of Art, 2009. Exhibition catalogue.

Bolaños, Alvaro Félix, and Gustavo Verdesio, eds. *Colonialism Past and Present: Reading and Writing about Colonial Latin America Today*. Albany: State University of New York Press, 2002.

Bolaños, Joaquín. *La portentosa vida de la Muerte*. 1792. Reprint. Frankfurt am Main: Vervuert, 2015.

Boorsch, Suzanne. "Breaking the Rules: The Woodcuts of Helen Frankenthaler." *Art on Paper* 6, no. 6 (July–August 2002): 36–39.

Boswell, Peter. *Afterimage: The Prints of Bruce Conner*. New York: Senior & Shopmaker Gallery, 2012. Exhibition catalogue.

Breslin, David, and David W. Kiehl. *David Wojnarowicz: History Keeps Me Awake at Night*. New York: Whitney Museum of American Art, 2018. Exhibition catalogue.

Brokaw, Galen, and Jongsoo Lee, eds. *Fernando de Alva Ixtlilxochitl and His Legacy*. Tucson: The University of Arizona Press, 2016.

Brooks, Catherine. *Magical Secrets about Line Etching and Engraving: The Step-by-Step Guide to Incised Lines*. San Francisco: Crown Point Press, 2007.

Brown, Kathan. "Kiki Smith." *Overview: Crown Point Press Newsletter* (Summer 2006).

Bruggen, Coosje van. *Bruce Nauman*. New York: Rizzoli, 1988.

Cameron, Dan, Mysoon Rizk, C. Carr, and John Carlin. *Fever: The Art of David Wojnarowicz*. Edited by Amy Scholder. New York: Rizzoli, 1998.

Castleman, Riva. *Jasper Johns: A Print Retrospective*. New York: Museum of Modern Art, 1986. Exhibition catalogue.

Catanese, Paul, and Angela Geary. *Post-Digital Printmaking: CNC Traditional and Hybrid Techniques*. London: A&C Black, 2012.

Centre for 21st Century Humanities, The University of Newcastle, Australia. "Precolumbian Codices Overview." Accessed August 31, 2021. https://c21ch.newcastle.edu.au/treeglyph/codices.php.

Chagoya, Enrique. "Collection Talk | Enrique Chagoya." Sheldon Art Museum, University of Lincoln, October 27, 2016. https://www.youtube.com/watch?v=WnW765A7KxM.

Chagoya, Enrique. "A Lost Continent: Writings without an Alphabet." In *The Road to Aztlan: Art from a Mythic Homeland*, by Virginia M. Fields and Victor Zamudio-Taylor, 262–73. Los Angeles: Los Angeles County Museum of Art, 2001.

Chagoya, Enrique, and Paul Karlstrom. "Oral history interview with Enrique Chagoya." Archives of American Art, August 25, 2001. https://www.aaa.si.edu/collections/interviews/oral-history-interview-enrique-chagoya-12495.

Chagoya, Enrique, Sarah Kirk Hanley, and Judy Hecker. "Enrique Chagoya and Bud Shark in Conversation with Sarah Kirk Hanley and Judy Hecker." International Print Center New York, May 14, 2020. https://www.ipcny.org/news/2020/5/6/may-14-reprint-artist-talk-with-enrique-chagoya-and-bud-shark.

Cherix, Christophe. *Print/Out: 20 Years in Print*. New York: Museum of Modern Art, 2012. Exhibition catalogue.

Chow, Kat. "If We Called Ourselves Yellow." National Public Radio, September 27, 2018. https://www.npr.org/sections/codeswitch/2018/09/27/647989652/if-we-called-ourselves-yellow.

Cordes, Christopher. *Bruce Nauman: Prints 1970–89; A Catalogue Raisonné*. New York: Castelli Graphics, 1989.

Corwin, Nancy A., Lucy R. Lippard, and Kazuko Nakane. *Roger Shimomura: Delayed Reactions; Paintings, Prints, Performance, and Installation Art from 1973 to 1996*. Lawrence, KS: Spencer Museum of Art, 1995. Exhibition catalogue.

D'arcy, David. *Michele Oka Doner: Bronze, Clay, Porcelain, and Works on Paper*. New York: Marlborough Chelsea, 2008. Exhibition catalogue.

Daston, Lorraine, and Peter Galison. *Objectivity*. New York: Zone Books, 2007.

Davis, Damon. Artist's website. Accessed August 25, 2021. https://heartacheandpaint.com/Graduation.

Davis, Damon. "Darker Gods in the Garden of the Low Hanging Heavens." St. Louis, MO: The Luminary, 2017. Exhibition brochure.

Delehanty, Suzanne. *Paul Thek: Processions*. Philadelphia: Institute of Contemporary Art, 1977. Exhibition catalogue.

Dembicki, Matt, ed. *Trickster: Native American Tales; A Graphic Collection*. Golden, CO: Fulcrum Publishing, 2010.

Devon, Marjorie, ed. *Tamarind: 40 Years*. Albuquerque: University of New Mexico Press, 2000.

Devon, Marjorie, Bill Lagattuta, and Rodney Hamon. *Tamarind Techniques for Fine Art Lithography*. New York: Abrams, 2008.

Dixon, Annette, and Robert F. Reid-Pharr, eds. *Kara Walker: Pictures from Another Time*. Ann Arbor: University of Michigan Museum of Art, 2003. Exhibition catalogue.

Doezema, Marianne, ed. *Jane Hammond: Paper Work*. University Park: Pennsylvania State University Press, 2007. Exhibition catalogue.

Donovan, Molly. "Richard Tuttle and the Comfort of the Unknown." *American Art* 20, no. 2 (2006): 102–25.

Dowling, Aileen. "Destabilizing Identity: The Works of Dorothy Cross." Unpublished undergraduate thesis, University of Central Florida, 2016.

Dumbadze, Alexander, and Suzanne Hudson, eds. *Contemporary Art: 1989 to the Present*. Chichester, West Sussex: Wiley-Blackwell, 2013.

Engberg, Siri, and Linda Nochlin. *Kiki Smith: A Gathering, 1980–2005*. Minneapolis: Walker Art Center, 2006. Exhibition catalogue.

Facio, Sara. *Luis González Palma*. Buenos Aires: Azotea Editorial Fotográfica, 1993.

Fick, Bill. Artist's website. Accessed August 27, 2021. https://billfick.com/.

Fick, Bill, and Beth Grabowski. *Printmaking: A Complete Guide to Materials and Processes*. 2nd ed. London: Laurence King Publishing, 2016.

Field, Richard S. *The Prints of Jasper Johns, 1960–1993: A Catalogue Raisonné*. West Islip, NY: Universal Limited Art Editions, 1994.

Fine, Ruth E. *Helen Frankenthaler: Prints*. Washington, DC: National Gallery of Art, 1993. Exhibition catalogue.

Finkelstein, Avram. *After Silence: A History of AIDS through Its Images*. Oakland: University of California Press, 2017.

Flood, Richard, Gary Garrels, and Ann Temkin. *Robert Gober: Sculpture + Drawing*. Minneapolis: Walker Art Center, 1999. Exhibition catalogue.

Forbes, Jack D., and Derrick Jensen. *Columbus and Other Cannibals: The Wetiko Disease of Exploitation, Imperialism, and Terrorism*. New York: Seven Stories Press, 1992. First published 1979 by D-Q University Press (Yolo County, CA) under the title *A World Ruled by Cannibals*.

Franits, Wayne. *Dutch Seventeenth-Century Genre Painting: Its Stylistic and Thematic Evolution*. New Haven: Yale University Press, 2004.

Frieling, Rudolf, and Gary Garrels, eds. *Bruce Conner: It's All True*. San Francisco: San Francisco Museum of Modern Art, 2016. Exhibition catalogue.

Fuller, Mary. "You're Looking for Bruce Conner, the Artist, or What Is This Crap You're Trying to Put Over Here?" *Currant* 2, no. 1 (1976): 8–12, 58–59.

Gascoigne, Bamber. *How to Identify Prints: A Complete Guide to Manual and Mechanical Processes from Woodcut to Inkjet*. 2nd ed. New York: Thames & Hudson, 2004.

Gemini G.E.L. Online Catalogue Raisonné. National Gallery of Art. Accessed October 18, 2021. https://www.nga.gov/gemini.

Getsy, David, ed. *From Diversion to Subversion: Games, Play, and Twentieth-Century Art*. Refiguring Modernism. University Park: Pennsylvania State University Press, 2011.

Gibson, Walter S. *Pieter Bruegel and the Art of Laughter*. Berkeley: University of California Press, 2006.

Gober, Robert, Brad Epley, and Jan Burandt. "Robert Gober." Artist Documentation Program, April 18, 2013. http://adp.menil.org/?page_id=830.

Gober, Robert, James Rondeau, and Olga M. Viso. *Robert Gober: The United States Pavilion, 49th Venice Biennale, June 10–November 4, 2001*. New York: D.A.P., 2001. Exhibition catalogue.

Gruzinski, Serge. *Images at War: Mexico from Columbus to Blade Runner (1492–2019)*. Durham, NC: Duke University Press, 2001.

Grynsztejn, Madeleine, ed. *The Art of Richard Tuttle*. San Francisco: San Francisco Museum of Modern Art, 2005. Exhibition catalogue.

Halbreich, Kathy. *Bruce Nauman: Disappearing Acts.* New York: The Museum of Modern Art, 2018. Exhibition catalogue.

Hammond, Jane. Artist's website. Accessed August 27, 2021. http://janehammondartist.com/.

Hanley, Sarah Kirk. "The Recurrence of Caprice: Chagoya's Goyas." *Art in Print* 3, no. 2 (2013). https://artinprint.org/article/the-recurrence-of-caprice-chagoyas-goyas/.

Hanley, Sarah Kirk. "Visual Culture of the Nacirema: Chagoya's Printed Codices." *Art in Print* 1, no. 6 (2006). https://artinprint.org/article/visual-culture-of-the-nacirema-chagoyas-printed-codices/.

Harrison, Pegram. *Frankenthaler: A Catalogue Raisonné: Prints, 1961–1994.* New York: Harry N. Abrams, Inc., 1996.

Hatoum, Mona, and Laura Steward Heon. *Mona Hatoum: Domestic Disturbance.* North Adams, MA: Massachusetts Museum of Contemporary Art, 2001. Exhibition catalogue.

Helfenstein, Josef, and Matthias Frehner. *Form, Color, Illumination: Suzan Frecon.* Houston: Menil Foundation, 2008. Exhibition catalogue.

Hickson, Patricia, Daniela Pérez, and Robert Storr. *Enrique Chagoya: Borderlandia.* Des Moines, IA: Edited by Patricia Hickson. Des Moines Art Center, 2007. Exhibition catalogue.

Hopps, Walter. *Kienholz: A Retrospective; Edward and Nancy Reddin Kienholz.* New York: Whitney Museum of American Art, 1996. Exhibition catalogue.

Ivins, William M. *Prints and Visual Communication.* Cambridge, MA: Harvard University Press, 1953.

Jansen, Maarten E.R.G.N., Virginia M. Lladó-Buisán, and Ludo Snijders, eds. *Mesoamerican Manuscripts: New Scientific Approaches and Interpretations.* Leiden: Brill, 2019.

Jansen, Maarten, and Gabina Aurora Pérez Jiménez. "Renaming the Mexican Codices." *Ancient Mesoamerica* 15, no. 2 (2004): 267–71.

Jennings, Francis. *The Invasion of America: Indians, Colonialism, and the Cant of Conquest.* Chapel Hill: University of North Carolina Press, 1975.

Jongh, Eddy de, and Ger Luijten. *Mirror of Everyday Life: Genreprints in the Netherlands 1550–1700.* Amsterdam: Rijksmuseum, 1997.

Judd, Flavin, and Caitlyn Murray, eds. *Donald Judd: Writings.* New York: David Zwirner Books, 2016.

Judd, Flavin, and Jeffrey S. Weiss. *Donald Judd: Woodcuts.* New York: Paula Cooper Gallery, 2008. Exhibition catalogue.

Jürgens, Martin C. *The Digital Print: Identification and Preservation.* Los Angeles: The Getty Conservation Institute, 2009.

Kastner, Carolyn. *Jaune Quick-to-See Smith: An American Modernist.* Albuquerque: University of New Mexico Press, 2013.

Kellein, Thomas. *Donald Judd: Early Work, 1955–1968.* New York: D.A.P., 2002. Exhibition catalogue.

Kernbauer, Eva. "Arbeiten an der Symmetrie. Robert Gobers US-Pavillon an der Biennale von Venedig 2001." *Zeitschrift für Kunstgeschichte* 75, no. 4 (2012): 547–66.

Kienholz, Ed. "Letter to Gemini G.E.L." January 4, 1984. Brochure.

Koch, Stephen, and Thomas Sokolowski. *Peter Hujar.* New York: Grey Art Gallery and Study Center, 1990. Exhibition catalogue.

Kolfin, Elmer. *The Young Gentry at Play: Northern Netherlandish Scenes of Merry Companies 1610–1645.* Leiden: Primavera Press, 2005.

Kraynak, Janet, ed. *Please Pay Attention Please: Bruce Nauman's Words; Writings and Interviews.* Cambridge, MA: MIT Press, 2005.

Kushner, Marilyn. "Island Press." Mildred Lane Kemper Art Museum. Accessed August 24, 2021. https://www.kemperartmuseum.wustl.edu/islandpress/html/essay.html.

Kuspit, Donald B. *Human Nature: The Figures of Michele Oka Doner.* New York: Charta, 2008.

Lahs-Gonzalez, Olivia. *My Nature: Works with Paper by Kiki Smith.* St. Louis, MO: Saint Louis Art Museum, 1999. Exhibition catalogue.

Las Casas, Bartolome de. *A Short Account of the Destruction of the Indies.* Translated by Nigel Griffin. 1542. Reprint, Harmondsworth: Penguin, 1992.

Laver, Marilyn. "Titanium Dioxide Whites." In *Artist's Pigments: A Handbook of Their History and Characteristics*, edited by Elizabeth West Fitzhugh, 3:295–356. Washington, DC: National Gallery of Art, 1997.

Linnaeus, Carl. *Systema naturae.* 10th ed. Stockholm: Impensis L. Salvii, 1758.

Lippard, Lucy. *Get the Message? A Decade of Art for Social Change.* New York: E. P. Dutton, 1984.

Lippard, Lucy R. *Roger Shimomura: Stereotypes and Admonitions.* Seattle, WA: Greg Kucera Gallery, 2004. Exhibition catalogue.

Lippard, Lucy. "Trojan Horses: Activist Art and Power." In *Art after Modernism: Rethinking Representation*, edited by Brian Wallis, 341–58. New York: New Museum of Contemporary Art, 1984.

López Binnqüist, Rosaura Citlalli. "The Endurance of Mexican Amate Paper: Exploring Additional Dimensions to the Sustainable Development Concept." PhD diss., University of Twente, 2003.

Lotringer, Sylvère, and Giancarlo Ambrosino. *David Wojnarowicz: A Definitive History of Five or Six Years on the Lower East Side.* New York: Semiotext(e), 2006.

Lydenberg, Robin. *GONE: Site-specific Works by Dorothy Cross.* Chestnut Hill, MA: McMullen Museum of Art, Boston College, 2005. Exhibition catalogue.

MacGregor, William B. "The Authority of Prints: An Early Modern Perspective." *Art History* 22, no. 3 (1999): 389–420.

Marshall, Richard D. *Ed Ruscha.* London: Phaidon, 2003.

Matt, Gerald, and Barbara Steffen, eds. *Bruce Conner: The 70s.* Nuremberg: Verlag für moderne Kunst, 2010. Exhibition catalogue.

McCarthy, David. *H. C. Westermann at War: Art and Manhood in Cold War America.* Newark: University of Delaware Press, 2004.

McDonald, Mark P., Mercedes Cerón-Peña, Francisco J. R. Chaparro, and Jesusa Vega. *Goya's Graphic Imagination*. New York: The Metropolitan Museum of Art, 2021. Exhibition catalogue.

McGavin, Patrick. "What Makes Tony Tick?" *Chicago Reader*, August 1, 1991. https://chicagoreader.com/news-politics/what-makes-tony-tick/.

Menil Collection. *Jasper Johns: Catalogue Raisonné of Drawing*. 6 vols. Houston: The Menil Collection, 2018.

Miller, Leslie, and David Storey. "Voices in Prints: Grenfell Press." *Art in Print* 6, no. 1 (2016): 31–35.

Morgan, Robert C., ed. *Bruce Nauman*. PAJ Books: Art + Performance. Baltimore: Johns Hopkins University Press, 2002.

Morris, Catherine, and Rujeko Hockley, eds. *We Wanted a Revolution: Black Radical Women, 1965–1985*. Brooklyn, NY: Brooklyn Museum, 2017. Exhibition catalogue.

Moss, Dorothy, Nancy Lim, Lucy R. Lippard, Elizabeth Partridge, and Philip Tinari. *Hung Liu: Portraits of Promised Lands*. Washington, DC: National Portrait Gallery, Smithsonian Institution, 2021. Exhibition catalogue.

Moxey, Keith. *Peasants, Warriors, and Wives: Popular Imagery in the Reformation*. Chicago: University of Chicago Press, 1989.

Murphy, Joni L. "Beyond Sweetgrass: The Life and Art of Jaune Quick-to-See Smith." PhD diss., University of Kansas, 2008.

North, Bill. *Freaky Fables from the Foothills: The Prints of Tom Huck*. Manhattan, KS: Marianna Kistler Beach Museum of Art, 2005. Exhibition catalogue.

Noyce, Richard. *Critical Mass: Printmaking Beyond the Edge*. London: A&C Black Publishing, 2010.

Parshall, Peter. "Imago Contrafacta: Images and Facts in the Northern Renaissance." *Art History* 16, no. 4 (1993): 554–79.

Pelzer-Montada, Ruth, ed. *Perspectives on Contemporary Printmaking: Critical Writing since 1986*. Manchester: Manchester University Press, 2018.

Pérez-Barreiro, Gabriel, Ursula Davila-Villa, and Gina McDaniel Tarver, eds. *The New York Graphic Workshop, 1964–1970*. Austin: Blanton Museum of Art, the University of Texas at Austin, 2009. Exhibition catalogue.

Picard, Charmaine, Alex J. Rosenberg, Hans-Michael Herzog, Danielle Knafo, Nelson Herrera Ysla, Yoan Capote, and Magda González-Mora. *Yoan Capote*. Edited by Charmaine Picard. Milan: Skira, 2016.

Pindell, Howardena, ed. *Kara Walker-No / Kara Walker-Yes / Kara Walker-? Essays by Twenty-eight Artists, Educators, Writers, and Poets*. New York: Midmarch Arts Press, 2009.

Pogue, Dwight W. *Printmaking Revolution: New Advancements in Technology, Safety, and Sustainability*. New York: Watson-Guptill Publications, 2012.

Porter, Liliana, Inés Katzenstein, and Gregory Volk. *Liliana Porter: In Conversation with Inés Katzenstein*. New York: Fundación Cisneros/Colección Patricia Phelps de Cisneros, 2013.

Portilla, Miguel León, ed. *The Broken Spears: The Aztec Account of the Conquest of Mexico*. Boston: Beacon Press, 1992.

Princenthal, Nancy. "Numbers of Happiness: Richard Tuttle's Books." *Print Collector's Newsletter* 24, no. 3 (July–August 1993): 81–86.

Reed, T. V. *The Art of Protest: Culture and Activism from the Civil Rights Movement to the Present*. Minneapolis: University of Minnesota Press, 2019.

Reilly, Maura. *Curatorial Activism: Towards an Ethics of Curating*. London: Thames and Hudson, 2018.

Richards, Mary. *Ed Ruscha*. Modern Artists series. London: Tate Publishing, 2008.

Richardson, Brenda, and Robert Gober. *A Robert Gober Lexicon*. Göttingen: Steidl, 2005.

Rippon, Jo. *The Art of Protest: A Visual History of Dissent and Resistance*. Watertown, MA: Charlesbridge, 2020.

Roberts, Benjamin R. *Sex and Drugs Before Rock 'n' Roll: Youth Culture and Masculinity during Holland's Golden Age*. Amsterdam: Amsterdam University Press, 2012.

Roberts, Jennifer. "Contact: Art and the Pull of Print." The 70th A. W. Mellon Lectures in the Fine Arts, Center for Advanced Study in the Visual Arts, 2021. https://www.nga.gov/research/casva/meetings/mellon-lectures-in-the-fine-arts/roberts-2021.html.

Rodriguez, Geno, Moira Roth, and Enrique Chagoya. *Enrique Chagoya: When Paradise Arrived*. New York: Alternative Museum, 1989. Exhibition catalogue.

Rooks, Michael, and Lynne Warren. *H. C. Westermann: Exhibition Catalogue and Catalogue Raisonné of Objects*. Chicago: Museum of Contemporary Art, 2001. Exhibition catalogue.

Rooney, E. Ashley, and Stephanie Standish. *Contemporary American Printmakers*. Atglen, PA: Schiffer Publishers, 2014.

Rosenblum, Robert. "Mike Bidlo." In *On Modern American Art: Selected Essays*, 312–16. New York: Harry N. Abrams, 1999.

Rosenblum, Robert. *Mike Bidlo: Masterpieces*. Zurich: Galerie Bruno Bischofberger, 1989. Exhibition catalogue.

Rosenblum, Robert. "Mike Bidlo Talks to Robert Rosenblum." *Artforum* (April 2003). https://www.artforum.com/print/200304/mike-bidlo-4472.

Rotenhan, Christina von, ed. *Richard Tuttle: Prints*. Zurich: JRP | Ringier, 2014. Exhibition catalogue.

Ruscha, Edward, and Siri Engberg. "The Weather of Prints: An Interview with Edward Ruscha." *Art on Paper* 4, no. 2 (1999): 62–67.

Samet, Jennifer. "Beer with a Painter: Enrique Chagoya." *Hyperallergic*, August 20, 2016. http://hyperallergic.com/318318/beer-with-a-painter-enrique-chagoya/.

Samet, Jennifer. "Beer with a Painter: Suzan Frecon." *Hyperallergic*, November 21, 2020. https://hyperallergic.com/602535/beer-with-a-painter-suzan-frecon/.

Sanders, Phil. *Prints and Their Makers*. New York: Princeton Architectural Press, 2021.

Schellmann, Jörg, and Mariette Josephus Jitta, eds. *Donald Judd: Prints and Works in Editions; A Catalogue Raisonné*. Cologne: Edition Schellmann, 1993. Exhibition catalogue.

Schwartzman, Allan. *The AIDS Project*. Toronto: Gershon Iskowitz Foundation, 1989.

Semff, Michael. *Al Taylor: Drawings*. Ostfildern: Hatje Cantz Verlag, 2006.

Shaw, Gwendolyn DuBois. *Seeing the Unspeakable: The Art of Kara Walker*. Durham, NC: Duke University Press, 2004.

Simon, Joan, ed. *Bruce Nauman*. Minneapolis: Walker Art Center, 1994. Exhibition catalogue.

Smith, Jaune Quick-to-See. "Celebrate 40,000 Years of American Art." *Frontiers: A Journal of Women Studies* 23, no. 2 (2002): 154–55.

Smith, Joel, Philip Gefter, Steve Turtell, and Martha Scott Burton. *Peter Hujar: Speed of Life*. Translated by Nicole Spiller. New York: Aperture, 2017. Exhibition catalogue.

Smith, Kiki. "Learning by Looking—Witches, Catholicism, and Buddhist Art." *Art21*, [2003?]. Accessed August 17, 2021. https://art21.org/read/kiki-smith-learning-by-looking-witches-catholicism-and-buddhist-art/.

Spiak, John D. *Mark Newport: Super Heroics*. Tempe: Arizona State University Art Museum, 2005. Exhibition catalogue.

Stamey, Emily. *The Prints of Roger Shimomura: A Catalogue Raisonné, 1968–2005*. Lawrence, KS: Spencer Museum of Art, University of Kansas, 2007.

Stewart, Allison. *Before Bruegel: Sebald Beham and the Origins of Peasant Festival Imagery*. Aldershot, UK: Ashgate, 2008.

Stokes, Charlotte. *Return of Realism, Part One, Four from the Allan Frumkin Gallery: Jack Beal, Alfred Leslie, Willard Midgette, Philip Pearlstein*. Rochester, MI: Meadow Brook Art Gallery, 1978. Exhibition catalogue.

Suhre, Terry, Richard S. Field, and David Bonetti. *Tom Huck: Hopeless Americana*. St. Louis: Gallery 210, University of Missouri–St. Louis, 2015. Exhibition catalogue.

Sussman, Elisabeth, and Lynn Zelevansky. *Paul Thek: Diver, A Retrospective*. New York: Whitney Museum of American Art; Pittsburgh: Carnegie Museum of Art, 2010. Exhibition catalogue.

Tallman, Susan. *The Contemporary Print from Pre-Pop to Postmodern*. New York: Thames and Hudson, 1996.

Taylor, Al, and Robert Storr. *Al Taylor: Early Work*. Göttingen: Steidl, 2008. Exhibition catalogue.

Temkin, Ann, ed. *Robert Gober: The Heart is Not a Metaphor*. New York: The Museum of Modern Art, 2014. Exhibition catalogue.

Thek, Paul. *Paul Thek: Paintings, Works on Paper and Notebooks 1970–1988*. Chicago: Arts Club of Chicago, 1998. Exhibition catalogue.

Torre, Blanca de la. *Palimpsesto caníbal*. Vitoria-Gasteiz: Artium, 2013.

Turvey, Lisa. *Edward Ruscha: Catalogue Raisonné of the Works on Paper*. 2 vols. New York: Gagosian Gallery, 2014.

Vail, Gabrielle, and Victoria R. Bricker, comps. "New Perspectives on the Madrid Codex." *Current Anthropology* 44, no. S5 (December 2003): S105–12. https://doi.org/10.1086/379270.

Valentine, Claire. "Damon Davis' 'Darker Gods' Imagines a New Black Mythology." *PAPER Magazine* (December 11, 2018). https://www.papermag.com/damon-davis-darker-gods-2623133746.html?rebelltitem=19#rebelltitem19.

Varnedoe, Kirk. *Jasper Johns: A Retrospective*. New York: Museum of Modern Art, 1996. Exhibition catalogue.

Vastokas, Joan M., and Romas K. Vastokas. *Sacred Art of the Algonkians: A Study of the Peterborough Petroglyphs*. Peterborough, ON: Mansard Press, 1973.

Vergne, Philippe, ed. *Kara Walker: My Complement, My Enemy, My Oppressor, My Love*. Minneapolis: Walker Art Center, 2007. Exhibition catalogue.

Vischer, Theodora. *Robert Gober: Sculptures and Installations, 1979–2007*. Göttingen: Steidl, 2007. Exhibition catalogue.

Watkin, Mel, and Manuel Ocampo. *Utopian Cannibal: Adventures in Reverse Anthropology*. St. Louis, MO: Forum for Contemporary Art, 2001. Exhibition catalogue.

Weitman, Wendy. *Kiki Smith: Prints, Books and Things*. New York: Museum of Modern Art, 2003. Exhibition catalogue.

White, Michelle. *Mona Hatoum: Terra Infirma*. Houston, Texas: Menil Collection, 2017. Exhibition catalogue.

Wojnarowicz, David, and Lucy Lippard. *David Wojnarowicz: Brush Fires in the Social Landscape*. Edited by Melissa Harris. New York: Aperture, 1994.

Woltmann, Marit. *Mike Bidlo: NOT Picasso, NOT Pollock, NOT Warhol*. Oslo: Astrup Fearnley Museum for Moderne Kunst, 2002. Exhibition catalogue.

Wyckoff, Elizabeth, and Gretchen L. Wagner. *Graphic Revolution: American Prints 1960 to Now*. St. Louis: Saint Louis Art Museum, 2018. Exhibition catalogue.

Yau, John, Stanley Whitney, Billy Sullivan, and Mimi Thompson. *Al Taylor: Early Paintings*. New York: David Zwirner Books, 2017. Exhibition catalogue.

York, Emily. *Magical Secrets about Aquatint: Spit Bite, Sugar Lift, and Other Etched Tones Step-by-Step*. San Francisco: Crown Point Press, 2008.

Zilber, Emily, and Sue Taylor. *Mark Newport: Super Heroes in Action*. Bloomfield Hills, MI: Cranbrook Art Museum, 2009. Exhibition catalogue.

Zurko, Kathleen McManus, ed. *Hung Liu: A Ten-Year Survey: 1988–1998*. Wooster, Ohio: The College of Wooster Art Museum, 1998. Exhibition catalogue.

Index

Page numbers in **bold** refer to illustrations.

Photo Credits

The Saint Louis Art Museum thanks the artists, representatives, and image sources for granting permission to reproduce the artworks illustrated in this book. Every attempt has been made to trace accurate ownership of copyrighted images. Any errors or omissions are unintentional and should be brought to the attention of the publishers.

The Art Institute of Chicago: fig. 10

© Michael Barnes, courtesy of the artist: cats. 39, 40, 41, 42; fig. 32

© Mike Bidlo: cats. 92, 93

© Yoan Capote, courtesy of the artist and Jack Shainman Gallery, New York: cat. 35

© Enrique Chagoya: cats. 43, 44, 45, 46, 47, 48, 49, 50, 51, 52, 53, 54, 55; figs. 3, 20, 22, 34, 35, 38

© 2022 Conner Family Trust, San Francisco / Artists Rights Society (ARS), New York: cat. 61

Published by Magnolia Editions, Oakland. © 2021 Conner Family Trust, San Francisco / Artists Rights Society (ARS), New York: cat. 62; figs. 36, 37

© Dorothy Cross: cat. 37

© Damon Davis: cats. 24, 25; figs. 13, 39

© 2021 Michele Oka Doner / Artists Rights Society (ARS), New York: cat. 68

© Bill Fick: cat. 76

© Tony Fitzpatrick: cats. 87, 88, 89, 90, 91

© 2022 Helen Frankenthaler Foundation, Inc. / Artists Rights Society (ARS), New York / Universal Limited Art Editions (ULAE), West Islip, NY: cat. 72

© 2021 Suzan Frecon / Artists Rights Society (ARS), New York: cat. 70

© Robert Gober, courtesy of Matthew Marks Gallery: cats. 27, 28, 29, 30; figs. 19, 24

© Luis González Palma: cat. 26

© Jane Hammond: cats. 96, 97

© Mona Hatoum: cat. 36

© Tom Huck: cats. 77, 78, 79, 80, 81, 82, 83, 84, 85, 86; figs. 11, 23

© Estate of Peter Hujar: cats. 14, 15, 17

© Jasper Johns: cat. 71

Donald Judd Art © Judd Foundation / Artists Rights Society (ARS), New York: cat. 73

© Estate of Nancy Reddin Kienholz, courtesy of L. A. Louver: cat. 34

© Hung Liu: cat. 69

The Metropolitan Museum of Art: fig. 21

© Sally Midgette Anderson: cat. 56

© Bruce Nauman / Artists Rights Society (ARS), New York: cats. 64, 95; figs. 5, 6

© Mark Newport, courtesy of Greg Kucera Gallery, Seattle and Duane Reed, St. Louis: cats. 98, 99

© Liliana Porter, courtesy of Sicardi, Ayers, Bacino, Houston, TX: cats. 31, 32, 33; figs. 16, 17, 18

© Ed Ruscha: cat. 38

© Roger Shimomura: cats. 100, 101, 102, 103, 104; figs. 12, 33

© Jaune Quick-To-See Smith, courtesy of the artist and Garth Greenan Gallery, New York: cats. 65, 66, 67; figs. 30, 31

© Kiki Smith, courtesy of Pace Gallery: cats. 1, 2, 3, 4, 5, 6, 7, 8, 9, 10, 11, 12, 13, 23; figs. 14, 15, 26, 27, 28, 29

© Steven B Smith Photography, LLC., courtesy of the artist: fig. 2

© The Estate of Al Taylor, New York. Reproduced by permission: cats. 74, 75

© Estate of George Paul Thek: cat. 16

© 2022 Wayne Thiebaud / Artists Rights Society (ARS), New York: cat. 94

© Richard Tuttle, courtesy of Pace Gallery: cats. 21, 22

© Kara Walker: cat. 63

© 2021 Estate of H. C. Westermann / Artists Rights Society (ARS), New York: cats. 57, 58, 59, 60; figs. 7, 8

Courtesy of the Estate of David Wojnarowicz and P·P·O·W, New York: cats. 18, 19, 20

This book is published in conjunction with the exhibition *Catching the Moment: Contemporary Art from the Ted L. and Maryanne Ellison Simmons Collection* presented at the Saint Louis Art Museum from June 26 to September 11, 2022.

Copyright © 2022
Saint Louis Art Museum, St. Louis
and Hirmer Publishers, Munich

Saint Louis Art Museum
One Fine Arts Drive, Forest Park
St. Louis, Missouri 63110 USA
slam.org

Hirmer Publishers
Bayerstrasse 57–59
80335 Munich
Germany

Publications Manager,
Saint Louis Art Museum:
Rachel Swiston

Senior Editor, Hirmer Publishers:
Elisabeth Rochau-Shalem

Project Manager, Hirmer Publishers:
Rainer Arnold

Copyeditor: Susan Higman Larsen

Proofreader: Danko Szabó

Indexer: Mary Mortensen

Designer, Hirmer Publishers:
Sophie Friederich

Prepress: Reproline Mediateam,
Unterföhring

Fonts: Agenda, Stolzl

Paper: Garda Ultramatt Art, 150 g/sqm

Printing and binding: Printer Trento s.r.l.

Printed in Italy

Bibliographic information published
by the Deutsche Nationalbibliothek
The Deutsche Nationalbibliothek lists
this publication in the Deutsche
Nationalbibliografie; detailed bib-
liographic data is available on the
Internet at http://www.dnb.de

ISBN 978-3-7774-3843-6
www.hirmerpublishers.com

Library of Congress Control Number:
2022901084

Cover illustrations
Front: Kiki Smith, *Pool of Tears II
(after Lewis Carroll)*, detail, cat. 11
Back: Enrique Chagoya, *Homage to
the Un-Square and My Cat Frida*,
detail, cat. 45

Detail illustrations
Page 2: Damon Davis, *Eyes of
Diamonds, Teeth of Gold*, cat. 24
Page 3: Bruce Conner, *BOMBHEAD*,
cat. 62
Page 4: Michael Barnes, *On the Road
to Bremen*, cat. 42
Page 6: Roger Shimomura, *White
Wash*, cat. 102
Page 10: Wayne Thiebaud, *Candy
Apples*, cat. 94
Pages 12, 13: Paul Thek, *Potlatch*, cat. 16
Page 20 fold: Kiki Smith, *Tidal
(I See the Moon and the Moon Sees
Me)*, cat. 7
Page 56 fold: Enrique Chagoya,
*La Bestia's Guide to the Birth of
the Cool*, cat. 53
Page 81: Tom Huck, *Snacktime
Marcy*, cat. 82
Pages 98, 99: Jane Hammond,
My Heavens, cat. 96
Page 100: Peter Hujar, *Candy Darling
on Her Deathbed*, cat. 14
Page 118: Bruce Nauman, *Pay
Attention*, cat. 64
Page 134: Liliana Porter, *Disguise*, cat. 32
Page 148: Jaune Quick-to-See Smith,
*Celebrate 40,000 Years of American
Art*, cat. 66
Page 162: Hung Liu, *Trademark*, cat. 69